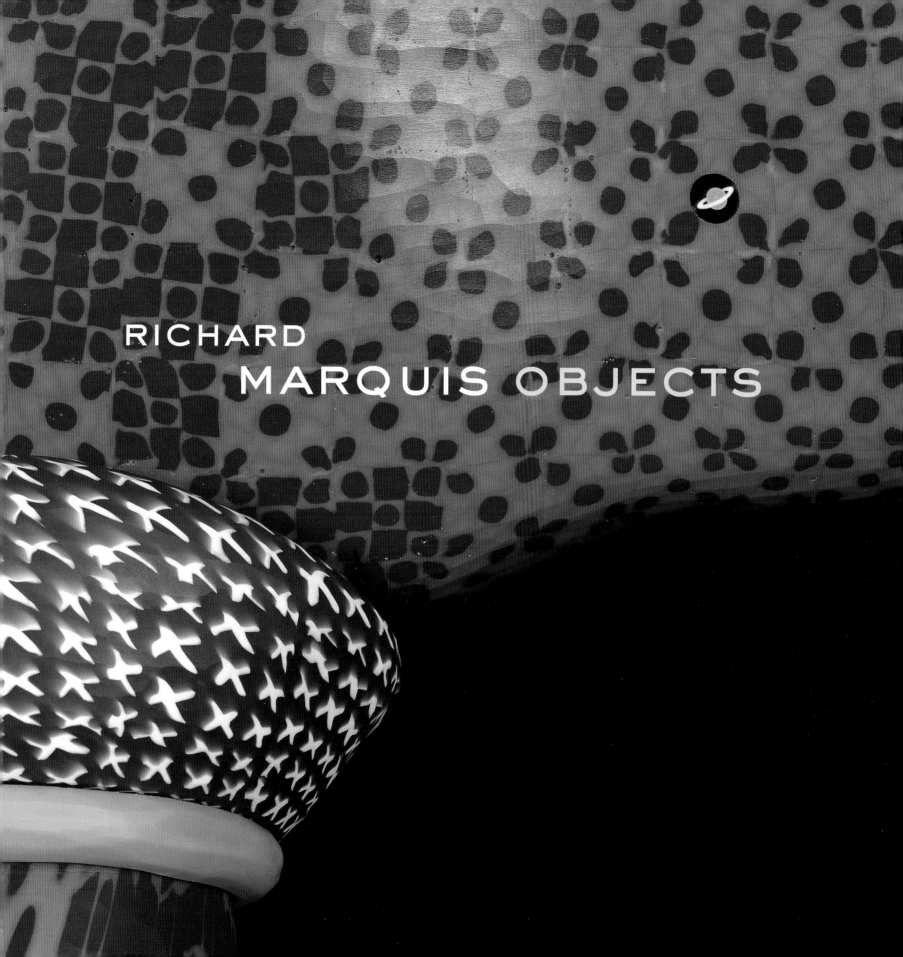

RICHARD
MARQUIS OBJECTS

RICHARD MARQUIS

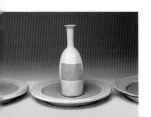

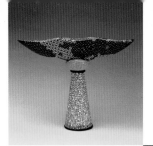

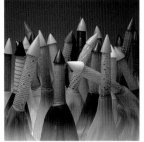

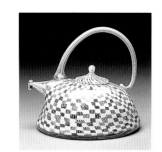

OBJECTS

BY TINA OLDKNOW

Published on the occasion of a retrospective
at the Seattle Art Museum

DISTRIBUTED BY

UNIVERSITY OF WASHINGTON PRESS
SEATTLE AND LONDON

ISBN 0-295-97687-X

Distributed by
University of Washington Press
P.O. Box 50096
Seattle, WA 98145

Printed in Hong Kong

Photo credits: H. Agriesti, pl. 106; Jane Beelby, pls. 7, 20; Peter
Brenner, p. 18; Buffalo Bill Historical Center, Cody, Wyoming,
p. 17; Corning Museum of Glass, p. 35 (top), pl. 27; Bill Dane,
p. 26; Geoerge Erml, pl. 16; Charlie Frizzell, pp. 23, 27, pls. 25,
26, 30–32, 36, 40–51, 53, 54, 56, 57, 60, 62, 64, 65, 105;
Charlie Frizzell and Richard Marquis, pls. 37, 58, 61, 81, 95,
97a–c, 99, 121; Lynn Hamrick, pls. 69, 70, 74–76, 103; Eva
Heyd, p. 13; Russell Johnson, p. 132; Steve Manning, p. 8;
Johanna Nitzke Marquis, p. 124; Richard Marquis, pp. 1, 6, 11,
19–21, 29, 30, 32, 33 (bottom), 35 (bottom), 36, 38, 41, 57,
pls. 1–6, 8–15, 17–19, 21–24, 29, 33–35, 38, 39, 52, 55, 59,
63, 66–68, 71–73, 77–80, 82–94, 96, 98, 100–102, 104, 107,
108–17, 119, 120, 122–38, 140–42, 144, 146, 147–53;
Shoppelin Studios, p. 12; Tom Van Eynde, pl. 143; Rob
Vinnedge, pls. 118, 139; Tom Ward, p. 16

CONTENTS

ACKNOWLEDGMENTS

I wish to express my thanks to Ben W. Heineman Sr., Francine and Benson Pilloff, Pam Biallas, and Denny Abrams for support and encouragement. I am grateful to Jim Manolides, Ruth Summers, Betsy Rosenfield, Franklin Parrasch, and especially Kate Elliott for their taste and good judgment.

I thank Tina Oldknow, Suzanne Kotz, Ed Marquand and his staff, Johanna Nitzke Marquis, and, again, Kate Elliott for being so good at putting a book together and putting up with me, a guy who doesn't even own a typewriter.

Thanks to Vicki Halper and the Seattle Art Museum for providing the impetus for this project. I also want to thank all my friends who gave the benefit of their time and thought. I am grateful to Charlie Frizzell, who explained to me that photographs have feelings too.

More grateful thanks to the following coworkers who have helped me make work over the many years: Fred Bauer, Les Blakebrough, Bill Concannon, Paul Cunningham, Captain Dave, Lark Dalton, Rafaella Del Bourgo, Mike Cohn, Fritz Dreisbach, Jody Fine, Kathy Grey, Jim Holmes, Katrina Hude, Ruth King, John Leggott, Dante Marioni, Johanna Nitzke Marquis, Josiah McElheny, Dimitri Michaelides, Robbie Miller, Janis Miltenberger, Ben Moore, Nick Mount, Bob Naess, Checco Ongaro, Flo Perkins, Brian Pike, Bob Potts, Janusz Pozniak, Ro Purser, Brian Rea, Rich Royal, Mike Selfridge, Steve Smyers, Therman Statom, Lino Tagliapietra, Jack Wax, and Mark Weiner.

I am respectfully grateful to the Fulbright Foundation, the National Endowment for the Arts, and the Australian Crafts Council for their support.

For my education there are old and overdue thanks to Betty and Kelly Anton, Pete Voulkos, Ron Nagle, Jim Melchert, Marvin Lipofsky, and Ludovico Diaz de Santillana.

This book is dedicated to Bear, half yellow Labrador and half palomino, and to his best friend, Johanna.

For continuing inspiration I honor the work of the dead artists Giorgio Morandi, H. C. Westermann, Joseph Cornell, and Carlo Scarpa, as well as the very much alive Ken Price, Jim Melchert, Ron Nagle, Pete Voulkos, and Lino Tagliapietra.

Mistakes and omissions in this book are my responsibility and I apologize for them. It's been a long strange trip.

Richard Marquis

FOREWORD

Richard Marquis's work is meticulous, outrageous, compulsive, iconoclastic, elegant, and wacky. Take, for example, a piece from the start of his consistently interesting career, a 1969 bottle formed with dozens of intricately patterned bits of glass displaying a crude four-letter verb. This is Marquis par excellence: fastidious technique, muted color, strict patterning, and scandalous text. Anyone can scrawl expletives on a wall, but Marquis traveled to Venice, mastered an ancient and laborious technique, and then used it to deliciously shock. He seems to have understood, years before the explosion of studio glass production, that a bracing corrective to the sheer beauty and technical demands of the medium would be needed.

The artist's participation in the California ceramics community of the 1960s and 1970s certainly encouraged his tendency to simultaneously delight and debunk, as well, perhaps, as his favoring a pottery-like opacity in glass. In that period, clay had achieved status as a contemporary medium in which neither beauty nor utility were sacred. Peter Voulkos tore holes in pots, and Robert Arneson sculpted life-size toilets that displayed their contents. Ron Nagle and Kenneth Price made small, precise, and exotically colored sculptures, often variations of cup forms, and Richard Shaw made trompe l'oeil porcelain sculptures that mimicked assemblages of wildly diverse materials.

Marquis has less stylistic affinity to the Voulkos-Arneson bravado than to the meticulous, thoughtful, yet often light-spirited works of Price, Nagle, and Shaw. In a similar vein, he made cups in both clay and glass, created housings for his vessels, and, after Price, collected multiple objects in wooden display cases. Like Shaw, Marquis created assemblages of disjunct parts. In *Green Rock, White Vase, Red Teapot* (see pl. 73) a teapot, nemesis of the utilitarian potter, is center stage. Marquis snatched a classical clay form and made it his signature in glass.

As a glass artist Marquis has transformed ceramics conventions like the teapot and mid-century clay innovations like assemblage sculpture. He also has adopted an attitude toward his craft medium that reflects prowess and delight, but not worship. He has used the maturity of contemporary ceramics, and its debts to twentieth-century sculpture, to help bring the nascent glass field into an adulthood that retains a healthy smattering of rebellious late adolescence.

The publication of this book is coordinated with the exhibition *Richard Marquis Objects,* held at the Seattle Art Museum from December 18, 1997, to August 2, 1998, as part of *Documents Northwest: The PONCHO Series.* The approximately fifty pieces and groupings in the exhibition are all illustrated here, along with additional works and the larger sculptures and installations which are not in the retrospective. The museum wishes to thank PONCHO (Patrons of Northwest Civic, Cultural, and Charitable Organizations) for its generous support of the retrospective and its continuing support of the fifteen-year-old *Documents Northwest* series. We also wish to thank the exhibition lenders for their generosity toward the public: Pam Biallas, Andy and Charles Bronfman, Susan and Jeffrey Brotman, the Corning Museum of Glass, Polly and Charles Frizzell, Art Liu, the Los Angeles County Museum of Art, Johanna Nitzke Marquis, Paul and Elmerina Parkman, Francine and Benson Pilloff, and two anonymous collectors. The major lender is the artist, Richard Marquis, whose astuteness and care in preserving his work is equaled by his intelligence, subtlety, and good humor.

Vicki Halper
Associate Curator of Modern Art
Seattle Art Museum

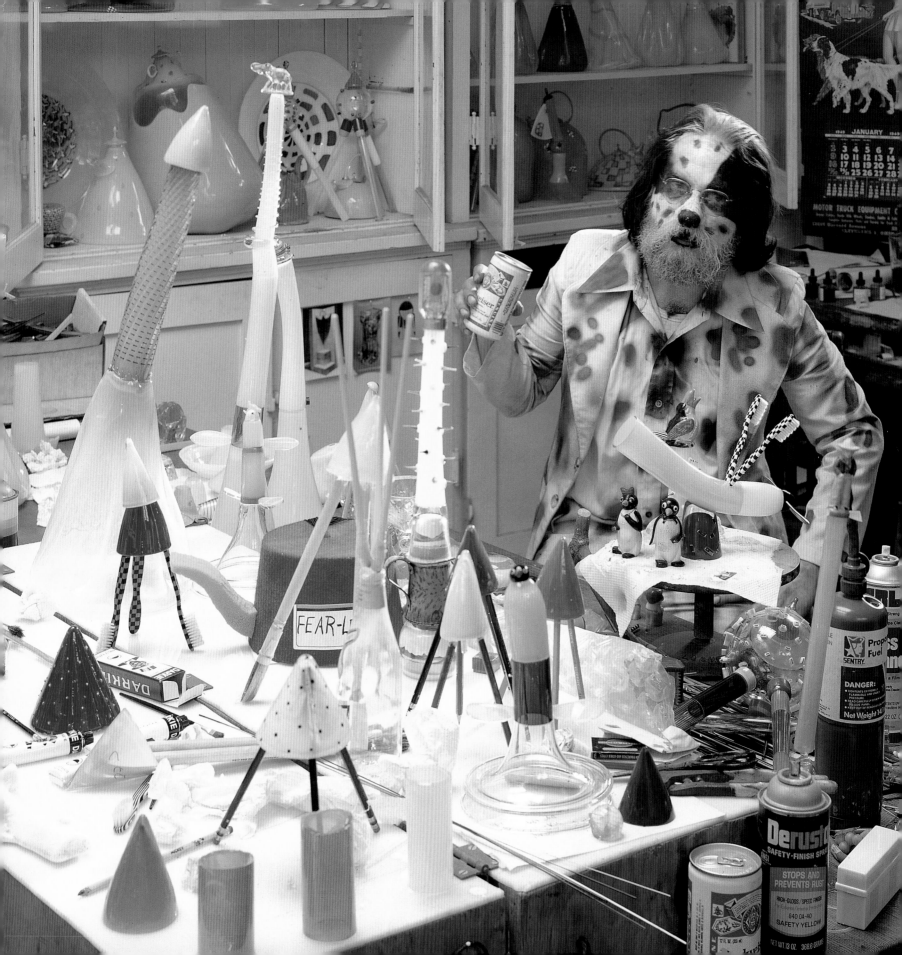

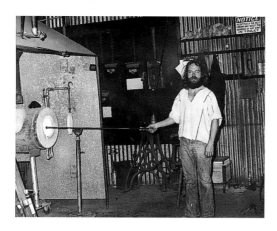

RICHARD MARQUIS

THERE'S SOMETHING VERY THOUGHTFUL,
WITH LOTS OF INTENTION, ABOUT WHAT
RICHARD MARQUIS WANTED TO DO. THERE'S
A LOT TO HIM AND I GUESS I COME AWAY
WITH THIS SENSE OF INTEGRITY ABOUT HIM
AS AN ARTIST, LIVING OUT A LIFE CONSIS-
TENT WITH THE EXPLORATION OF HIS ART.

—LOIS MORAN[1]

Above:
The excitement of blowing
glass, 1975.

Opposite:
Working on the *Fabricated
Weird* series, Marquis
Deluxe Studios (Marlux),
Berkeley, 1979.

Richard Marquis was born, a second child and a triple Virgo, in the small, hot, and dusty desert town of Bumblebee, Arizona, in 1945. For astrology and birth order experts, this is all that is needed to understand what Marquis does, how he does it, and why. His individual brand of obsession and rebellion is tempered by a fortunate mix of intelligence and humor. Marquis has strong opinions and doesn't hesitate to voice them. His under-standing of and participation in the growth of the American studio glass movement over the past thirty years have given him the singular ability to see the phenomenon of studio glass in perspective and the authority to comment on it. Marquis's best advice, however, is not about glass but about art, and how it is made.

In 1981 Marquis wrote a statement summarizing a presen-tation he made at the Glass Art Society conference. The style was pure Marquis: a serious subject presented in a context both intriguing and absurd:

History tends to condense and simplify . . . (I love it when you wear no underwear). In five hundred years, the art nouveau style may be given the slot from 1880–2000 or so . . . (Your old boyfriend called; he sounded drunk). Orient and Flume will stand with Frederick Carder. I feel this is okay; quality should speak for itself. However, I also think it is rewarding . . . to relax about projecting how one will be remembered in history and instead consider for whom one is . . . making art. Disregard answers like dream response and self-fulfillment—what does that mean? (Stop that, I'm trying to concentrate). . . . Choose your aesthetic heroes well and be ready to abandon them at any time (Hey, no biting). And remember meeting heroes can be so very disappointing. Legends loom large (Ouch!). . . . [Finally, I didn't want to] have to explain . . . [but I will] that I see my recent work as a sort of contemporary folk art commentary about things that interest me and how they relate to historical precedents in my craft and the current states of glass and art, while hopefully displaying finesse in terms of form, color, imagery and technique . . . (Put your robe back on).[2]

As in Marquis's artwork, appealing diversions must be overcome to find the Cracker Jack prize of meaning and intent. Throughout his artistic career, Marquis has created an aston-ishing variety and range of work. A prolific maker, he is also a prolific doer, remodeling his house, building studios, fixing old cars, chopping firewood, searching for vintage objects and tools for his collections, demonstrating his glassmaking techniques all

over the world, and helping out friends. If a project involves learning something new, acquiring another technique or tip to add to his encyclopaedia of talents, Marquis is there, giving 150 percent. If not, you'll probably find him in his studio. Happily working.

FROM BUMBLEBEE TO BERKELEY

I WAS IN BOY SCOUTS ONE SUMMER AT THE LOS ANGELES COUNTY FAIR IN POMONA AND WE WERE MESSENGERS. THERE WAS A GUY ON A POTTER'S WHEEL FROM SCRIPPS COLLEGE, I CAN'T REMEMBER HIS NAME. HE HAD A KICK WHEEL, HE HAD HIS SHIRT OFF AND HIS SHORTS ON AND HE WAS THROWING POTS. AND I THOUGHT, THAT'S A JOB? THIS IS AN OPTION? —RICHARD MARQUIS[3]

Marquis had few role models growing up, and he had little idea what employment opportunities he might have as an adult. His older brother, Bill, was the first person on either side of his family to finish high school (Marquis was the second), and Marquis was the first to attend college. He took academics seriously and expected to major in science or math; his goal in life was to be as unlike his father, an itinerant grocery-store worker, as possible. Coming out of a difficult childhood spent moving from place to place, he wanted stability and self-sufficiency, which manifested, partly, in an abiding desire to learn how to do everything and to collect things.

Since grade school, Marquis and his brother had been steadily accumulating categories of scavenged objects, such as cigar bands and bottle caps—which Marquis enjoyed looking for and then lining up for display—in addition to building complex hobby models that he remembers as "obsessive and really, really perfect." He was never allowed to enjoy his possessions for long, however: every time the family moved, which happened at least once a year, the brothers' collections were thrown out. Although the children were told that their belongings would be shipped later, somehow they never arrived; it always was claimed that the collections had been lost or misplaced.

Escalating disagreements between Marquis and his father led him to leave home at fifteen to live with another family, but he stayed enrolled in his Southern California high school in Upland, near San Bernardino. It was at this school that his interest in ceramics developed, and he was encouraged by his

The artist with his older brother, Bill, Phoenix, 1946.

teachers to continue his studies in art. In 1963 Marquis moved to the San Francisco Bay Area and enrolled at the University of California at Berkeley, where he majored in architecture.

While in Berkeley, where he made his home, off and on, until 1982, Marquis continued to indulge his passion for collecting objects that displayed aesthetic qualities which he would come to think of as intrinsic, unintentional, and unself-conscious. "The thing about unintentional art is that it was usually made for some reason other than to be art or be beautiful," observes Marquis. "Some stuff that you see in the craft area at county fairs—made out of lowbrow materials like Popsicle sticks—can be so unintentionally good. There's a cross-over line when it becomes art. Sometimes it's elevated simply by the fact that the collector has chosen it. Sometimes it's just age, time. . . . The oldest intact collection of mine is a collection of hot rod decals my brother and I put together in the late 1950s, and my enamel graniteware collection was probably started in 1963, which was early. . . . Everything was a dime, then it was a dollar. And then when things started getting expensive, I lost interest in them." Marquis took his time finishing his undergraduate degree, taking "hard classes twice" and staying out of the draft. It was not long before his interest in architecture waned in favor of the exciting atmosphere of the ceramics shop, and later, the glass hot shop.

In the early 1960s, Berkeley was on the cusp of its golden age of social and cultural revolution, and had much to offer a serious-minded nihilist like Marquis. The decorative arts department at the university was a hub of activity at that time, with the funk movement just "roaring into high gear."[4] On his arrival at Berkeley, Marquis immediately enrolled in ceramics courses, which were taught by abstract-expressionist ceramist Peter Voulkos and jeweler, ceramist, and musician Ron Nagle, whose early funk style soon turned toward the polished techniques and carefully finished surfaces of the so-called fetish-finish artists living in Southern California.[5]

The cutting-edge potter/sculptor Peter Voulkos had been lured away from Otis Art Institute in Los Angeles to start a ceramics program at Berkeley in 1959. According to historian and critic Garth Clark, Voulkos represented the heart of the revolution in ceramics during the 1950s and early 1960s. "[From 1954 to 1958] Voulkos changed from being a maker

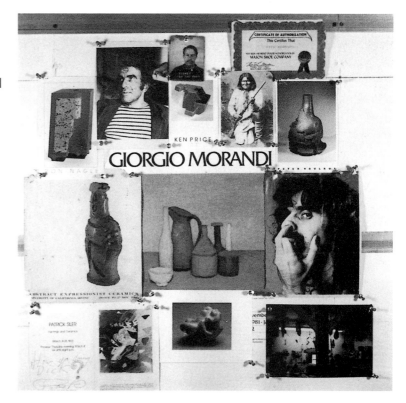

Posters on the artist's glass shop wall, 1997.

of functional, stoneware pottery," Clark writes, "to a radical vessel maker, piling up volumes on top of one another . . . gouging holes into the once sacrosanct volume of the pot . . . and encouraging, for the first time in Western ceramics, the surface to engage in dynamic competition with the form. . . . The impact of the Otis group [including artists Ken Price, John Mason, and Billy Al Bengston] . . . was felt not only in the world of ceramics but had considerable impact on avant-garde West Coast painting and sculpture. . . . [When] Voulkos left Otis for . . . UC Berkeley, a new surge of development took place [in the] . . . redefining of the vessel."[6]

As at Otis, at Berkeley Voulkos inspired and energized an influential group of artists, including Ron Nagle and sculptor James Melchert. A ceramics student and later faculty member, Melchert remarks that the decorative arts department "was one of the few—and I'm tempted to say the only—departments devoted to decorative arts in any American university. It was pretty unusual."[7] "A lot of the things—political and artistic—that were

developing in the 1960s were happening at Berkeley," says Ron Nagle. "And Dick Marquis was around for that."[8]

Marquis remembers that most of the good artists in his ceramics courses were students from the fine art (painting and sculpture) department and the infamous "auditors," individuals who came from around the world to work with Voulkos. "Pete was there half the time [and] . . . John Mason and Ron Nagle would fill in," Marquis relates. "Pete was the most dynamic; I really liked his work but knew it wasn't my style. Ron Nagle's work was the exact opposite of Pete's. And I liked both their work, both the extremes. But Jim Melchert [who was teaching sculpture] was probably the most continuing influence because he did so many different kinds of things so well."

By the mid 1960s, the university had restructured its art departments, subsuming the decorative arts department into a larger school of environmental design. The old decorative arts department at Berkeley, according to James Melchert, had sprung from the arts and crafts movement in the Bay Area. "When the department was taken over," he explains, "the overriding concern of the new college of design was much more connected with the international style [than] . . . the notion of handcraft/decorative arts. . . . There was no place for ornament. So the [crafts] . . . were eventually phased out." The remarkably fertile milieu for ceramics and glass that Marquis had the fortune to experience at Berkeley would end in the next decade.

FUNK AND FETISH FINISH

FUNK ART, SO PREVALENT IN THE SAN FRANCISCO BAY AREA, IS LARGELY A MATTER OF ATTITUDE. . . . FUNK IS AT THE OPPOSITE EXTREME OF SUCH MANIFESTATIONS AS NEW YORK "PRIMARY STRUCTURES" OR THE "FETISH FINISH" SCULPTURE WHICH PREVAILS IN SOUTHERN CALIFORNIA. FUNK ART IS HOT RATHER THAN COOL; IT IS COMMITTED RATHER THAN DISENGAGED; IT IS BIZARRE RATHER THAN FORMAL. . . . FUNK IS VISUAL DOUBLE-TALK, IT MAKES FUN OF ITSELF, ALTHOUGH OFTEN . . . IT IS DEAD SERIOUS. . . . IN CONTRAST TO POP ART, WHICH AS A WHOLE IS PASSIVE, APATHETIC, AND ACCEPTING, THE FUNK ARTIST BELONGS TO A NEW GENERATION WHICH IS CONFIDENT, POTENT, AND OFTEN DEFIANT.
—PETER SELZ[9]

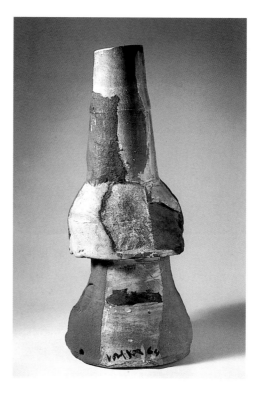

Peter Voulkos, *Vase/Stack*, 1964. Stoneware with low-fire glazes, slip, and epoxies, h. 27¼ in. Private collection.

Richard Marquis's distinctive style in ceramics and glass in the 1960s and 1970s was indebted (not surprisingly) to what was happening in ceramics in California during the mid 1960s. Ron Nagle recalls:

When ceramics started to develop in a variety of directions in the late 1950s and early 1960s, there were several approaches available to us. First, there was traditional or studio pottery, which people were trying to rebel against. If you were going to do that, you could go the Peter Voulkos route, which was a much more expressionistic, organic, intuitive way. . . . Then there were people like John Mason and Jim Melchert, all of whom were around the periphery of Berkeley when Dick Marquis was there and when I was there. And then there were other approaches, specifically Ken Price's, which was smaller scale, more delicate, more color. In terms of color in contemporary ceramics, Price is the guy who made it happen. Up until that point, everything was brown.

California artists waged a constant battle against mindlessness in contemporary studio ceramics, extending Peter Voulkos's notion that each ceramist needed "to think from himself out."[10] At the University of California at Davis, near Sacramento,

Robert Arneson and David Gilhooly championed funk; in Los Angeles Ken Price pioneered a style that would become known as "fetish finish." Berkeley and San Francisco, however, were in the eye of an aesthetic hurricane that had swept up a little bit of everything: abstract expressionism, funk, and at the same time, reactions to abstract expressionist, funk, and fetish-finish concerns.

Many artists, critics, and curators consider Peter Selz's 1967 *Funk* show, held at the University Art Museum in Berkeley, to be the ultimate statement on the funk art movement. Yet it generates controversy even after thirty years. In this show, mixed-media and ceramic sculpture referenced pop art, abstract expressionism, a direction in painting and sculpture that was termed "brute" or "dumb," and finally, "funk." While most consider Selz's show to have been legendary in its presentation of a vigorous West Coast movement, others, notably Berkeley artists, regarded it as a vehicle for Selz, who sought to establish a curatorial presence after his move to Berkeley from a position at the Museum of Modern Art in New York. Selz, it was said, hated pop art and used funk to make an antipop statement. James Melchert, who contributed work to the *Funk* exhibition, comments:

I never felt there was a funk art movement on the West Coast. In clay [the movement was called] . . . abstract expressionism, which applied to Pete Voulkos but I'm not sure it did to the rest of us. There was Ken Price and Ron Nagle and they were hardly abstract expressionists, ever. Manuel Neri was, and to some extent that was apt. Then, when this funk art show came along . . . I think [Selz] . . . thought here was a chance to show that pop art had not taken over the country. But what a number of us realized was, here was an exhibition that was going to have a catalogue, so if we made something "funky" for it that we thought could get into the show, then we'd be included in the catalogue. We needed the exposure. Ken Price was included because he already had a name . . . and they needed more known people in that show.

Ron Nagle adds:

The funk show that Peter Selz put together and the people he included in it . . . were his idea of what funk was, but nobody thought about funk at Berkeley. Historically, it always gets confused. But somehow, because we were from California, everybody wanted to lump us all together into one

big, happy, funky family and we resented that. . . . None of us ever thought of ourselves as being funk artists. The word that preceded "funk" was the word "dumb" [which] was used by Manuel Neri and several others. It basically referred to a certain kind of brute sensibility, dumb in an inarticulate yet sophisticated way. . . . It had to do with the way the work was handled, how it was executed. And funk—especially as associated with the Davis school—had to do with cheap laughs.

Nevertheless, Selz's exhibition, with its widespread exposure, validated the art that was emerging out of the West Coast hippie culture, a society denigrated by the hip, mod, pop art contingent so firmly entrenched in New York. "Funk art is dumb," declared San Francisco mixed-media artist Bruce Connor in Selz's *Funk* exhibition catalogue. "Funk art is a primitive urban art (by country folk or natural folk); it is antimechanical, organic, human, unsophisticated; hobby craft is funk; lowbrow ideals."[11]

In Marquis's ceramics and glass, the debt to California funk has been duly and repeatedly noted. Yet Marquis's artwork was also influenced by the "pristine and beautiful cups," in Marquis's words, of fetish-finish ceramists Ken Price and Ron Nagle. And both Nagle and James Melchert were experimenting with low-fire earthenware and commercial glazes, which Marquis would also pursue. "A lot of those colors were associated at that time with the hobbyist and not the artist," says Nagle. "Things like molds, bright colors, china paints, decals, things which I got into, I was exposed to as a kid. My mother had a

James Melchert, *Legpot I,* 1962. Stoneware, lead, and cloth, 11 × 32 × 13 in. American Craft Museum, gift of the Johnson Wax Company, from *Objects USA,* 1977. Donated to the American Craft Museum by the American Craft Council, 1990.

hobby ceramics set-up in the basement." "I knew about low-fire [earthenware and glazes]," adds Marquis. "It was unusual. Most university ceramics programs were based on the Japanese purity concept, using [high-fire] . . . porcelains and . . . [high-fire] Cone 10 stoneware. Low-fire glazes were available in all kinds of colors. . . . You could buy them in craft stores. And you could paint images with them."

Low-fire, brightly colored glazes were part of the Bay Area ethos in ceramics celebrating the anti-intellectual lowbrow, the mundane, and the "dumb."[12] "For me, a classic example of great painting that might exemplify dumb would be Philip Guston's pictures where there's this brilliant sophistication married with a clumsy, awkward execution," comments Ron Nagle. "But I wouldn't call Guston a funk artist." Guston gave up abstract expressionism in 1966, turning his attention to lowbrow subjects like the soles of old shoes, rusted nails, mended rags, brick walls, and cigarette butts, among other things. Like Jasper Johns and Robert Rauschenberg, Guston used his "dumb," comics-inspired imagery to make both an anti–abstract-expressionist statement and to explore private concerns.[13]

In Berkeley, Nagle and his students, including Marquis, understood the terms "dumb" or "stupid" not to mean idiotic but "brute," primal, and intentionally awkward, qualities that referred, for example, to the anti-intellectual, carefully considered investigations of form and subject matter that intrigued artists like Guston and Neri. "There are roots to Dick's sensibility, historically, which are worth mentioning," remarks Nagle. "Because I think they do come from a ceramics tradition. Obviously there are things that are peculiar to glass. . . . But a lot of what he does comes from another place. Some of it came from painting traditions. . . . For example, we all were into Morandi."[14]

The dumb aesthetic was considered to be "the opposite of what would be accepted practice in the academy," adds James Melchert. "The art department at Berkeley could be a stuffy place and the painters were very much influenced by the abstract expressionists. They were rather dogmatic and had notions of so-called high art, like "high" church. And it didn't go down well with young people like the students and some of us junior members of the faculty. Consequently, if you thought of anything that you knew would get under the skins of these older gentlemen you rather delighted in its existence."

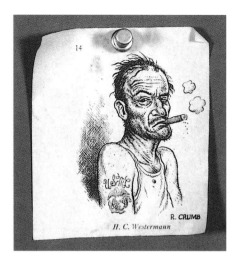

Drawing of assemblage artist H. C. Westermann by underground-comic artist Robert Crumb, taken from a *New Yorker* magazine, on the artist's studio wall, 1993.

Thus, the so-called funk approach that Marquis would become known for was actually a compound of interests drawn from the fetish-finish ceramics of Ken Price and Ron Nagle, Peter Voulkos's abstract expressionism, Manuel Neri's "dumb" and James Melchert's conceptual sculptures, the paintings of Giorgio Morandi, underground comic imagery, and the assemblage works of H. C. Westermann and Joseph Cornell, which the artist saw in exhibitions and catalogues.[15] Smart, anti-intellectual, and lowbrow, Marquis's art was obsessive in technique and rebellious in appearance, "both tight and loose," as the glass artist Dante Marioni would later characterize Marquis's distinctive style.[16]

GLASS AND OTHER REVOLUTIONS IN BERKELEY

DURING THE EARLY 1970S, A PREVAILING LITERAL AND PICTORIAL STYLE OF IMAGERY (WHICH WAS TO STAY FIRMLY ATTACHED TO GLASS IN THE YEARS TO COME) WAS INFLUENCED BY POP ART AND ITS CERAMIC OFFSHOOT, FUNK. THAT IMAGERY WAS USED EFFECTIVELY FOR MAKING SERIOUS COMMENTARY ON THE CURRENT SOCIAL AND POLITICAL UPHEAVALS. . . . THE BOLD COLOR AND GRAPHIC DESIGN STYLES OF PSYCHEDELIC, SCIENCE FICTION, AND COMIC-BOOK ART WERE LIKEWISE WIDESPREAD.

—SUSANNE FRANTZ[17]

While working in ceramics at Berkeley, Marquis was introduced to glass, which he quickly came to prefer. From the mid 1960s into the early 1970s, he worked in both media—sometimes even combining them in objects such as small *raku* ceramic bottles with glass stoppers[18]—but he also explored other materials. Marquis relates:

Ceramics is mostly about ideas. Anyone can take clay home to their kitchen table and make something nice if they're thinking. With glass you have to go through years of practice to do anything. You can't go into the hot shop and just putz around. . . . So, I was doing glass and ceramics. Glass held my interest the most [because it] . . . was wide open. . . . It was hard to do. I was just learning another skill, something else to do, another vocabulary. I wanted to know how to make everything and I was interested in a lot of difficult things. I was doing glass, ceramics, photography, welding, jewelry, bronze casting; . . . I was interested in all of those skills and found that I could pick them up pretty quickly. But glass was always the hardest and most interesting."

In 1964 Marvin Lipofsky, who had been a student of Harvey Littleton's at the University of Wisconsin, Madison, was hired to start a glass program in the decorative arts department at Berkeley. He was one of the fledgling studio glass movement's most influential teachers. "One afternoon I saw Marvin blowing glass and I thought it was so cool," says Marquis. "I tried to get in the class but he wouldn't let me in at first. Later, I was his teaching assistant and he would leave me lists of things to fix or repair. . . . It was impossible to work; in class Marvin only let us blow once a week for three hours so we had to sneak in after hours. At that time you blew glass by yourself because that's the way Harvey Littleton did it at Madison. Only when we were making big things did we help each other and work as a team." "I don't remember exactly when Dick started [blowing glass] but it was early," adds Lipofsky. "It was a good group of students: they were very active and worked all night. . . . Dick built some equipment and repaired the furnaces."[19]

Marquis remembers that during the mid and late 1960s he was learning mostly "from people in the pot shop" although he loved blowing glass.[20] Because he could not practice blowing as much as he wanted, he "went independent early on." Building his first studio in 1967, he melted glass, practiced blowing at all hours, and managed to bootleg gas and electricity. His best friend at the time was the glassblower and sculptor Robert Naess.[21] James Melchert recalls:

I had my office in the same building as the decorative arts department. The ceramics shop was across the hall, and the glass shop was a floor above. So even though I wasn't teaching with Pete Voulkos in ceramics, I saw all the students and all the activity, and it was the same with Marvin Lipofsky's operations upstairs. That's how I met Dick Marquis. . . . There was something so positive and cheerful about him that I was very much aware of him. . . . It was quite a lively circle.

In ceramics, Marquis focused on cups although he experimented with more abstract forms, some of which would be echoed in his later glass work. "Dick was pretty self-motivated as a student," comments his teacher Ron Nagle. "I spoke to him and saw what he was doing and I think I encouraged him but he had his own path pretty well set. . . . His general sensibility was already established." Marquis's choice of the cup form was not incidental: Nagle was well known for his cups, often enclosed in precious wood and Plexiglas boxes, and Ken Price, who was much admired by Marquis, built elaborate, mixed-media displays for his ceramics. The bright colors and graceful forms of Marquis's early stoneware and earthenware cups reversed traditional cup shapes: instead of an open lip tapering through the round body to a small base, Marquis's cups were heavier, with a

Ron Nagle, '55, 1975. Earthenware, glaze, and china paint, 4 × 3 × 3 in. Collection of the artist.

lipless collar and spreading, rounded body supported by a flat patty base. Yet instead of being "naturally" brown, clumsy, and thick-walled—the treasured hallmarks of the handmade—Marquis's thin-walled cups were refined and skillfully potted with bright patterns and colors.

In glass, Marquis did not have much control over the material at the beginning, and he made things that he had the skills to do. Unlike ceramics, in 1966 there was little work to look at, and no magazines devoted to contemporary glass, so Marquis went to the library and read about historical glass. "He was the first person to really think about researching," says Lipofsky. "He used the library, [checking out] . . . all the books on Italian glass." "I looked at books and at all this stuff that was going on, especially in California in the 1960s, all the abstract-expressionist stuff," adds Marquis. "But [ultimately] . . . it wasn't as interesting to me as [ancient Roman or] . . . early American blown glass." One of Marquis's first glass pieces, the *Double-Handled Vessel* of 1966 (pl. 1), engraved by Marise Picou, is unusual for Marquis but reveals what he learned from his research into historical glass forms as well as his beginner's skill level. The result was blown glass's most elemental form: a simple, bubble-shaped flask with a constricted neck, tooled lip, and two whimsically applied handles for decoration.

After he built his first studio in Berkeley, Marquis's glass-making skills improved dramatically. From basic bubbles, Marquis moved to more complicated shapes such as the 1967 *Trapezoidal Bottle* (pl. 2), a form, like his glass cups, still very much tied to ceramics. But other glass pieces from 1967, notably the *Tall Double-Handled Bottles* and the *Double Bubble Vessel* and *Square Bottle* (pls. 3–4), reflect his continued interest in early American and ancient Roman glass forms. Marquis also experimented with surface treatments, using a silver nitrate overlay to create iridescent checkerboard patterns and stripes on some of

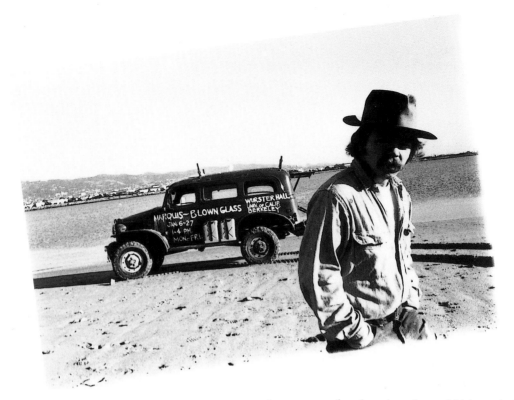

Announcement for solo undergraduate exhibition at the University of California, Berkeley, taken on the Berkeley salt flats, 1968.

his cups and bottles, trying to make them look "as unlike art nouveau as possible." The rediscovery of silver nitrate, which produced a surface finish akin to Tiffany art nouveau–style glass, precipitated a glut of iridescent craft glass which became as ubiquitous as the equally popular, lumpy, brown craft ceramics.

By the end of the 1960s, most studio glass artists knew no more about color than the limited palette of greenish-clear, green, and blue glasses they melted; they were unaware of commercial German glass color bars, which would become indispensable to glassmakers from the late 1970s on. "[Artist] Joel Myers told me about Kugler when I worked with him at the Blenko [glass] . . . factory in West Virginia in 1969," recalls Marquis. "He said, 'Use color rods' and I wrote it down in my book: Klaus Kugler color rods, 1–1½ inches diameter. But I thought to myself, What will I do with those? They're too expensive to throw in the furnace."

In the late 1960s Marquis was also experimenting with mold-blown, multiple glass forms that he put inside Plexiglas

boxes. He found that he liked stacking objects and putting things in boxes, and he enjoyed the process of making multiples which allowed him to practice his glassblowing skills. "Some of the pieces I made then I couldn't make now because I know too much," observes Marquis. "The character and the playfulness and the struggle wouldn't be there. Some of the early things interest me because of that struggle from idea to finished object. And I made them all by myself: I didn't have anyone bringing me handles or anything." Collecting also remained a passion and Marquis made glass and ceramic coffeepots imitating the graniteware originals that he loved. "Dick very early was a collector of things: I think he made some ceramic pieces [from molds made out of] . . . small oil cans and funky shop items," recalls Marvin Lipofsky.

Marquis earned early recognition for his work in glass that surpassed—technically and aesthetically—the prevailing "dip n' drip" approach of many of his contemporaries. His work was chosen, along with pieces by Robert Arneson, Ron Nagle, woodworker Wendell Castle, and jeweler Arlene Fisch, for a 1968 show curated by LaMar Harrington for the Henry Art Gallery at the University of Washington, Seattle, and he was also included in the landmark 1969 exhibition, *Objects USA*, curated by Lee Nordness and Paul Smith. "Richard Marquis has received unusual recognition for his delicate and innovative blown glass," noted the *Objects USA* catalogue. "His tall functional bottle in iridescent, transparent glass . . . and the tiny-lipped, trapezoidal, mold-blown bottle . . . stem from an extension of the abstract expressionist aesthetic."[22] Art critic and independent curator Paul Smith remembers:

I met [Dick] in the late 1960s . . . when I was working on Objects USA *with Lee Nordness. We made many trips throughout the country, not only to seek out the best work of known people but also of new and emerging talent. Dick was one of those younger people; I believe he was still a student at the University of California at Berkeley. The pieces that were in* Objects USA *were very delicate, beautiful and accomplished for a student. One has to think of this in terms of the criteria of the time— the glass movement was relatively new and the pieces selected for the show had to represent the best work, especially if the artist was emerging.*[23]

In 1969 Marquis was awarded a Fulbright-Hayes fellowship to work in Italy on the Venetian island of Murano, the historic home of the world's most skilled glassblowers. The artist Dale Chihuly, having just graduated with an M.F.A. from the Rhode Island School of Design, had been awarded a Fulbright for the 1968–69 academic year, which he spent at the Venini glassworks on Murano and in Germany and Czechoslovakia. At the request of the foundation, Chihuly wrote a friendly letter to Marquis, advising him what to expect and warning him that he would probably get little of his own work done. But the twenty-four-year-old Marquis did make "tons of work," and, like Chihuly, he would have an unforgettable experience in Italy, one that would forever change his approach to glassblowing and his understanding of glass.

MURANO, VENICE, AND VENINI

IT HAS BEEN OVER TWENTY-FIVE YEARS SINCE I WORKED AT VENINI. THE EXPERIENCE LOOMS LARGE IN MY DEVELOPMENT AS AN ARTIST AND AS A PERSON. IT WAS A GENEROUS AND AMAZING OPPORTUNITY. THERE WERE SO MANY THINGS GOING ON [THAT] I WAS LIKE A KID IN A CANDY STORE WITH ONLY A PENNY OR TWO TO SPEND. . . . AT THE TIME I RECEIVED THE FULBRIGHT GRANT TO GO TO ITALY, I WAS CONSIDERED ONE OF THE MOST SKILLED [AMERICAN] . . .

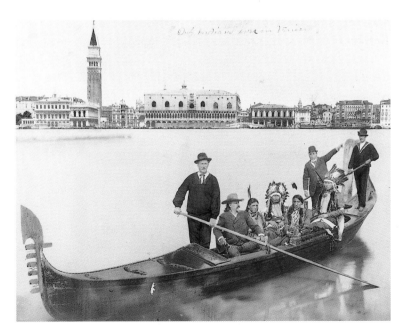

Hand-tinted photograph of Buffalo Bill and Sitting Bull in Venice, c. 1890, attributed to Paolo Salviati. Buffalo Bill Historical Center, Cody, Wyoming.

When Richard Marquis arrived in Italy in August 1969, he went
first to Bologna for the Fulbright orientation and, while there,
made a pilgrimage to the studio of the late painter Giorgio
Morandi. From Bologna, he continued to Venice where he
rented a small apartment in the Dorsoduro quarter. Marquis
had written a few letters to glass factories before leaving Berke-
ley but had received no replies and since nothing had been ar-
ranged for him, he was free to wander around Murano at will.
"I checked out all the factories," says Marquis. "I realized that if
you looked like you knew what you were doing, you could walk
right in. So I walked in and stood around until someone asked
me to leave. Sometimes I could spend days at a factory before
anyone figured out that I shouldn't be there." Finally Marquis
approached the Fulbright office in Rome, asking them to arrange
interviews for him at two famous glass factories: Salviati & Co.,
founded by Antonio Salviati in 1856, and Venini & Co., founded
by Paolo Venini, in partnership with Andrea Rioda and Giacomo
Cappelin, in 1921.[25]

Marquis spent nearly two weeks at Salviati, observing the
glassblowers and studying the historic collections, and then
interviewed at Venini Fabbrica.[26] Under Paolo Venini's direction,
the firm had attracted an international roster of artists, design-
ers, and architects from Italy, Europe, and the United States.
Venini's son-in-law, Ludovico Diaz de Santillana, took over
direction of the company upon the founder's death in 1959,
continuing the factory's artistic open-door policy. It was
de Santillana who had welcomed Americans Thomas Stearns
and, later, Dale Chihuly to Venini and who would also open
its doors to Richard Marquis.

"I went out and bought a sport coat, cleaned up, and went
in to Venini to interview with the director," remembers Marquis.
"I had memorized my speech in Italian . . . and was doing disas-
trously. . . . De Santillana listened to everything I had to say and
then answered me in perfect English." In exchange for his time
at the factory, de Santillana agreed to let Marquis prepare a
series of time-motion studies of the factory glassblowing opera-
tion (to improve efficiency) and to execute a few tableware and

lighting designs for production.[27] Marquis was not paid, but he
did receive a hot pasta lunch, like the other workers, every day.
He was given the title of "guest designer," a small office, and
was left, more or less, to his own devices. Marquis relates:

Every once in a while I was allowed to have a maestro *and his team make
things for me. For that privilege I chose to work with the* maestro *Checco
Ongaro because he was the friendliest and seemed the most interested.
. . . The workers could never figure out why I wanted to blow glass. First, I
was so unskilled; second, I tried to make weird things; and third . . . since
I had been given an "office" upstairs, why would I want to hang around
the hot and dirty furnace area with sweaty men when I could spend my
time with the pretty secretaries? . . . It took months for the workers to
accept me.*[28]

At Venini, the glassblowers had their own chain of com-
mand in the hot shop. Marquis was the first guest designer who
wanted to actually work on the floor, rather than submit designs
to be made from his office upstairs, and he quickly decided to
deal directly with the workers rather than go through manage-

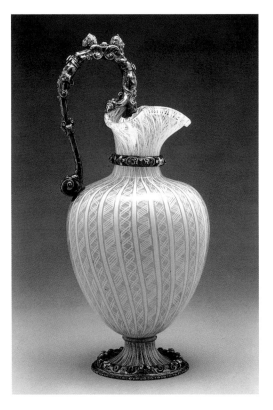

Vetro a Retorti Ewer, Vene-
tian, early 17th century.
Glass, silver gilt mounts,
h. 10¾ in. Los Angeles
County Museum of Art,
gift of Hans Cohn.

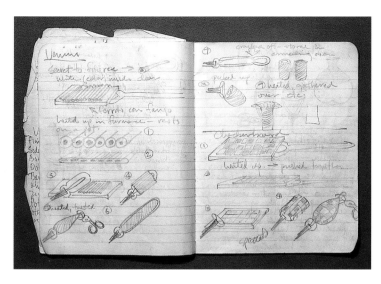

Notebook kept by Marquis with sketches of *filigrana* and *murrine* techniques, Venini Fabbrica, Murano, Italy, 1969.

myself and that it was hard for me to tell people how to make things lean, or be off-center. To make intentional mistakes."

Marquis won the trust of the workers by sitting with them in an impromptu strike that was called to protest the firing of a glassblower. "I remember Ludovico's eyebrows raised slightly when he saw me there," remarks Marquis. "Later, he told me he understood and it was a wise thing to do. After [that] . . . things were much easier for me on the blowing floor."[30] Anna Venini Diaz de Santillana, the daughter of Paolo Venini and wife to Ludovico Diaz de Santillana, recalls:

I remember Dick coming to Murano and the quiet way he came in to the factory and was accepted by the workers. It was not easy: the masters on the whole were quite surprised that somebody from such a far land wanted to do what was a very hard job and make such strange and unexpected shapes. But Dick—whom Ludovico liked very much for the unobtrusive but alive way he had—became part of that strange body that was Venini and slowly began developing his ideas.[31]

Marquis was delighted with the incredible palette of colors that Venini offered and was immediately struck by their potential. The factory melted about twenty pots of compatible colored

ment. He started out at the bottom of the line, content to take the lowliest jobs on the glassblowing team. "In a five-man team, I would replace the fifth guy who would then move to the fourth guy's position. Then the fourth guy would move to the third guy's position," explains Marquis. "The third guy moved to the second guy's position, and he could go out and have a glass of wine. The number one guy, the *maestro*, never left the floor. So then I was appreciated. And when I needed some help with my work, they were willing to help me, as opposed to being told by management to help me."

Although Marquis's schedule at the factory was punishing—coming over to Murano on the *vaporetto* at dawn and returning to his Dorsoduro apartment after dark—he was absorbed in his observations.[29] He would watch all the blowing techniques that the masters performed and then go upstairs to his office to write and draw what he had seen in a notebook. Marquis particularly enjoyed learning how to blow and marver (that is, to shape and cool hot glass by rolling it on a flat surface), and different *maestros* gave or lent him their old tools. "All the tools were so much better compared to the clunky ones that I was used to," Marquis recalls. "The thing that was hardest for the workers to understand was why I wanted to make things myself when I could draw something and have a *maestro* make it for me ten times better. I told them I was just interested in doing it

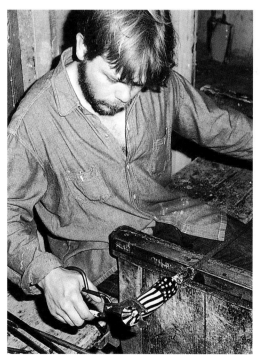

Making an *American Acid Capsule* at Venini Fabbrica, Murano, Italy, 1969.

glasses a day, mixed from Venini's own recipes. If the glassblowers did not use all the glass by the end of the day, it was thrown out, much to Marquis's chagrin. "An old guy named Carlo mixed everything without wearing a respirator," says Marquis. "But they did dampen their sand to minimize the dust. I learned that when you use Italian recipes, the weights are always determined for damp sand, not dry [as in most recipes] . . . so it can mess up your calculations." Some of the colors, rarer ones like orange and black, only came up once in a while in limited amounts, and Marquis would have to ask for permission to use them.

During his first week at the factory, Marquis saw blue, red, and white glasses and realized that he could make the stars and stripes of the American flag by using the *murrine* process. Marquis had seen *murrine* before coming to Venini and had even purchased bags of Italian *murrine* in American craft stores (although the glass proved to be incompatible with his). Perhaps most familiar as the bits of colored glass found in paperweights, *murrine* are cut from pencil-thin cylindrical glass canes embedded with a pattern arranged to read in cross section. The pieces can be ground and polished for jewelry or enclosed in clear glass. *Murrine* can also be arranged inside, or over, a mold and slumped or fused inside a casting kiln or furnace, or, in a difficult technique first invented by fifteenth-century Italian glassmakers and later pioneered by Marquis in the United States, picked up onto a hot bubble of glass and blown.[32]

Soon Marquis was producing a variety of *murrine* cups and "pills," all clothed in the American flag. Ludovico and Anna Diaz de Santillana's son, Alessandro, recalls going to visit the factory as a child, with his father and grandmother. "I remember seeing a young American, hippie-like, going back and forth to the furnace and I remember the room on the third floor where . . . [Dick] had his office," says de Santillana. "One day, I opened the door and saw masses of small objects with the American flag on them: stars and stripes all over the place!"[33] The master Francesco "Checco" Ongaro also remembers the stars and stripes well; most of the glassblowers at Venini thought they were strange and weird but respected Marquis for his original approach. As Muranese glass master Lino Tagliapietra has observed:

The maestros might say, "Okay, we don't like this but we'll see. Maybe it's something we don't understand." For example, when I was young, Venini always showed their latest production line in their front window. We would see it and say, "Oh my God, these are terrible things!" After ten days or so, we'd say, "Oh, these might be interesting after all." Then, another five days would go by and we would find ourselves stopping at the window and exclaiming, "These are great!" Sometimes when we see something new we laugh a little. But when we look at it several times, then we begin to understand it.[34]

Politically loaded symbols, such as the American flag, were a recurrent and controversial theme in American art of the late 1960s and early 1970s. At that time, any American using the stars and stripes inappropriately risked a run-in with law enforcement. Thus the American flag became a favorite counterculture symbol, hung in homes and even stamped on cigarette papers. Marquis's interest in the flag grew out of the intense political climate he had just left behind in Berkeley. "First, it was the free speech movement and then People's Park," notes Marquis. "It was about those bumper stickers—America: Love It or Leave It—and [President Lyndon B.] Johnson and a whole bunch of antiwar stuff going on and the burning of the American flag. It was contemporary to me. It wasn't historical, like the American Revolution or anything like that. It was what was happening the week before I left for Italy." Marquis's American flag "pills," titled *American Acid Capsules* (pl. 17), were shaped

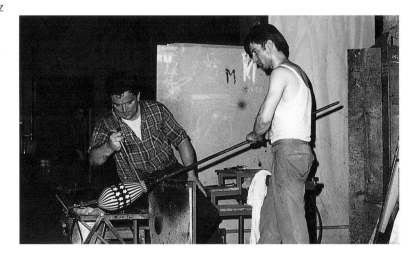

Checco Ongaro and Tulio Manin working on the *Stars and Stripes* prototypes, 1969.

like the prescription downers (Darvon, Seconal) that were popular recreational drugs at the time. Calling them acid (LSD) "capsules" made the flag imagery even more outrageous.

Complementing the American flag pieces were Marquis's word canes: while working with the *murrine* technique, he realized that it would be fairly easy to make letters. "And if I was going to make a *murrine* word," explains Marquis, "the first one obviously had to be 'fuck.' The number one word. . . . And I only had to make three letters since the 'u' and the 'c' were the same." He blew the *murrine* into the shapes of cups, very similar in form to his ceramic versions, and bottles, sometimes combining them with flag imagery as in his *Free Speech Cup* (pl. 16). Later, on his return to the States, Marquis had special cloth covers made for these cups as well as for the "pills" and the *zanfirico*-striped cups that he blew at Venini. The tailored and embroidered covers became presentation bags for the objects, protecting the treasured glass from harm, much like the leather cases traditionally made for historic European glasses or like the exquisite presentation boxes made by Ron Nagle and Ken Price to house their ceramic cups.[35]

"Dick was very famous at Venini," remarks Lino Tagliapietra. "He was the one artist that made something there—like his *murrine*—that really made an impression. They liked him very much although what he did is not exactly what they do in Murano. The 'fuck' pieces were a little shocking. But, I see incredible energy and talent in Dick's work. He transforms everything through American culture but his work is not only about American culture because he looks beyond his own culture." "Dick did something uniquely American with Italian glass," agrees Seattle art dealer Kate Elliott. "Doing the 'fuck' and the American flag *murrine* basically made the techniques his own. Other artists seem to have kept their work more Italian."[36] The influence of Venice, and of Venini in particular, would have a profound effect not only on Marquis's art but on the American studio glass movement as a whole.

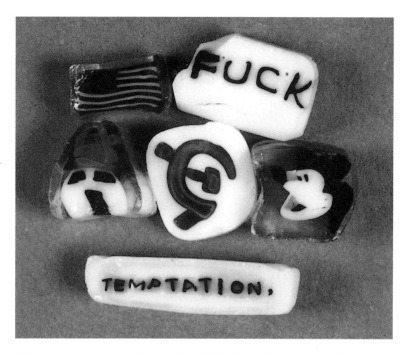

Various word and American icon *murrine* by Richard Marquis, some made with Robert Naess, 1969–72.

HIP[PIE] MURRINE: FROM VENICE TO AMERICAN STUDIO GLASS

UNQUESTIONABLY DICK'S GREATEST CONTRIBUTION TO THE AMERICAN GLASS MOVEMENT IS AS A TEACHER. THE GUY'S DONE MORE WORKSHOPS THAN ALMOST EVERYONE ELSE PUT TOGETHER . . . AND HE'S TAUGHT AT THE UNIVERSITY OF WASHINGTON, UCLA, UC BERKELEY, SAN FRANCISCO STATE, PILCHUCK, PENLAND, AND HAYSTACK. . . . GOING AROUND AND TURNING PEOPLE ON TO THE EXCITEMENT OF GLASS—BOTH GLASSBLOWING AND MURRINE—WAS IMPORTANT TO THE MOVEMENT. DICK'S BEEN EVERYWHERE, SEEN EVERYTHING, AND DONE EVERYTHING. . . . HE TEACHES PEOPLE HOW TO THINK, NOT WHAT TO THINK. —PAUL MARIONI[37]

Returning to the States in August 1970, Marquis stopped to teach a summer course in *murrine* at the Penland School of Crafts, near Asheville, North Carolina, before proceeding to the University of Washington in Seattle, where he had been hired to start a glass program. Marquis worked with early studio glassmakers Mark Peiser and Richard Ritter, who would both develop the *murrine* technique in interesting ways. At Venini

Marquis had attempted to blow designs made in *murrine* and to add drawings made from hot bits of glass applied at the furnace. But he succeeded in making only two pieces this way, the *Red Riding Hood's Grandma's House Landscape Bottles* (pl. 9). Marquis was unsatisfied with the results of the complicated process and preferred his drawings to the finished objects.

Mark Peiser, however, took a special interest in this difficult technique and would use it in multilayered vessels decorated with *murrine* and bit-work landscape drawings. Richard Ritter, who had already experimented with cane making, made elaborate *murrine* portraits with the new skills he had learned, in part, from Marquis. Robert Naess produced a variety of American icons in *murrine* with Marquis while visiting him at Venini, including the head of Mickey Mouse *(Il Topolino),* dollar signs, and a Better Dead than Red hammer and sickle. Naess later combined these *murrine* with American flag imagery in his 1972 *Political Nose Cups*.[38]

Corning Museum of Glass curator Susanne Frantz observes that Richard Marquis's focus and dedication to mastering a difficult technique beyond glassblowing was unusual in the early years of American studio glass. "At a very early date . . . Dick took this one area of interest, *murrine*, and completely mastered it," says Frantz. "And he is still . . . developing it all the time. . . . I can't think of another American in blown studio glass . . . who had that kind of discipline and persistence. . . . [It is] thanks, in part, to workshops and classes presented by Dick around the world that the *murrine* technique has established an international presence in contemporary glass."[39] Glass artist Klaus Moje adds, "During the 1970s and into the early 1980s, 'skill' was a four-letter word in the American glass scene. And there was Dick, showing off with pride a knowledge and understanding of the material that was much ahead of his peers."[40]

In September 1970 Marquis arrived at the University of Washington and went to work on the glass hot shop, which fell under the aegis of the ceramics program. The university's ceramics department was a particularly vigorous one: its faculty included such influential Northwest ceramists as Howard Kottler, Robert Sperry, Fred Bauer, and Patti Warashina. Howard Kottler, in fact, had attended one of the historic studio glass workshops held by Harvey Littleton at the Toledo Museum of Art in 1962,[41] and in 1968 he set up a temporary glass furnace

at the University of Washington with a student, Clair Colquitt.[42] Marquis was hired by his good friend Fred Bauer to fill in while Kottler was out on sabbatical, and Bauer hoped to turn Marquis's position into a permanent one. Although Kottler had briefly worked in glass, it had been Bauer who wanted Marquis to develop the university's glass program and who made all the arrangements to get him there, including the often difficult communications while the artist was in Murano.[43]

Soon after his arrival at the university, Marquis realized that things were not going to go very smoothly. "Fred Bauer and his wife, Patti Warashina, split up and it wasn't pretty," relates Marquis. "Fred fled the state, Patti took Fred's job, and all of a sudden the guy I'd gone there to work with is gone and I'm dealing with . . . someone who doesn't really trust me because . . . I'm Fred's friend." On top of that, funding for the new glass program was imperiled. But Marquis tried to make the best of the situation. He kept a poster in the shop which said "Technique is not so cheap," an obvious rejoinder to Harvey Littleton's most-quoted aphorism, "Technique is cheap." In spite of Littleton's position that technique was overrated, and that artists should explore experimental approaches in glass rather than become mired in "craft," the mastery of technique quickly became a necessary rallying point of the struggling studio glass movement.

And then there was Pilchuck. Dale Chihuly dropped by Marquis's Seattle home in the spring of 1971, looking for technical advice on how to set up his summer glass camp, which would take place on a tree farm north of Seattle owned by art patrons John and Anne Gould Hauberg. That first summer at Pilchuck, as the glass camp was later called, Marquis drove up to the site to check it out and maybe blow some glass. He recalls:

It was just pouring down rain. And it was pretty scary seeing those hippies in the mud with chainsaws. I thought, This is never going to work. . . . I was a hippie, too, but I had more sense, at least it seemed to me. I had just come from Venice and I knew if you wanted to learn to blow glass, that was how to do it. I couldn't see doing it in the woods. . . . No one had any technical expertise. . . . It was just a totally adverse situation [and] . . . they were up against so many odds. But the perseverance was good and the energy was good.[44]

At about this time, Marquis was offered a teaching assignment at the Kansas City Art Institute, and he resigned from the University of Washington. But the Kansas City position fell through, and Marquis was suddenly left without a job. "It really turned out just fine," muses Marquis. "I decided to go back to Berkeley to get my master's. . . . You know, I don't take any claim or pride in having much to do with what happened . . . [with glass in] Seattle. I was there for a year and gone. I left, and people were like, Who was that guy? I had certain skills and technical knowledge, but it didn't stick."[45] Marquis picked Berkeley for his graduate studies after considering the University of Wisconsin at Madison and the Rhode Island School of Design in Providence; the glass facilities they offered, Marquis remarks, "weren't that great." In 1972, having completed what was a two-year program in just one year, Marquis earned his M.A. in glass in the school of environmental design, Berkeley's former decorative arts department.

For his master's thesis, Marquis wrote and illustrated a detailed manuscript on the making of traditional Venetian *murrine* and decorative canework techniques.[46] The thesis was based on his research on historic Venetian glass and the careful notes he had taken in Murano. For his exhibition, he made a *zanfirico* cup and two small *murrine:* one portraying the American flag and the other, a *murrina* cane embedded with the words of the Lord's Prayer (pls. 18–19). "The *Lord's Prayer*, to me, is a statement unto itself of where he was as a student," comments Paul Smith. "That was an exceptional concept and certainly it couldn't have been a more visible evidence of his ingenuity and technical know-how." "He was the first person to [absorb] . . . all that Italian technology and make something new with it," adds glass artist Therman Statom. "No one else had done that. He made the *Lord's Prayer*. He learned the technique, digested it, and made it something that was his."[47]

For Marquis, doing the Lord's Prayer in *murrine* was "just obvious." "If I was going to do something I figured it had to be that," explains Marquis, "because of the *Ripley's Believe It or Not* connection, you know, the tradition of the prayer being written on the head of a pin."[48] The *Lord's Prayer* was a brilliant reflection of the prayer's long tradition in American popular culture. And because the *murrine* could be infinitely stretched out, the size of the words could be relatively large (that is, easily read-able) or reduced to the size of a *Ripley's* pinhead. "This potent, classic prayer," observes James Melchert, "connected very common people who might buy something like it at a county fair . . . [with the art world]. . . . Suddenly there was a whole vast world of allusions, as it were, brought together."

TEAPOTS

DICK'S . . . TEAPOTS WERE REAL IMPORTANT. . . . HE VARIED THE FORM AND DECORATION; HE DID ALL THOSE CLASSIC ITALIAN TECHNIQUES BEFORE ANYONE ELSE KNEW HOW THEY WERE DONE. CHIHULY . . . DIDN'T BRING BACK TECHNIQUES LIKE DICK—THEY WERE IN HIS HEAD, MAYBE, BUT HE DIDN'T PROMOTE THEM THE WAY DICK DID. . . . NO ONE KNEW ABOUT MURRINE . . . SO DICK'S WORK WAS A BIG INFLUENCE. HE WAS DOING WHAT I WANTED TO DO, BUT DIDN'T KNOW HOW TO. —FRITZ DREISBACH[49]

After receiving his M.A., Marquis based himself in Berkeley but embarked on a series of trips, mixing his varied teaching jobs with travel. After a visit to Central America, he worked on

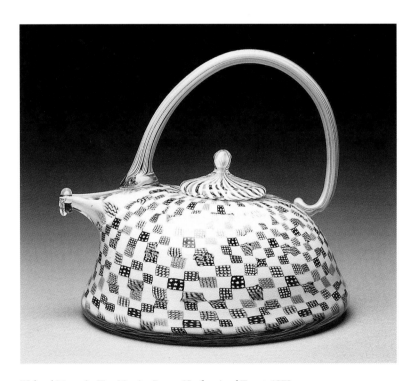

Richard Marquis, *Tiny Murrine Pattern Nonfunctional Teapot*, 1978. Blown glass, *murrine* technique, 5½ × 4¾ × 4¾ in. Private collection.

building a new studio in Berkeley, and then took off in 1973 for Europe and the Far East. During this time he landed briefly at Haystack, in Maine, where he made his first blown *murrine* teapots. Returning to Berkeley in early 1974, he continued his part-time teaching jobs and ran his own production studio where he produced *murrine* and *filigrana* marbles as well as his own work. "There weren't any situations like the Glass Eye in Seattle [a production studio run by glass artist Rob Adamson]," observes Marquis. "There, you could go and work and develop skills. And the whole hired gun thing hadn't happened yet, where you'd make work for other people. The only way to improve skills was to work constantly. At that time, you were just making your own work and doing it pretty much by yourself, although having been in Italy, I knew it was not the best way. Both Chihuly and I learned that working in teams was how to do it."

Marquis began to develop the *murrine* teapots that would become his signature form. "Dick was probably the first person I ever watched blow glass," remarks glass artist Paul Marioni. "We were teaching at a community college in Marin County and I kind of wandered over to his studio. I watched [him for a while] . . . and was amazed. I had been to Murano when I was eighteen or nineteen . . . but I wasn't interested at all in what they did. They were making swans and stuff. Dick was making [*murrine*] . . . heart teapots and I was stunned to see what he was doing."

The teapot form has always appealed to Marquis, and he has made good use of it throughout his artistic career. "I like the history of Dick's teapots," remarks Kate Elliott. "I like seeing them all through his work, including the *murrine* teapots he made in clay. . . . I like the fact that he has stayed with the teapots his whole career, yet has succeeded in doing something different with them along the way."[50]

Marquis relates:

Ken Price and Ron Nagle were using the cup as a basis for form, a place to start. People like Pete [Voulkos], Ron, and Ken didn't touch the teapot because it was such a ceramics tradition. It was anathema. That baggage didn't bother me because it was a non-tradition in glass. There are similar spouts to mine in German Waldglas *forms and in the fifteenth-century Catalonian oil lamps. I had only seen three of the Catalonian lamps in my life and two are in the Victoria and Albert Museum [London]. That's*

where I saw how to make the spouts. The teapot had more elements than any other form I could think of. It had a spout, a lid, a handle, plus the body. Just being able to play with all those parts, and it could still be recognizable even when you went to extremes. People were upset that the lids [of my teapots] . . . didn't come off. Or upset that they didn't actually pour. Even when I made ceramic teapots, I glazed the lid on.

"Dick's teapots always had a kind of a quirk that was quite delightful . . . [and] intentional, though they looked absolutely unintentional," notes Bernard Kester, former UCLA faculty member and dean of the school of art. "Things would take place in the form of his pieces, [qualities that] . . . resided in the molten characteristics of the glass, resulting in a relaxed nature where you might expect a strong curve to be. And they all turned out, I always thought, to have a humorous aspect, as if something unexpected took place. But I don't think that unexpected things took place because I always thought that he was totally in control of the unexpected. . . . And he used colors as additives rather than as essential volumes of his forms. Bright yellows, pinks, lavenders."[51]

The *murrine* teapots were the perfect vehicle for Marquis to indulge his many interests: color, funk and fetish-finish ceramics, cartoon imagery, and historical European glass. The teapots, "dumb" in a lowbrow sense and flawless in technique, were immediately popular. "They were so damn cute," remarks Susanne Frantz. "I remember you could buy some of them in craft shops in the 1970s and I wanted one. It was a couple of hundred bucks but it was just way out of my price range at the time." "I liked that offbeat quirkiness," says independent curator and critic Lloyd Herman. "Dick brought an American irreverence into his objects which also respected traditional processes."[52] Dante Marioni adds:

The teapot is my favorite thing. I remember my dad [Paul Marioni] pointing out one of Dick's teapots at a show in California when I was seven or eight years old. It made quite an impression, but in a strange way. It was a cool object and colorful and it had a lot of appeal. But I asked, "Can you make tea in it?" And my dad said, "No, you can't use it." And I remember thinking, What's the point of making a teapot you can't use? I grew up around all these artists—my dad and my uncles [Joe Marioni and Tom Marioni]—and people making weird things, but it was the first example to me of a sculptural object that referred to a functional thing.

I mean, it sounds kind of corny, but when I was eight, it cleared up a couple of things right away.

The animated character of the *murrine* teapots, and particularly the *Wizard Teapots* (pl. 35) begun in 1979, was inspired by the domestic objects drawn in cartoons like Walt Disney's feature-length *Fantasia*, the drawings of underground comic artist Robert Crumb, ceramic objects by Pat Siler (a student at Berkeley with Marquis), and even the anthropomorphized, vintage salt-and-pepper shakers that Marquis collected. "There's a quality of playfulness about Dick which I think is consistently there, and one of its manifestations is his [remarkable] . . . sense of color," observes *American Craft Magazine* editor Lois Moran. "Great contrasts of rich color and very animated objects." Susanne Frantz notes: "You know, the old Saturday morning cartoons? The dancing utensils and inanimate objects that came to life after everyone went to sleep and then went nuts in the kitchen? I know that's buried in Dick's subconscious."

Marquis experimented with varying the forms of his teapots from 1979 into the early 1980s, and again in the early 1990s. These more unusual pieces included the *Wizard Teapots*; the *Broken Greys* (pls. 30–31), in which Marquis placed small *murrine* teapots and marbles inside large, broken gray teapots; and weirder still, the *Big Greys* (pl. 34), in which a gray teapot sat atop a huge mountain of a dimpled, 30-inch-high, gray glass bubble. This strange and evidently difficult technique (Marquis successfully made only five *Big Greys*) was later demonstrated in a 1984 class at Pilchuck Glass School. Team-taught with Therman Statom, the class, called "Secrets Revealed," promised to impart information about some of the artists' most esoteric processes.

"When we blow together, every blowing technique that you're not supposed to use, we've done," says Statom. "You know those crazy gray pieces? The big gray teapots? Some of what Dick knows is unbelievable. He blows a teapot and it's still on the blowpipe—the spout and the handle and the body. Then he'll ladle out a bunch of glass [from the furnace] . . . into a thin stainless steel bowl that's sitting in water. Then, as the glass cools, he sticks the bottom of the teapot in it and starts blowing a bubble. He blew these huge things, teapots on top of moun-

tains. He's always been in the forefront of figuring out stuff on the floor. He's like a scientist gone artist." Marquis admits he developed the process from physics experiments he had been assigned in high school. The scale he liked in those *Big Greys* turned into the tall *Teapot Tripods,* (pl. 32) the wizard-hatted *murrine* teapots precariously perched on long aluminum legs encased by hollow rods of multicolored glass.

TASMANIA, TOPANGA, AND THE BIG COMMUTE

THERE ARE CERTAIN PEOPLE WHO KNOW AND RESPECT ME FOR MY SKILLS OR MY IDEAS. BUT THEN THERE'S A WHOLE GROUP OF PEOPLE—HUNDREDS OF GLASSBLOWERS—WHO KNOW ME FOR DESIGNING A FURNACE. THEY MIGHT NOT KNOW MY WORK BUT MY FURNACE DESIGN HAS BEEN HANDED DOWN. —RICHARD MARQUIS

"In 1974 . . . [glassblower] Sam Herman introduced Australia to the misshapen bubble," wrote Dan Klein on the genesis of the Australian studio glass movement. "Herman decided to stay on in Adelaide where he established a glass workshop at the Jam Factory, a government-sponsored enterprise. This idea of converting a derelict factory into artists' workshops proved popular and a second, called the Meat Market, opened in Melbourne. At about the same time Richard Marquis was invited by the Crafts Board to visit Australia and during the course of his stay established glass workshops in Melbourne and Hobart [Tasmania]."[53] In 1974 Marquis received a grant from the Australian Crafts Council to tour Australia, where he was expected to teach a series of workshops. In a three- to four-month period, he built six or seven glass shops at various locales. "I would build a furnace, an annealing oven, and all the miscellaneous equipment," Marquis recalls. "Then I'd blow glass for a few days and leave town."

"You have to look at Dick in the context of when glass was still relatively new. Technical skills were being accomplished at a rapid pace but there was still a lot of pioneering work to be done," observes Paul Smith. "And like a lot of people in the glass field, he was willing to share information and did not keep secrets, which was why the whole glass movement escalated so rapidly." Marquis returned to Hobart, Tasmania, in 1976 on another grant as an artist-in-residence at the Tasmanian School

of Art. "I built a studio," relates Marquis, "was paid handsomely, and I blew glass. I trained a few people. That was the year of the Bicentennial and I thought it was a good time to be gone." Marquis also put together a solo exhibition that year to tour Australia; the theme and title, *Technique Is Not So Cheap,* reflected the core of the artist's teaching philosophy. "I seriously thought about staying in Australia," says Marquis. "I loved the place and the people. Someone said I could be 'the Harvey Littleton of Australia.' I knew I couldn't handle that, in any sense."

When he returned from Australia, Marquis, in partnership with glass artists Jack Wax and Jody Fine, ran a production studio in Berkeley, named Marquis Deluxe, from 1977 to 1980–81.[54] Marquis explains:

At that time, you couldn't really support yourself selling things, except by doing production work. I always had teaching jobs, but I did the production [work too] . . . because with teaching jobs, you don't get any better. You don't have time to work. So, I always tried to do both.

The concept of Marquis Deluxe Studios was to assemble some young artists I wanted to work with and to make commercially viable products (marbles, Christmas ornaments, etc.), which would enable us to get the necessary equipment and to hone our skills so each of us could make our own work. The operation was to last only a couple of years and then we would move on.

Left to right: Jack Wax, Dick Marquis, and Jody Fine, Marquis Deluxe Studios (Marlux), Berkeley, Calif., c. 1977.

In 1977 Marquis accepted a teaching position at UCLA offered by the school of art faculty chair, Bernard Kester. Marquis decided to keep his studio in Berkeley and every week he made the 400-mile commute to Los Angeles, living in a trailer in Topanga Canyon each Wednesday through Friday. Bernard Kester recalls:

Dick wasn't an academic like you think of academics, or even as you think of artists in academia. He was more free-wheeling and kind of loose-jointed, so to speak, and open to all sorts of varieties of expressive impulses in glass. And he had a sense of humor which was refreshing. So many glass artists, during that period anyway, seemed to me to be so utterly serious about their blobs. He was sort of anti things that faculty members had to put up with, like being chairman of committees and things like that, he couldn't stand that. But students enjoyed being in his classes and I think he was very good with them.

From his first semester as a student at Berkeley, Marquis thought the perfect university teaching assignment would be one where, like in Peter Voulkos's and Ron Nagle's classes, students just came into the pot shop or hot shop and made work in a relatively free-form, unstructured environment. But in reality Marquis is a very methodical teacher. "Dick's expectations are high," relates Dante Marioni. "He doesn't just let people come in and do whatever they want. He gives them specific assignments, tells them the rules." "At UCLA, I wanted to build a star basketball team in glass, kind of like what Dale Chihuly did at the Rhode Island School of Design," remembers Marquis. "But I couldn't do that because there was no community. No one hung out together, people left after class. Everyone lived forty minutes away; it was a commuter school. And it was too expensive to have studio space. It took me three or four years to figure out why my idea wasn't working."

In 1978, after his first year at UCLA, Marquis was awarded his second National Endowment for the Arts fellowship to develop a new series, *Fabricated Weird,* which he worked on in 1979 and 1980. The series is still his personal favorite. Marquis remembers:

This was the first time I used found objects in my work, in these fabricated pieces. I was using the new anaerobic, Loctite glues . . . which set almost instantly. I would never have made them if I had to use the glues people

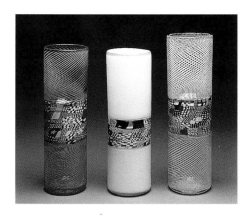

Richard Marquis, *Crazy Quilt Banded Cylinders,* 1979, made at Marquis Deluxe. Blown glass, *murrine, filigrana,* and *incalmo* techniques, greatest h. 14 in.

Dick with Nigel, Jody with Blue, Jack with Sadie, Berkeley, 1977.

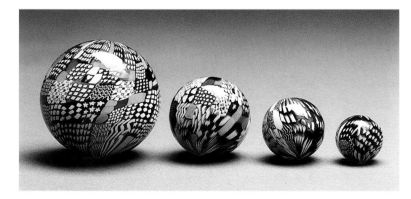

Richard Marquis, *Crazy Quilt Marbles,* 1978, made at Marquis Deluxe. Solid-worked *murrine* glass, greatest diam. 2½ in.

use now, because they can take up to fifty-four hours to set and the work would have lost all its spontaneity. . . . Hardly anyone understood this body of work. I thought it was a bold move . . . and, in fact, these are the pieces I have been trying to buy back lately. . . . But people had trouble with the highbrow/lowbrow thing.[55]

Marquis cold-fabricated strange teapots, impenetrable cup shapes, and other odd little pieces—combining *murrine,* parts from broken blown teapots, and chunks of glass cullet with specially made elements—which he assembled in a labor-intensive process.[56] For the cups, consisting of a closed collar or bowl-like form with *a canne, filigrana,* and *zanfirico* handles attached to a blown glass pillow, Marquis experimented with color combinations that resulted in the *Good Taste* series (or pleasing colors, facet cut in Bohemian style [pl. 40]) and its evil twin, the *Bad Taste* series (difficult *murrine* color combinations [pl. 41]). Among the earliest pieces of the *Fabricated Weird* series is the *Rock Crystal Airtwist Goblet* (pl. 44), imitating sixteenth- and seventeenth-century Venetian luxury goblets and the simpler, eighteenth-century English drinking glasses. But instead of being a true goblet, the "bowl" is a chunk of glass cullet attached to a historically accurate airtwist stem (a *filigrana* technique) and simple spun-glass foot. Calling the goblet "rock crystal" alluded to the ancient Mediterranean and later European practice of making colorless wares to imitate and replace more expensive versions in rock crystal. Marquis's goblet also reflects, on a satiric note, the functional object's elevation to uselessness, seen not only in contemporary studio glass wishing to distance itself from "craft" but also in historic luxury glasses, which were prized as heirlooms and not intended for actual use.

Marquis embellished some of the *Fabricated Weird* pieces with found objects from his many collections, which by now included salt-and-pepper shakers, car parts and tools, German plastic toothbrushes, mass-produced, molded glass objects, and other novelty items in addition to graniteware coffeepots. The 1979 *Potato Landscape Piece* (pl. 50) was one of the first works in the series to incorporate a found object (a souvenir landscape sand painting in a whisky glass); by 1980 the new pieces commonly featured vintage salt-and-pepper shakers and other items such as glass candy containers. According to Marquis, nobody really appreciated these works, although there was

at least some interest on the part of museums, if not private collectors. "The pieces I liked were the *Potato [Landscape Pieces]*," remembers Lloyd Herman. "I wanted to acquire one for the [Smithsonian's] Renwick Gallery, but couldn't get it [approved]. . . . I later felt somewhat justified when the piece ended up going to the Corning Museum of Glass." "Dick will take American [and European] icons, or things that we think of as souvenir icons, and put them into an overly elevated context, or in some way that piques the mind to think about how it got to be an icon in the first place," observes New York art dealer Franklin Parrasch. "And then he executes it so beautifully. His technique: it's just taken for granted that he speaks this language and it comes out in glass."[57]

The *Fabricated Weird* series also referenced historical glass forms, such as the 1980 *Venetian Waldglas Fish Goblet* (pl. 59), a whimsical arrangement of a German-style *Stangenglas* form with a Venetian-style *zanfirico* bowl and fish salt-and-pepper shakers. The thick, *Stangenglas*-type stem, adorned with blobs (prunts) of white silicone, was inspired by the fifteenth-century, green, prunted glasswares made in the cottage *Waldglas* glasshouses of Germany. The stacked elements of the *Egyptian Sand-core Shriner Duck,* 1981 (pl. 60), also looked to historical glass forms, combining a vintage salt shaker with Marquis's reproduction of an ancient Egyptian/Greek double-handled, core-formed vessel.[58]

In contrast to his *murrine* and *zanfirico* objects, Marquis worked on several *Fabricated Weird* pieces at the same time. In a portrait of Marquis at work in the Berkeley Marlux studio (in which he is caught without his human disguise; see p. 8), the artist sits at a worktable full of the pieces and parts to be incorporated in new *Fabricated Weird* works; behind him, strange teapots and the short-lived *Rocket Jars* (pl. 65) are arranged on shelves. Marquis explains:

This picture of me working—that's pretty much the way it was, the way the shop looked. I was working on all these things at once, some finished, some not. . . . Sometimes I had to make my own found objects, like the [ancient Egyptian or Greek] sand-core piece, because I couldn't use a real one. I combined things [for visual effect] . . . working on them until they looked good. I would work on maybe ten or fifteen things at once. As soon as the idea of one clicked, then I'd finish it: I'd do all the grinding and polishing and assembly. . . . The toothbrushes and salt-and-pepper shakers

were chosen for things other than being humorous. There are formal considerations: form, color, and mass which people often don't see because they are struck by the content. For instance, I might have a yellow plastic dog salt shaker next to something because I needed something yellow there, not because it's a dog . . . although, I also like the dog. . . . My work has a lot more formal considerations than most people ever think about. There's humor in it because I can't help it . . . but the basic thing I try to do is to make [the assemblages] . . . look good.[59]

While Marquis's characteristic balance of humor and serious artistic intent are easily appreciated in his *murrine* and *zanfirico* works, the *Fabricated Weird* series was more difficult because of Marquis's increasingly obscure references and partly because his humor, always absurd, had acquired a cynical edge. "[His serious side sometimes] . . . gets lost behind the whimsical cute[ness]," muses Susanne Frantz. "He downplays it himself, when he speaks about his work . . . and he's very funny. I think that gets overlooked, that steel will of discipline. . . . His work has continued to grow and become more and more interesting while still rotating around this central theme which, funny enough for an artist, is a technique. For an artist, as opposed to a craftsperson, you wouldn't think of technique as being pivotal. But he has a way of balancing that. . . . I think his technique is equal to the design but it certainly doesn't over-shadow . . . the formal qualities [of his work]."

In one of Marquis's rare published statements, he clarifies his approach, often mistakenly understood as "irreverent," to making his art:

Decoration is not a pretty word. An object first must have a strong form which decoration can then either enhance or confuse, depending upon what the artist intends. Glass is so "pretty" that a dog turd made with Kugler and a good clear can be a striking object. Form can be checked out by imagining the object as it might be if it were made of cardboard, brown stoneware, or rusty steel.

I put things together so they look good. If it needs decoration, I do it; if it doesn't, I don't. I keep working on something until it works. There's a vast background vocabulary of revered historical images, techniques, and decorations. By using these in combination with lowbrow objects and intentionally sloppy or loose techniques, I'm able to question and re-examine traditional aspects of working with glass. What some see as my irreverence toward glass, I see as a good balance of form, color . . . [and] decoration.[60]

LOST AND FOUND IN PUGET SOUND

WHEN I AM ASKED THE QUESTION, "WHO IS YOUR FAVORITE
ARTIST?" I ALWAYS MENTION DICK MARQUIS. A MAN OF SURPRISES.
HE IS A SEEKER THAT PROVES THAT RISK GIVES GLORY.

—BERTIL VALLIEN[61]

By 1982 Richard Marquis knew that his time in California—in both Los Angeles and Berkeley—had come to an end. He had never really liked L.A., but UCLA, as Marquis explains it, was "paying me a bunch of money and I got to do what I wanted." Gradually, Marquis started making more and more demands, hoping he would get fired by saying he needed more money and more time off. The university finally called his bluff and Marquis left. In the meantime, Berkeley had changed dramatically: the Marlux studio had been repeatedly burglarized and the Bay Area was becoming too intensely urban. During his last years at UCLA, Marquis had been conducting a "world search" for a hospitable place to move, and the islands of Puget Sound in Washington State emerged as a major contender. Marquis remembers:

I came up to Washington and looked around the islands. I looked at pieces of property and asked about building codes and fuel availability and it turned out that some islands were more practical than others. . . . I didn't think life on the islands would ever really change because, as far as I could tell, no one had a job. They just sold firewood to each other to support themselves.

Pulling up deep roots in California in 1982, where he had lived for thirty years, Marquis moved twelve truckloads of his equipment, work, collections, and other belongings to one of the islands of Puget Sound. There, in partnership with his old friend Ro Purser—a glass artist who had also left California—Marquis started a new production glass enterprise named Noble Effort Design. Besides the odd and eclectic production ware he made for Noble Effort, for the next several years Marquis explored strange and experimental directions in his work such as the relatively minimalist *Bottles and Plates* of 1983 (pl. 67). These consisted of complex, patterned *zanfirico* glass bottles painted over and presented on glazed and painted ceramic plates made by Marquis. The concept was unusually direct for the artist, and he made only one set of five. "Some of the bottles are blown

zanfirico and they are on ceramic plates that were my test plates for underglazes and lusters," relates Marquis. "They are very highly decorated and I spent hours on each one. Then I painted over them. The idea was pretty much based on [Robert] Rauschenberg's erasing of a drawing by [Willem] de Kooning. And the concept that just because you're good at doing something is not a good reason to do it. I thought this was a good idea, but actually making the pieces turned out not to be that interesting."

Other experimental objects included some scary blown glass and neon heads with titles like *Orange Smiley Face* (pl. 69) and *Yellow Screamer* (pl. 70), made at Pilchuck Glass School in 1984 with the help of glass artist Richard Royal. "My career had been picking up recently and these pieces succeeded in almost torpedoing it completely," Marquis fondly recalls. "They were an incredible step backward and I had to do it. I had this need to go backward, to do something entirely stupid." Marquis also turned his attention to his earlier experiments with the *Big Greys,* siliconing teapots and vase forms onto blown glass "rocks" and then gluing small pieces of *murrine* to the surface. Like the painted *zanfirico* bottles, Marquis went through these ideas quickly, one after the other, trying to work out where he could go with them.

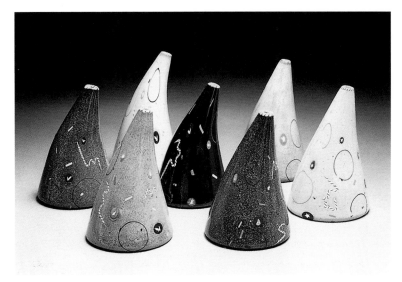

Noble Effort Design, *High Speed Cones*, 1985. Blown glass, *murrine*, greatest h. 6 in.

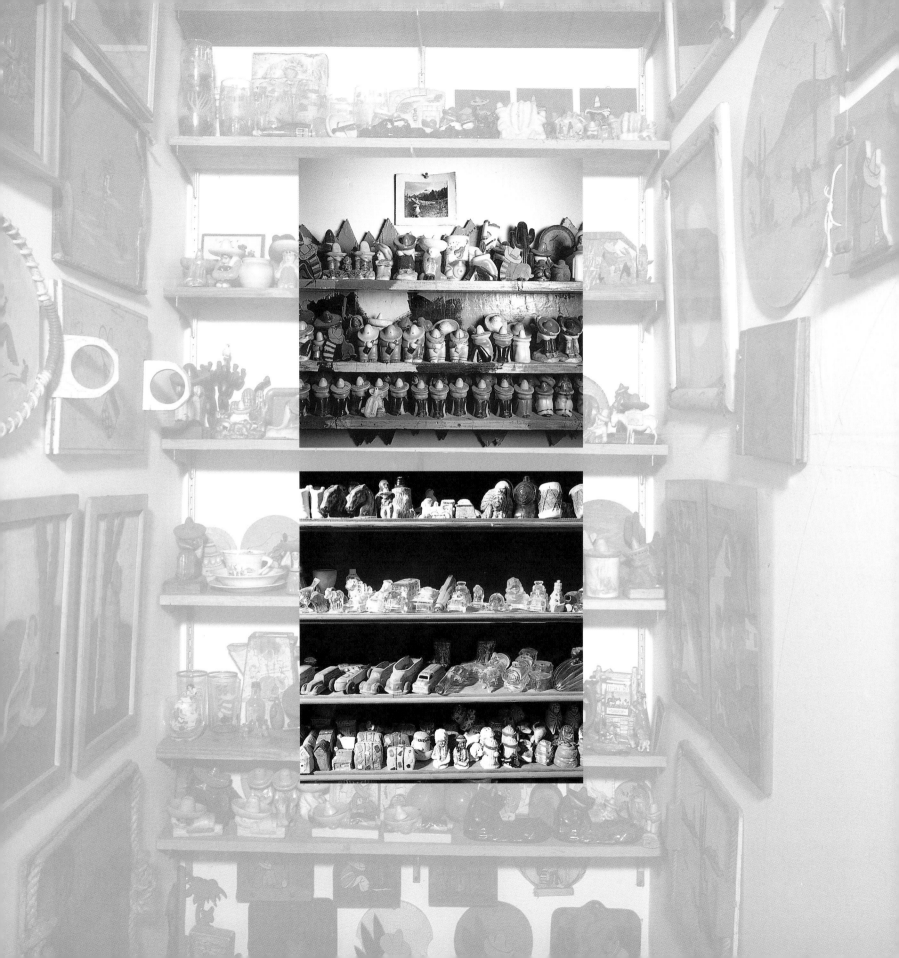

At this time Marquis returned to an aspect of the *Fabricated Weird* pieces which he particularly enjoyed, the combination of his glass pieces with found objects from his collections. Thinking about making small environments for himself, he considered different methods of presentation. The display contexts he most admired were H. C. Westermann's wood and glass cases, and the finely made wood cabinets that Ken Price used for his ceramics in *Happy's Curios,* his 1978 exhibition at the Los Angeles County Museum of Art. Marquis was enamored with Price's ability to make beautiful artworks out of his arrangements of objects. "[The *Happy's Curios* exhibition] was one of the best things I had ever seen," Marquis emphasizes. "The whole thing, from concept to execution to installation was so perfect that . . . it didn't scare me but it took me aback it was so good. And so little appreciated. The concept and the craftsmanship were so incredible."

Marquis habitually arranged found objects with his own works on shelves and in cabinets and display cases in his studio. "All my stuff in the studio was [mixed up]. . . . [There would be] all this junk, and then a *[murrine* teapot or a *Rocket Jar].* And I got used to seeing my work that way. In a museum or gallery, one of my pieces would be on a white pedestal with a light on it and I would think, Where's all the stuff? I wanted to present [my work] the way . . . I saw it in my studio."

Marquis made his first *Personal Archive Unit,* as he soon called them, in 1984. From Price he took the idea of using cabinets, but crudely fabricated from plywood with a saber saw. Into the *Personal Archive Units* (pls. 74–76) he placed blown glass works as well as an assortment of objects selected from his collections such as a porcelain grave photo found in a dump on the Venetian cemetery island of San Michele, a *murrine* teapot, shotgun shell salt-and-pepper shakers, an oil can, a *Fabricated Weird* cup, a souvenir Aunt Jemima, a sand painting in a tiny bottle, and Rempel rubber toys. "This was my response to *Happy's Curios,*" states Marquis. "The *Personal Archive Units* had layers and layers of complexity which I like. A lot of the objects had personal value for me." By this time, Marquis's vintage collections had grown to include old black cars and bullet-nose Studebakers, fat pencils, metal and porcelain signs, bowling balls, pump insect sprayers, ballpoint pens, anything with a Mexican siesta or English setter motif, Hallware, automotive books, Hawaiian

Ken Price, *Happy's Curios (Unit 3),* 1972–77. Ceramic and wood, 70 × 20 × 20¼ in. (cabinet). Los Angeles County Museum of Art, gift of Betty M. Asher.

Opposite:
In the background, the stairwell in the artist's studio featuring his siesta motif collection; at the top, siesta salt shakers in the artist's studio; and bottom, a curio cabinet filled with glass toys, salt-and-pepper shakers, rubber cars, and more, 1997.

Artist's house with bullet-nosed Studebaker and line-up of old black cars, 1985.

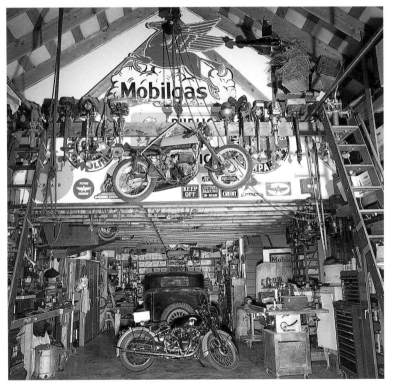

Artist's garage, 1997.

shirts (this collection was eventually sold to rock musician Rod Stewart), advertising cards, wire ware, rotten wood boats, push-button knives, old cameras, paint-by-number paintings, burnt-match furnishings, baseball mitts, outboard motors, glass toys, cigar bands, bottle openers, prison art made with empty cigarette packs, slide viewers, stupid wrenches, Christmas bubble lights, hobby chemistry sets, Fiesta ware, oil cans, Victorian tiles, bamboo fly rods, and outdated film.

At first, Marquis did not intend to sell the *Personal Archive Units* but once he had completed them and taken photographs, he felt he didn't need to keep them: it was the process he enjoyed rather than the result. And, like the *Fabricated Weird* pieces, he made several of them at once. "I think the [assemblages] . . . are a way for Dick to change his way of thinking and to relax," speculates Kate Elliott. "Because the obsessive [*murrine* and *zanfirico* pieces] . . . are so draining on a certain level, he has to go back and forth between the two. . . . The teamwork needed for the blown things is also a factor: he can't work on his own. But he likes to work on his own, he can't always work with other people." "In terms of his assemblages . . . he's fearless," remarks Fritz Dreisbach. "He . . . pushes himself way out on a limb." "He's been pretty adventuresome," agrees Therman Statom. "I've come to like all the collection pieces. I thought they were too obvious at first and then I found myself making drawings that looked like them."

The *Fabricated Weird* series and the *Personal Archive Units* are related to the ephemeral installations made by Marquis, from 1981 to 1988, in collaboration with Therman Statom (pls. 102–3). Although these installations did include vintage and Marquis-made objects (such as teapots and other characteristic elements), they were primarily about the creation of large-scale environments, arrangement, and display. Therman Statom recalls that when he met Marquis, at the 1979 Glass Art Society conference, in Corning, New York, he thought:

His work was Californian, with a lot of color. At the Rhode Island School of Design, we were all into minimalism. I went to the Craft and Folk Art Museum in Los Angeles for a show. That was the first installation I did and Dick invited me . . . to make the parts at UCLA. . . . At UCLA, I used Kugler—Dick's Kugler—for the first time. I don't know if it was conscious on his part [introducing me to color]. . . . He just said, Here's

Biconical Waldglas Flask, German, 15th century. Glass, h. 6 in. Private collection. This flask is the "haystack" form admired by Marquis.

Richard Marquis and Therman Statom standing behind their collaborative work, *Teapot Fan,* 1981.

all my color. Use it. . . . He's one of the few people I've done installations with and he gave 190 percent. . . . He was always there . . . and he offered me a lot of structure to work through. . . . Our work is different and it's not, in a funny way. We both paint on stuff, use shards a lot, a lot of color.

Because the installation for the Craft and Folk Art Museum show was technically difficult, and Marquis had already been working with esoteric glues, he became Statom's technical advisor. Soon thereafter, Marquis was invited to do a show in Washington, D.C., and he asked Statom to collaborate with him. "So, there was my work, his work, and then we collaborated on an installation," says Marquis. "I think we [ended up doing] . . . thirteen installations together. We called it 'hard fun.' We never argued . . . and we worked exactly the same way: neither of us measures anything, it's all done by eye. . . . The result of my working with Therman is being able to . . . take advantage of larger scale, paint, and broken shards." Marquis returned to making installations, by himself this time, in the mid 1990s. Commissioned by private collectors for the most part, these recent installations are an appealing hybrid of giant *Personal Archive Units* and Marquis's work with Statom.

About this time, in the mid 1980s, Marquis began a series he called *Time Frames* (pls. 109–10), consisting of glass boxes that incorporated photographs, glass pieces, and found objects. Artists and collectors loved these objects but some curators did not. "They were made in response to my wanting to document the installations I made with Therman," explains Marquis. "They later turned into my documentation of processes and bodies of work." During the period of his collaboration with Statom, Marquis made other experimental pieces, including the 1985–88 *Shard Rockets* (pls. 77–79), made of siliconed, stacked elements—which reminded Marquis of Voulkos's shapes in ceramic as well as what he calls the "haystack" form in historic German *Waldglas*—encrusted with shards and then painted.

Near the end of his collaborations with Statom, around 1986–87, Marquis developed his *Trophy* series. The *Trophies* featured stacked elements similar to some of the earlier *Fabricated Weird* pieces and also referenced historical glass forms, incorporated found objects, and made use of *zanfirico* handles (pls. 82–85). New to this series were geometric forms and a

dense surface encrustation of *murrine* or other materials such as tiny mirrors (giving a pleasing disco ball effect). Marquis then combined and recombined aspects of the *Shard Rockets* and *Trophies* in his *Teapot Trophies* (pls. 82, 85), *Bubble Boys* (pls. 86–87), and *Oil Cans* (pls. 90–92), begun around 1988–90. It was during this fertile period that Marquis met the artist, collector, plantswoman, and former gallery director and arts administrator Johanna Nitzke, whom he married in 1987, and dissolved his Noble Effort enterprise, making the important decision to concentrate exclusively on his art.

MARQUISCARPAS AND TEAPOT GOBLETS

THERE'S NOTHING WRONG WITH HAVING A GAS STATION, WAITRESS, OR CONSTRUCTION JOB, AND A DISSATISFIED CUSTOMER YOU SERVED OR A TACKY BEDROOM ADDITION YOU BUILT WILL NEVER COME BACK TO HAUNT YOU TWENTY YEARS LATER IN A MAJOR RETROSPECTIVE. IT MAY BE TRUE THAT "THOSE WHO CAN, DO; THOSE WHO CAN'T, TEACH; AND THOSE WHO CAN'T TEACH, TEACH GLASS." BUT I FEEL IF ONE DOESN'T LOSE PERSPECTIVE AND KEEPS IN MIND THAT IT'S JUST ANOTHER GAS STATION JOB TO ENABLE ONE TO DO ONE'S ART, THEN IT'S POSSIBLE TO OVERCOME ONE'S TEACHING JOB—BUT LOOK OUT FOR TENURE, FRINGE BENE-FITS, AND BEAUTIFUL STUDENTS TOO YOUNG TO REMEMBER WHEN THE BEATLES BROKE UP. . . . TIME AND MISERY . . . HAVE TAUGHT ME THAT WHILE IT'S IMPORTANT TO HAVE YOUR BASIC NEEDS COVERED, IT'S JUST AS IMPORTANT TO KEEP IN MIND THE BIG PICTURE AND GO FOR THE ART AND LET THE REST TAKE CARE OF ITSELF. —RICHARD MARQUIS[62]

Marquis continued to make fabricated assemblages from the late 1980s into the 1990s in addition to his technically demand-ing *murrine* and *zanfirico* projects. Extending the work he did in the *Time Frame* series, he continued to assemble objects in glass boxes; many of these assembled "collections" were inspired by the Christmas and Valentine's Day presents he devised for his wife, Johanna, such as his *murrine* sample boxes (pls. 112–14) and *murrine*-filled heart-shaped "candy" boxes (pls. 126–27). Marquis made glass sample boxes of his own work, such as the *Shotglass Sample Boxes* (pl. 119) and *Coffeepot Sample Boxes* (pl. 118), and also incorporated vintage found objects. In the glass boxes of his *Object Comparisons* (pl. 117), found objects

are paired with Marquis's own work in a stimulating, purely visual exploration of form.

In 1987, just before Marquis's dissolution of the Noble Effort production studio, Dante Marioni came to work for the artist from a previous job at the Glass Eye, in Seattle. Marioni relates:

My loyalty was to [Muranese master] Lino Tagliapietra and his school. Generally, people are hesitant, without seeing something first-hand, to accept things. But Dick was cool about taking it from me that that's the way we ought to do it. He was very respectful of me, even though I was twenty-three. . . . He had a special T-shirt made for Noble Effort. On the back it said, "Are you sure Lino does it this way?" The joke was that I always made a point of saying, "Well, that's not how Lino does it." But he was cool about it and open-minded, especially for a guy who had invented so many things. Of all the people of his generation, he is the most fun loving, in my opinion. And of all the older glassblowers—I haven't worked with all of them but I've worked with a lot of them—he's the one most accepting of change. It made an impression on me.

The main project Marquis worked on with Marioni was the blown *Teapot Goblets* series (pls. 95–97a–c), begun in 1988. "The *Teapot Goblets* were eccentric and beautiful," observes Lloyd Herman. "They brought together a distinctive form, the teapot, that Dick brought to glass from his background in clay, but he treated them in the way that Venetian goblets are treated, kind of operatically." The *Teapot Goblets* combined elaborate *zanfirico* technique with a whimsical arrangement of a straightforward bowl and foot joined by a stem in the form of a teapot, some-times positioned upside down (Marquis believes that a form, if it is successful, should look equally good upside down as right side up). With their quirky individuality and flawless technique, the *Teapot Goblets* were reminiscent of the early *murrine* teapots; they were immediately popular and looked good in groupings, practically begging to be collected in numbers. Formally and technically, the *Teapot Goblets* looked to Marquis's vocabulary of historical images and techniques, as did a *zanfirico* series (pl. 99) based on the form of the ancient Greek *kylix*, a double-handled drinking cup, which he made with Dante Marioni and Lino Tagliapietra. But it would be Marquis's next series of *murrine* vessels, the *Marquiscarpas*, that would most challenge the artist to interpret historical precedent.

Mosaic Cup with Face Canes, Roman Empire, late 1st century B.C.–early 1st century A.D. Glass, 1½ × 3⅞ × 3⅞ in. diam. Corning Museum of Glass, Corning, N.Y.

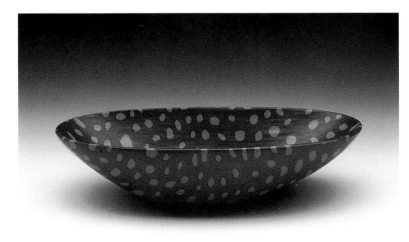

Carlo Scarpa, *Murrine Bowl,* designed c. 1940 for Venini. Glass, 2 × 7½ × 3½ in. Collection of Richard Marquis.

The *Marquiscarpas* (a title suggested to the artist by Lino Tagliapietra) flaunt Marquis's expert knowledge and handling of the *murrine* technique and his unique and inventive response to the history of glassmaking and glass design (pls. 128–31, 133–39). The name *Marquiscarpa* alludes to the influential Venetian architect and designer Carlo Scarpa, who was hired by Paolo Venini (founder of Venini Fabbrica) as a designer in 1932 and subsequently promoted to artistic director in 1934. Of all the glasshouses producing *murrine* vessels in Murano at mid-century, Scarpa arguably created the most brilliant interpretations of the technique.[63] Marquis discussed his interest in Scarpa's work in a 1996 statement:

Glass objects have been made for thousands of years. I've been doing it for thirty. Sometimes, it seems like all the good ideas have been used up and the new things are either reflections, comments, adulations, or rip-offs of old stuff. . . . The [Marquiscarpas] . . . are the result of my wonder and admiration of . . . [ancient] Roman work and Carlo Scarpa's designs for Venini before World War II. I made [the Marquiscarpas*] . . . because I pay attention to history. I made them because I wanted to see how I would make them. I made them because to me it was the obvious thing to do.[64]*

Marquis devised the complex technique used in the *Marquiscarpas* after studying Carlo Scarpa's brilliant and colorful designs from the 1940s and discussing them with contemporary Muranese glass masters.[65] The form of the *Marquiscarpas*—a canoe-shaped, oblong lens or square shallow dish on top of a tall or short columnar foot—refers to historic European chalices, ancient Egyptian and traditional African and Asian headrests, and ancient Greek ceramic footed drinking cups *(kylikes).*[66] For the artist, the *Marquiscarpas* were the first pieces he had ever made whose process he did not enjoy: working on them was slow and tediously repetitive. "I'm more interested in the finished result than I am in the process," Marquis confirms. "Doing something difficult and interesting is okay. Doing something easy and boring is okay. But doing something difficult and boring is just a bad combination."

Marquis makes the *Marquiscarpas* in parts, first selecting and laying out his *murrine* for the shallow dishes. The *murrine* forming the dish are heated until they fuse flat. Once fused, the *murrine* sheet is reheated and slumped over a ceramic mold in the furnace. The bead-shaped sphere (historically called a knop but

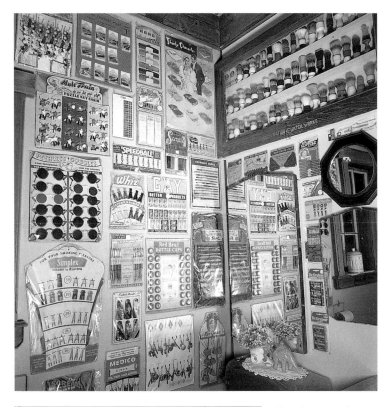

Sample cards, advertising displays, and shaving brushes in the bathroom of the artist's studio, 1997.

Window shelf in the grinding room of the artist's studio, 1997.

by Marquis, a doughnut) and columnar foot are blown, as opposed to slumped or fused, using a special pick-up method. Before the piece is assembled, the elements are individually wheel-ground, to give them a matte, hammered appearance.[67] Sometimes Marquis will include a tiny signature *murrina* or another of his typical images, such as a dollar sign or teapot. In concept and technique, the *Marquiscarpas* are a major accomplishment for the artist and make an equally powerful impression on people familiar with glass as well as those who are not.

"When Dick started doing the *Marquiscarpas* and I started reading about Scarpa, I finally understood the historical references in his work," says former Los Angeles art dealer Ruth Summers. "And saw that he was always pushing the edge of the envelope a little further, trying to do something different."[68] "I like the *Marquiscarpas* that display Dick's humor," muses Kate Elliott. "Like the ones he photographed with the birds perched on them. There isn't anyone in the entire world that would ever dream of doing anything like that, or even making anything like that. . . . So time consuming and difficult. . . . In Italy, even at Venini where they could probably pull it off, they would never dream of undertaking such a project." "When you look at a body of work [like the *Marquiscarpas*] . . . or at any one element of his work, it's strictly Dick Marquis, no one else," adds Paul Smith. "He simply has had his own definite path, always."

Marquis's remarkable interpretation of Carlo Scarpa's designs and processes are an important achievement in the world of international contemporary studio glass. The artist's interest in Scarpa has expanded in recent years with his re-invention of other Scarpa *murrine* techniques, including *granulare* and *occhi* (developed by Scarpa's son, Tobia Scarpa).[69] Dante Marioni, who helped Marquis replicate the *occhi* technique, recalls:

We were always interested in the occhi *and at the beginning, Dick said, "No . . . we'll do it some other time." . . . Then we were invited to Japan and they had all this colored glass available, which made it really easy to make* murrine *squares. Otherwise we would have had to use Kugler bars which is a real pain. . . . And we made an* occhi *piece and I got all excited. It was black with little clear windows. From there, we went to Australia and made more of them. We made one with red and yellow checkerboards. Then, that spring, in 1994, we bought a whole bunch of color bars and went up to Pilchuck and made all these pieces for fun.*

While Dante Marioni later used a variation of the *occhi* technique—called "blown mosaic"—to make his tall, *Whopper*-style vases, Marquis paired his *occhi,* mosaic, and *granulare* vessels with cast-glass English setters hierarchically positioned on a flat, oblong, almost surfboard-shaped base. The *Dog Pieces,* as they are known, were named after the registered titles of the artist's deceased English setter, those fascinating, multiple names favored by breeders such as *Wellwyn Geronimo Boy* (pl. 144) or *Blue Boy's Mamie* (pl. 146). In the *Dogs,* for the first time, the artist integrated, rather than assembled, found objects with Marquis-made ones. This new course combined Marquis's mastery of difficult, obsessive techniques with his looser, humorous, and more relaxed approach to fabricated and assembled works.

MARQUIS OBJECTS

DICK HAS INCREDIBLE CREATIVE ENERGY AND A GORGEOUS ARTISTIC VISION. I RESPECT DICK, HE IS MY FRIEND, HE IS A VERY GREAT ARTIST, AND HE IS UNLIKE ANYONE ELSE I KNOW. HE IS A GOOD GLASSBLOWER, A GOOD PHOTOGRAPHER, HE MAKES A FANTASTIC MURRINA, AND HE IS A BUILDER. HE IS A CRAFTSMAN FOR CARS, BOATS, HOUSES, MURRINE, CANES, TEAPOTS, EVERYTHING. HE IS ALSO AN INTELLECTUAL THINKER WHO CHANGES AND TRANSFORMS EVERYTHING. —LINO TAGLIAPIETRA

"Dick is one of the most under-recognized people in glass. He brings an artist's point of view to the process . . . bringing together Venetian glass history with an independent American point of view," observes Lloyd Herman. "He seems almost to have two personalities. There's something loose and slapdash . . . [and then there's] his mastery of technique." Marquis's binary personality traits—his seriousness and humor, his obsession with technique and the rebellious "looseness" of his fabricated and assembled works, his desire to create and collect—joyfully collide in his most recent pieces such as the *Dog Pieces, Tea Services* (pls. 148, 150), and the *Rubber Chick* (pl. 143), *Siesta,* and *Dog Bowls.* The juxtaposition of the *murrine* lumpyware teapot and cups of the *Tea Services* with thrift-store paint-by-number paintings, for example, is formally and conceptually outrageous but successful. In all these extreme pieces, the artist's love of challenging techniques is combined with his passion for vintage found objects, resulting in an approach that is uniquely Marquis.

The intellectual component underlying Marquis's concepts of the "dumb" and the lowbrow have not gone unnoticed in spite of his facile ability to hide behind humor. "Over a period of time I have been impressed with Dick's singular approach to his work and by the fact that he has always been willing to explore new horizons, new areas," observes Paul Smith. "It's really remarkable in relation to other artists in the glass field. Many of them have done a range of work, but he has been especially prolific as well as innovative in exploring new things. . . . All the departures he has taken are interesting and reflect his strong intellectual capacity." "He has an eye," asserts former Seattle art dealer Jim Manolides. "I don't think anybody can make a piece like Dick. They're things to be coveted. . . . His work is sublime." "You won't see a lot of people copying Dick's work, unlike [some other] . . . artists, who are easy to copy because they do a lot of the same kind of thing," adds Paul Marioni. "Once you get to know him it becomes obvious how smart he is, questioning everything, and opinionated, of course. But his wonderful sense of humor. . . comes out of a place you never expect."

Richard Marquis's title for this monograph, *Richard Marquis Objects,* is a nutshell definition of his artistic philosophy, uniting a master's keen interest in objects and artistic process with the rebel's defiant need to declare "I object," to provoke and promote new perspectives. Without a doubt, Marquis is an American original, an artist with a natural gift for brilliant craft, scholarship, and an unerring eye for color and composition. His art is always fresh, witty, personal, unexpected, and unselfconscious. As an individual, he is inventive, obsessive, direct, independent, challenging, kind, and observant. And it should be mentioned that he is incredibly intelligent, seriously bizarre, and hopelessly funny. Welcome to Marquisworld!

The artist with Johanna, Pete, and Cupcake in front of 1935 Dodge truck.

NOTES

1. Lois Moran (editor, *American Craft Magazine*), interview with the author, March 20, 1997. Unless otherwise noted, all quotes by Moran are from this interview. My sincere thanks go to the following people who helped me better understand Richard Marquis and his work: Alessandro Diaz de Santillana, Anna Venini Diaz de Santillana, Fritz Dreisbach, Kate Elliott, Susanne Frantz, Vicki Halper, Lloyd Herman, Bernard Kester, Marvin Lipofsky, Jim Manolides, Dante Marioni, Paul Marioni, James Melchert, Klaus Moje, Lois Moran, Ron Nagle, Franklin Parrasch, Patterson Sims, Paul Smith, Therman Statom, Ruth Summers, Lino Tagliapietra, and Bertil Vallien. I am also indebted to project manager Suzanne Kotz for her keen editorial eye and perceptive comments, and to Peter Herzberg for his useful suggestions. My most grateful and appreciative thanks belong to Richard Marquis—who was tirelessly cooperative, generous, and always available—and his wife, Johanna Nitzke Marquis, for her warm hospitality and encouragement.

2. Excerpt from Richard Marquis, "Richard Marquis–Editorial," *Glass Art Society Journal 1981* (1981), pp. 55–56.

3. Richard Marquis, interview with the author, March 17, 1997. Unless otherwise noted, all quotes by Marquis are from this interview.

4. Maria Porges, "Richard Marquis: Material Culture," *American Craft* (December 1995/January 1996), p. 36.

5. Garth Clark, Introduction in Garth Clark and Oliver Watson, *American Potters Today* (London: Victoria and Albert Museum, 1986), p. 13.

6. Ibid., pp. 12–13.

7. James Melchert, interview with the author, April 22, 1997. Unless otherwise noted, all quotes by Melchert are from this interview.

8. Ron Nagle, interview with the author, April 2, 1997. Unless otherwise noted, all quotes by Nagle are from this interview.

9. Peter Selz, *Funk* (Berkeley: University Art Museum, University of California, 1967), pp. 1–3.

10. This sentence is a combination and recontextualization of comments made by art historian Patricia Failing (about Seattle ceramist Howard Kottler) and art historian Martha Lynn (about Davis ceramist Robert Arneson). See Patricia Failing, *Howard Kottler: Face to Face* (Seattle: University of Washington Press, 1995), p. 4, and Martha Lynn, *Clay Today: Contemporary Ceramists and their Work* (Los Angeles: Los Angeles County Museum of Art; San Francisco: Chronicle Books, 1990), p. 36.

11. Selz, *Funk*, p. 56.

12. Both Ron Nagle and former Seattle gallery owner Jim Manolides emphasize the anti-intellectual aspect of Bay Area ceramics, although the artists and artwork are recognized as intelligent and smart. Nagle interview and Jim Manolides, interview with the author, April 29, 1997. Unless otherwise noted, all quotes by Manolides are from this interview.

13. Kirk Varnedoe and Adam Gopnik, "Comics," in *High & Low: Modern Art and Popular Culture* (New York: Museum of Modern Art, 1990), pp. 187–88, 225.

14. Giorgio Morandi (1890–1964) was an Italian painter famous for his beautiful and deceptively simple still lifes incorporating bottles and jugs. California painter/ sculptor Vija Celmins has also noted: "There were a lot of changes going on in the late 1950s and early 1960s. Johns . . . Rauschenberg . . . all those people started doing dumb objects, dumb painting. . . . I . . . began to look at Morandi too because he was showing up in magazines." Vija Celmins interview with Chuck Close, in William S. Bartman, ed., *Vija Celmins* (Los Angeles: A.R.T. Press, 1992), p. 11.

15. To this list of artists should be added ceramist Richard Shaw, who shares Marquis's love of assemblage. As Vicki Halper has observed, interesting stylistic and thematic parallels may be discerned in their artwork; see, for example, Shaw's 1972 *Cup on a Rock*, illustrated in Richard Marshall and Suzanne Foley, *Ceramic Sculpture: Six Artists* (New York: Whitney Museum of American Art in association with the University of Washington Press, 1981), p. 123. Regarding the influence of comic imagery,

Marquis read mostly Donald Duck and Uncle Scrooge comics when he was young. In the late 1960s and 1970s, he was into underground comics by Robert Crumb. He also appreciated Walt Disney's *Fantasia* for its psychedelic presentation.

16. Dante Marioni, interview with the author, April 4, 1997. Unless otherwise noted, all quotes by Dante Marioni are from this interview.

17. Susanne K. Frantz, *Contemporary Glass: A World Survey from the Corning Museum of Glass* (New York: Harry N. Abrams, 1989), p. 69.

18. Unfortunately, these early pieces were given away by the artist and never documented.

19. Marvin Lipofsky, interview with the author, April 11, 1997. Unless otherwise noted, all quotes by Lipofsky are from this interview.

20. In addition to the instructors, there were accomplished students including Susan Dangberg, Joan Dickson, Jun Kaneko, Richard Lindenau, Sally Lorch, Nancy Selvin, and Patrick Siler.

21. Marquis, Naess, and their friends were involved in a number of related artistic activities fairly characteristic of the time, such as making underground-style movies. The most notorious of these extracurricular events was the *Chicken Film*, made by Tom Ward and featuring Marquis, Naess, and Bob Potts, so named because it featured Marquis sticking a store-bought fryer into the glass furnace and going through various technical processes, using jacks and other tools.

22. Lee Nordness, *Objects USA* (New York: Viking Press, 1970), p. 162.

23. Paul Smith, interview with the author, April 1, 1997. Unless otherwise noted, all quotes by Smith are from this interview.

24. Letter to Anna Venini Diaz de Santillana, 1995. This letter is reprinted in its entirety (in English) in Susanne Frantz, "Venini e l'arte del vetro in America," in Alessandro Bettagno et al., *Gli artisti di Venini: Per una storia del vetro d'arte Veneziano* (Milan: Electa, 1996), p. 40.

25. From the factory's inception in the 1920s, Paolo Venini's aim in glass design was to strip away the excesses typical of Venetian glass at the turn of the century. He and his partners were not interested in imitating the popular historical forms and sometimes garish decorations for glass made by factories such as Salviati, but wanted to revive the graceful, elegant, and pure spirit of Venetian glass at its finest, like the simple and clean shapes depicted in paintings by such Venetian Renaissance masters as Jacopo Tintoretto and Paolo Veronese. Peggy Loar et al., *Venini Glass* (Washington, D.C.: Smithsonian Institution, 1981), pp. 5, 11, 16.

26. Much of the information on Marquis's year in Murano comes from Susanne Frantz in Bettagno et al., *Gli artisti di Venini*, pp. 29–45.

27. On the theme of efficiency, Marquis remembers an interesting practice at Venini: "At that time, you could order any design that Venini had produced since the 1920s. [The prototypes] . . . would come out; a lot of them were Scotch-taped and glued together. They were beat up because they were always getting knocked over by the blowers when they were on the marver. The glassblowers would bring one out and put it on the marver and they would all look at it and talk about it and figure it out. Then everyone would disappear to get what they needed and then, all of a sudden, they'd be making this piece that hadn't been made in ten years. And they'd make one because they had an order for one. I couldn't believe it! I'd say, Why don't you make four or five? And they'd tell me it was because they had no place to store them."

28. This paragraph combines information from my interview with Richard Marquis and the essay by Susanne Frantz in Bettagno et al., *Gli artisti di Venini*, pp. 34, 40 (reprint of Marquis letter).

29. Marquis, Chihuly, and other American glass artists like Thomas Stearns, who visited Venini in 1962, stayed at Venini for months, learning techniques that had been carefully guarded for centuries. To the workers' horror, Ludovico Diaz de Santillana allowed Chihuly to shoot Super-8 movies of glassblowing processes. According to his wife, Anna, de Santillana "did not mind stirring up controversy within the rather rigid environment of Murano" (Susanne Frantz in Bettagno et al., *Gli artisti di Venini*, p. 33).

30. Susanne Frantz in Bettagno et al., *Gli artisti di Venini*, p. 40.

31. Anna Venini Diaz de Santillana, letter to the author, April 5, 1997.

32. *Murrine* had been used as far back as the third century B.C. by the Egyptians for inlay decoration and by the Romans, from the first century A.D., for inlay and luxury wares. Renaissance glassmakers revived the technique, and it enjoyed another comeback in the nineteenth century, when it was used to reproduce ancient and Renaissance glasswares, jewelry, and other objects. The first Muranese artists to reinterpret *murrine*, around 1913, were the painter and glass designer Vittorio Zecchin and glassmaker Giuseppe Barovier. See Jutta Annette-Bruhn, *Designs in Miniature: The Story of Mosaic Glass* (Corning, N.Y.: The Corning Museum of Glass, 1995).

33. Alessandro Diaz de Santillana, interview with the author, March 20, 1997.

34. Lino Tagliapietra, interview with the author, April 8, 1997. Unless otherwise noted, all quotes by Tagliapietra are from this interview.

35. In 1969 the ceramist Howard Kottler made a series of porcelain plates with an American flag theme and embroidered cloth envelopes (*American Supperware* series) similar to, but independent of, Marquis's activity; see Failing, *Howard Kottler*, pp. 73-75. One of the most elaborate of the historic European glass cases was the tooled leather bag, commissioned by a fourteenth-century British collector, for the enameled and painted mid-thirteenth-century Syrian beaker known as the Luck of Edenhall, which is now in the Victoria and Albert Museum in London; see W. B. Honey, *Glass* (London: Victoria and Albert Museum, 1946), p. 47.

36. Kate Elliott, interview with the author, April 1, 1997. Unless otherwise noted, all quotes by Elliott are from this interview.

37. Paul Marioni, interview with the author, April 11, 1997. Unless otherwise noted, all quotes by Paul Marioni are from this interview.

38. Naess came to work with Marquis at the Venini factory since it was difficult for Marquis to enlist help from the busy glassblowers. For American glass artists using *murrine*, see Susanne Frantz, "The 20th Century: New Departures," in Annette-Bruhn, *Designs in Miniature*, pp. 41, 43.

39. Ibid. and Susanne Frantz, interview with the author, March 20, 1997. Unless otherwise noted, all subsequent quotes by Frantz are from this interview.

40. Klaus Moje, letter to the author, June 11, 1997.

41. The Toledo workshops are generally identified with the birth of the contemporary American studio glass movement. Harvey Littleton, the organizer, had been making tentative steps toward developing a one-person glass studio since 1959. Otto Wittmann, director of the Toledo Museum of Art, offered the resources of the museum and its art school to Littleton. The first glassblowing workshop was held in March 1962. Norman Schulman, ceramics instructor at the museum's school of design, assisted in the workshop, as did Dominick Labino, vice president and director of research at Johns-Manville Fiber Glass Corporation, who gave crucial technical advice. Harvey Leafgreen, a retired glassblower from Libbey-Owens, provided hands-on expertise. This Toledo workshop was followed by a second seminar in late June 1962, which Howard Kottler attended. See Tina Oldknow, *Pilchuck: A Glass School* (Seattle: Pilchuck Glass School and University of Washington Press, 1996), pp. 34, 36–37, and Frantz, *Contemporary Glass*, pp. 45–51.

42. Failing, *Howard Kottler*, p. 48. For academic glass programs in the Pacific Northwest, see Oldknow, *Pilchuck*, pp. 37–38.

43. Richard Marquis, interview with the author, March 27, 1995.

44. Marquis interview, March 27, 1995. For his interaction with first-year Pilchuckers, see Oldknow, *Pilchuck*, pp. 59–61, 65.

45. Marquis interview, March 27, 1995.

46. Decorative canework techniques include many types of so-called filigree glass *(vetro a filigrana)*. The terms used by Marquis in general, however, do not reflect the terms used by glass historians (which are grouped by decorative style) but those used by glassblowers in Murano (grouped by technique). Thus "cane" glass *(a canne)* describes glass decorated with internal stripes of color (color canes integrated into the surface of the vessel by being picked up onto a hot bubble and then rolling, or marvering, the canes into the surface); *filigrana* (filigree; in England, this included "airtwist") refers to thin lines of internal color; *zanfirico* (also known as *latticinio* [a British term] and *vetro a retorti*) consists of internally decorated, often multicolored glass canes picked up onto the hot bubble and marvered, producing complex, netlike patterns often with twists and spirals; and *reticello*, yet another distinct technique, involves trapping air bubbles between two layers of *filigrana* "net" glass.

47. Therman Statom, interview with the author, April 18, 1997. Unless otherwise noted, all quotes by Statom are from this interview.

48. The Lord's Prayer was not the only subject Marquis considered: "The other thing I thought about was copying a page out of a British encyclopaedia, but that would have been so much more work."

49. Fritz Dreisbach, interview with the author, April 18, 1997. Unless otherwise noted, all quotes by Dreisbach are from this interview.

50. Marquis made the clay *murrine* teapots about 1970–71 while at the University of Washington and when he returned to the Bay Area. The clay versions were not studies for the glass teapots, although they preceded them. Marquis used clay because he had not yet figured out the technique in glass.

51. Bernard Kester, interview with the author, April 3, 1997. Unless otherwise noted, all subsequent quotes by Kester are from this interview.

52. Lloyd Herman (former curator of the Smithsonian's Renwick Gallery), interview with the author, April 4, 1997. Unless otherwise noted, all subsequent quotes by Herman are from this interview.

53. Sam Herman, an American glassblower living in England, was a student of Harvey Littleton's at Madison; see Dan Klein, *Glass: A Contemporary Art* (New York: Rizzoli, 1989), p. 200.

54. In 1979 the name was changed to Marlux and finally to HOTMIRE (Hippies Out to Make It Rich Experiment).

55. A few collectors made the effort to understand them, notably Michael and Cathy Brillson, Elmerina and Paul Parkman, and George and Dorothy Saxe.

56. Marquis makes a distinction between objects that are cold fabricated and just glued together with silicone, although both types are technically "fabricated." "Cold fabrication" involves shaping the individual elements to be assembled on a grinding wheel (usually called cold working) and then performing a complicated gluing process using anaerobic glues and ultraviolet light. Marquis uses the term "siliconed" to describe assembled objects whose elements have not been cold worked but simply glued together with silicone.

57. Franklin Parrasch, interview with the author, April 1, 1997.

58. The older term for this technique is "sand core." Originally used to hold makeup, scented oils, and unguents, ancient core-formed vessels were most likely made by applying molten glass from the furnace over a sand and clay core built up on a ceramic pipe or by casting. Once the glass cooled, the core was picked out. Harvey Littleton attempted to replicate these vessels and the trailing technique, but his objects were poor imitations of the ancient ones. British glass artist Colin Reid has been more successful in casting new core-formed vessels in the ancient style. In antiquity, this type of vessel was considered a status object, as precious as those made of fancier materials such as carved stone.

59. This quote draws on my interview with Richard Marquis and statements by the artist in Bonnie J. Miller, "The Irreverent Mr. Marquis," *Neues Glas* (April/June 1988), p. 82.

60. Richard Marquis, "Decoration and Expression (Richard Marquis)," *Glass Art Society Journal 1985–86* (1986), pp. 64–65.

61. Bertil Vallien, letter to the author, April 1, 1997.

62. Marquis, "Editorial," pp. 55–56 (as in n. 2).

63. Frantz in Annette-Bruhn, *Designs in Miniature*, p. 38.

64. Patterson Sims, *Holding the Past: Historicism in Northwest Glass Sculpture* (Seattle: Seattle Art Museum, 1996), unpaginated.

65. In 1933 Scarpa developed the *murrine romane* (Roman *murrine*) series for Venini Fabbrica, introducing a new effect by using large, thick, square *murrine* with circular centers to cover the entire vessel surface, leaving the naturally uneven texture of the fused *murrine* unmarvered. Carlo Scarpa's son, Tobia, improved on Venini's *murrine* techniques by having objects wheel carved to a bladelike thinness, achieving a maximum translucency in the thick, opaque, mosaic glass (see Frantz in Annette-Bruhn, *Designs in Miniature*, pp. 35–40).

66. The lens shape of the *Marquiscarpa* bowls also refers to ancient prototypes which David Grose discusses in *The Toledo Museum of Art: Early Ancient Glass* (Toledo, 1991), fig. 131, and cat. nos. 359–67. Grose believes this "curious" shape was made for a specific function.

67. Slumping, like casting, fusing and other so-called warm techniques, is usually done in a kiln, although Marquis uses the furnace. In slumping, the heat allows the fused *murrine* to relax and slowly bend over a form; precise control over the temperature is crucial. The grinding technique (in Italian, *battuto*, which means "beaten") is particularly difficult and time consuming.

68. Ruth Summers (currently executive director of the Southern Highlands Craft Guild, Asheville, North Carolina), interview with the author, March 20, 1997.

69. Carlo Scarpa's *granulare* (sometimes called *perleto*) *murrine* technique is referred to by Marquis as both *granulare* ware and "lumpyware." The *granulare* pieces are made from *murrine* that have a hard center inside a soft field. Marquis explains: "When the *murrine* are picked up on a blowpipe, shaped, and then blown, [the glass] . . . goes all lumpy. It doesn't want to be a smooth bubble. . . . It's like trying to blow a bubble with chewing gum impregnated with B.B.s." Ancient glass reminiscent of the lumpy surface of *granulare*, although not the technique, are the core-formed Etruscan vessels with applied scale decoration dating to the seventh and sixth centuries B.C.; see Grose, *Early Ancient Glass*, fig. 52. *Occhi murrine* have clear glass centers surrounded by a band of color. The younger Scarpa introduced this *murrine* technique in the early 1960s in a series of *occhi* vessels produced for Venini; see Frantz in Annette-Bruhn, *Designs in Miniature,* p. 40.

PLATES

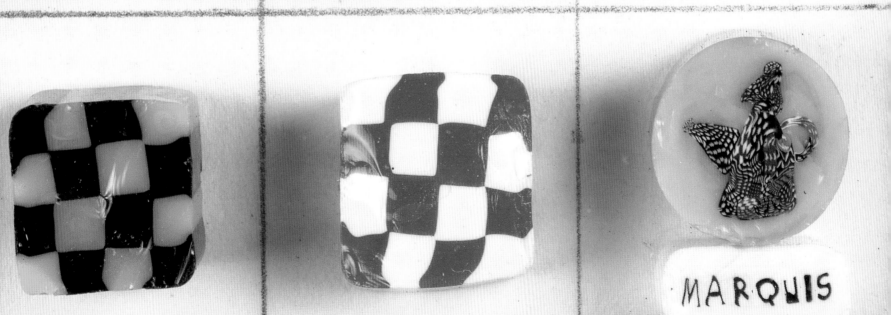

MARQUIS

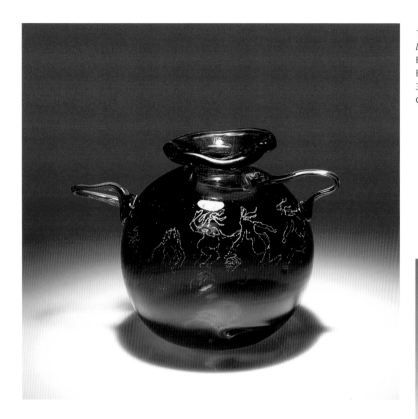

1
Double-Handled Vessel, 1966
Blown and engraved glass
Engraving by Marise Picou
3½ × 4¾ × 3¼ in.
Collection of the artist

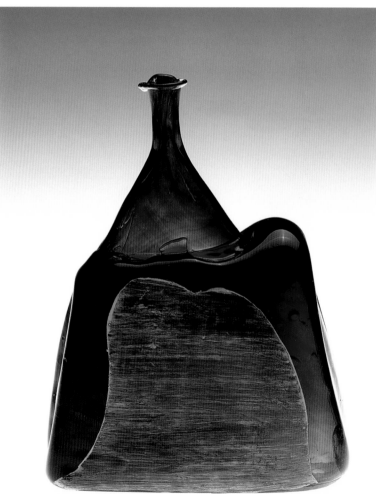

2
Trapezoidal Bottle, 1967
Blown glass, paint
4¼ × 3½ × 1¼ in.
Collection of the artist

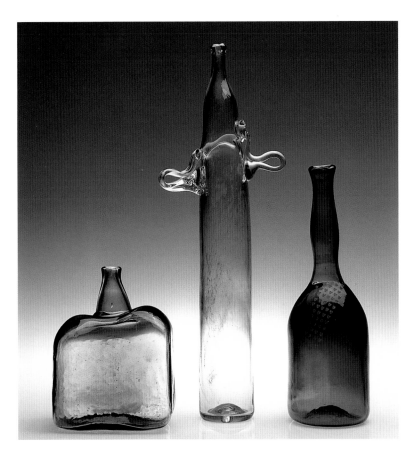

3
Square Bottle, Tall Double-Handled Bottle, Blue Bottle, 1967
Blown glass
Greatest h. 14½ in.
Collection of the artist

4
Double Bubble Vessel, 1968, and *Double-Handled Bottle,* 1967
Blown glass
8½ × 2 × 2 in., 10 × 5 × 2 in.
Collection of the artist

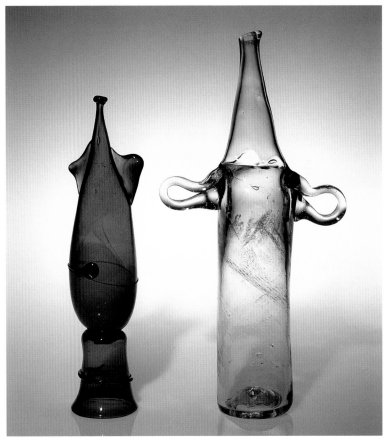

5
Ceramic Cups, 1966–68
Wheel-thrown stoneware, porcelain, and
low-fire clay with various glazes, underglazes,
and overglazes
Greatest h. 4 in.
Collection of the artist

6
Porcelain Covered Jars, 1967
Wheel-thrown and hand-built porcelain with
high- and low-fire glazes
Greatest h. 7 in.
Collection of the artist

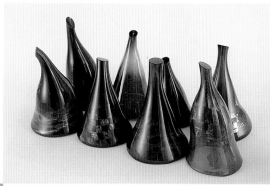

7
Untitled, 1968
Multiple mold-blown glass forms with checkerboard pattern metallic overlay
5 × 14 × 7 in.
Whereabouts unknown

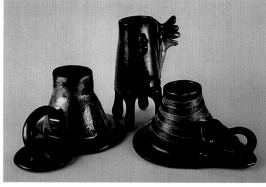

8
Glass Cups, 1967
Blown glass with metallic overlays
Greatest h. 5 in.
(l. to r.) Estate of Lee Nordness; collection of
Nora Fanshell; collection of Jim Melchert

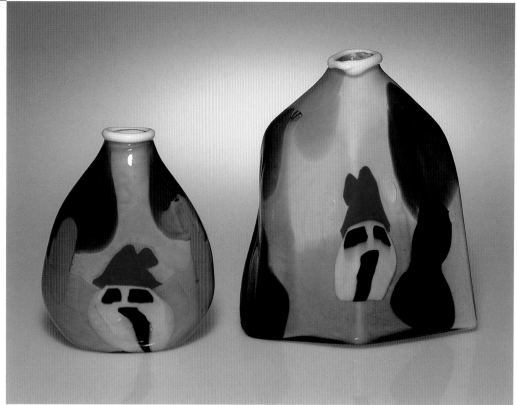

9
*Red Riding Hood's Grandma's House
Landscape Bottles,* 1970
Blown glass, *murrine*, hot-bit drawing
Made at Venini Fabbrica, Murano, Italy
4¼ × 3½ × 1¾ in., 5½ × 4¾ × 3 in.
(l. to r.) Collection of the artist; collection of
Pam Biallas

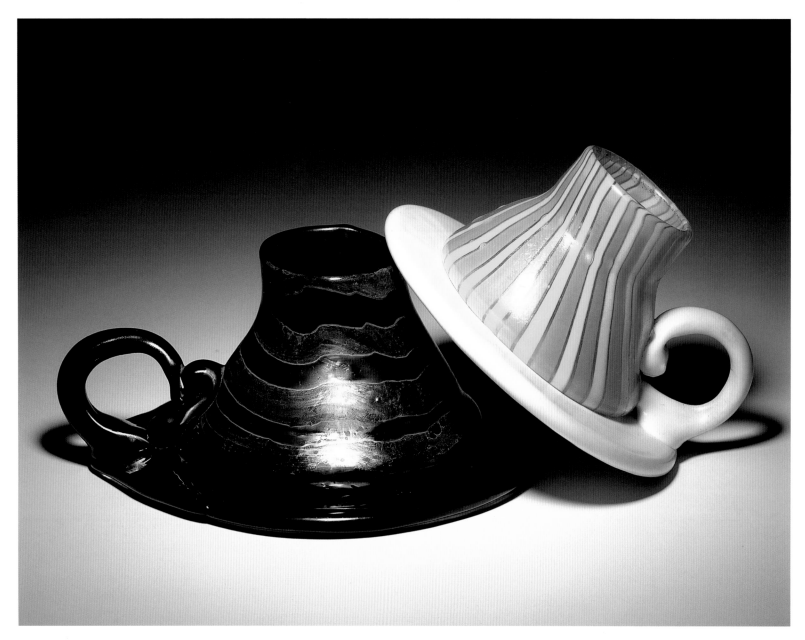

10
Iridescent Cup, 1968, and *Striped Cup*, 1969
Blown glass, cup at right is *a canne* technique,
made at Venini Fabbrica, Murano, Italy
2½ × 5½ × 5 in., 2½ × 4¼ × 4¼ in.
Collection of the artist

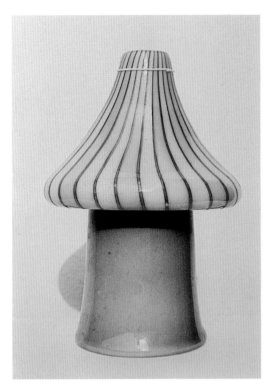

11
Double Bubble Vessel, 1969
Blown glass, *a canne* technique
Made at Venini Fabbrica, Murano, Italy
13 × 7 × 7 in.
Destroyed

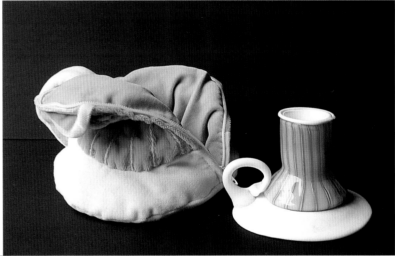

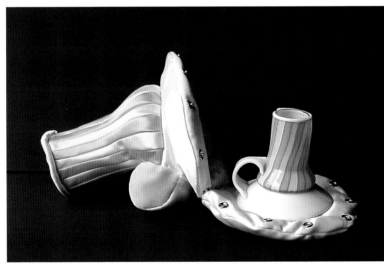

12
Mae West Cup with Cloth Container, 1970–71
Blown glass, *a canne* technique
Made at Venini Fabbrica, Murano, Italy
Cloth container by Nirmal Kaur (Barbara Brittell)
Approx. 4½ × 3½ × 3½ in. (glass), approx. h. 8 in. (cloth)
Collection of the Lannan Foundation

13
Candy Cup with Cloth Container, 1970–71
Blown glass, *a canne* technique
Made at Venini Fabbrica, Murano, Italy
Cloth container by Nirmal Kaur (Barbara Brittell)
Approx. 4½ × 3½ × 3½ in. (cup), approx. 8 × 7 × 7 in. (cloth)
Collection of the Lannan Foundation

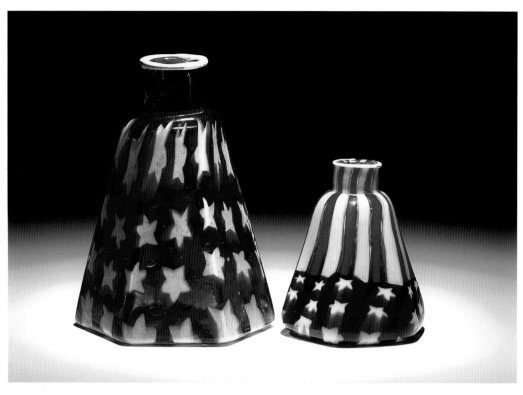

"YOUNG GLASSBLOWERS ENVY ME FOR
HAVING WORKED AT VENINI IN THE LATE
1960S. LISTEN: IT WAS A BIG PAIN IN THE
BUTT. IT WAS A CLASSIC CASE OF DELAYED
GRATIFICATION. THE WORKERS DIDN'T
NECESSARILY LIKE ME. I HAD MY HAIR
BURNED AND MY TEETH CHIPPED. IT WAS
A CONSTANT STRUGGLE. EVERY DAY I
EXPECTED TO BE TOLD IT 'WASN'T WORK-
ING OUT' AND THAT I SHOULD LEAVE.
THEN AFTER AWHILE IT WAS CLEAR THAT I
WAS ACCEPTED AND JUST SOMEBODY WHO
WAS THERE."

14
Hexagonal Star Bottle and *Stars and Stripes Bottle,* 1969
Blown glass, *murrine* and *a canne* techniques
4¼ × 3 × 2¾ in., 2¾ × 2½ × 2¼ in.
Collection of the artist

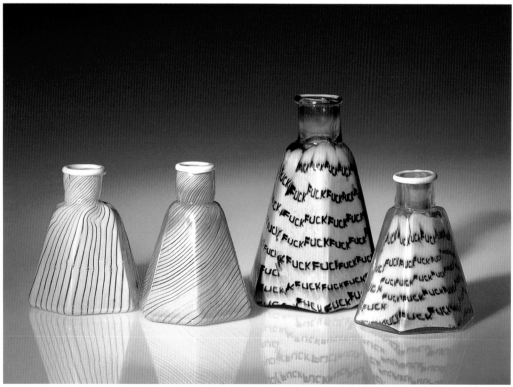

15
Hexagonal Bottles, 1969–70
Blown glass, *filigrana* and *murrine* techniques
Greatest h. 4¼
Collection of the artist

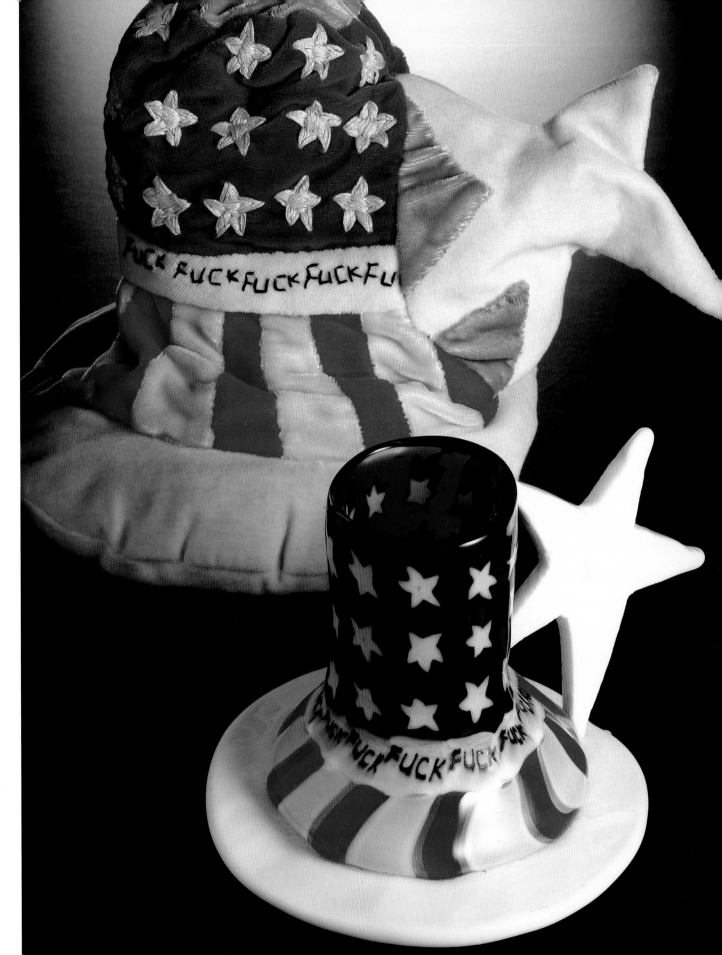

16
Stars and Stripes Cup with Container (Free Speech Cup), 1970
Blown glass, *murrine*, *a canne*, and *incalmo* techniques, embroidery and appliqué on velvet
Made at Venini Fabbrica, Murano, Italy
Container by Nirmal Kaur (Barbara Brittell)
3½ × 5¼ × 4 in. (cup), 7½ × 9½ × 6 in. (container)
Collection of George R. Stroemple

Following pages:
17
American Acid Capsule with Cloth Container, 1969-70
Solid-worked glass, *murrine*, *a canne*, and *incalmo* techniques
Made at Venini Fabbrica, Murano, Italy
Case by Nirmal Kaur (Barbara Brittell), c. 1970
2¾ × 4½ × 2¾ in. assembled
Collection of Pam Biallas

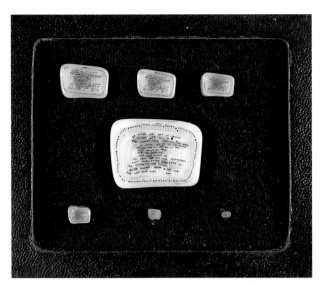

18
Display Box of Lord's Prayer Murrine, 1972
Glass *murrine,* specimen box
Box: 2¾ × 3¼ in. (shown actual size)
Collection of the artist

"OH YES . . . THE LORD'S PRAYER. WHEN I MADE MY FIRST WORD MURRINA ('FUCK') AT VENINI, I REALIZED THAT IF I MADE THE ALPHABET IN MURRINE I COULD WRITE ANYTHING. THE OBVIOUS THING WAS THE LORD'S PRAYER. I COULD STRETCH IT OUT TO THE SIZE OF A PINHEAD (WHICH I DID) AND SEND IT TO RIPLEY'S BELIEVE IT OR NOT (WHICH I NEVER DID). I LOOK AT IT NOW (TWENTY-FIVE YEARS LATER) AND KNOW I COULD MAKE IT BETTER. BUT WHY BOTHER."

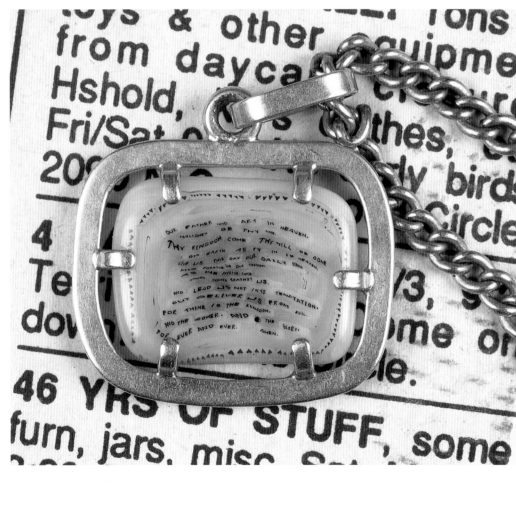

19
The Lord's Prayer Murrina, 1972
Glass *murrina,* set in gold
Murrina: ⅝ × ⅞ × ⅛ in.
Collection of Lina Tagliapietra

Opposite:
20
Scattering of Pills, 1971
Pulled and lampworked cane
Dimensions vary
Destroyed

Pulling cane, c. 1974

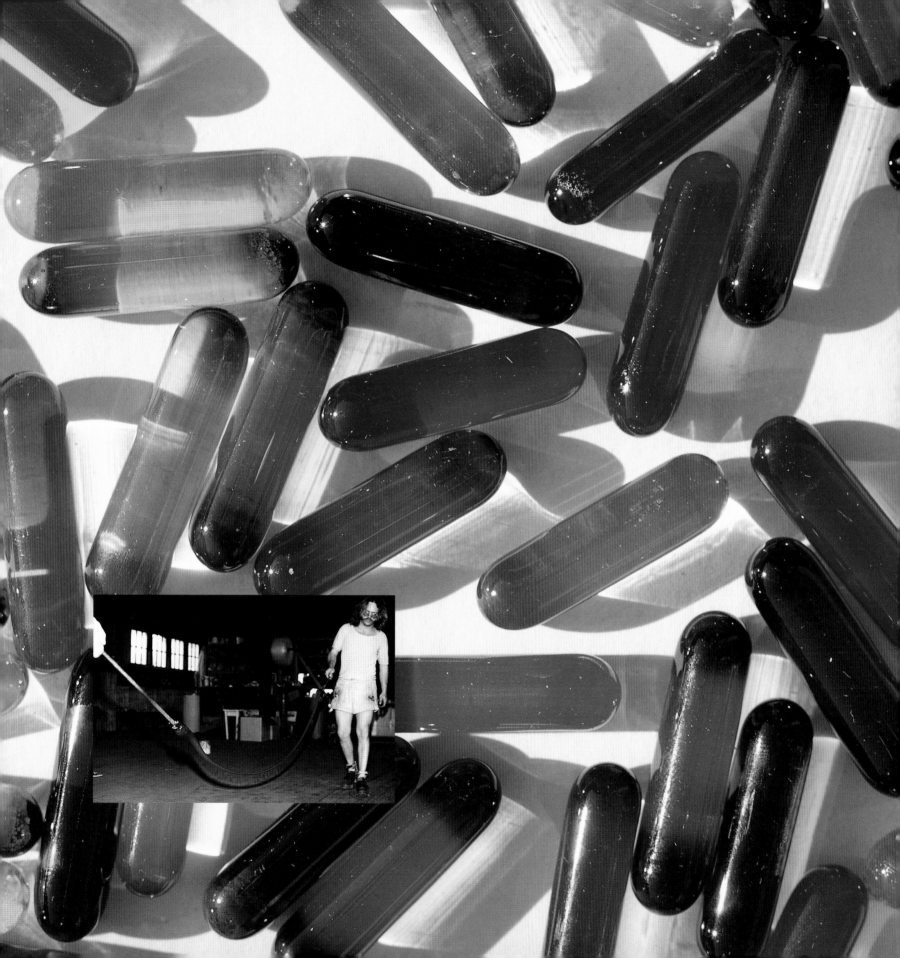

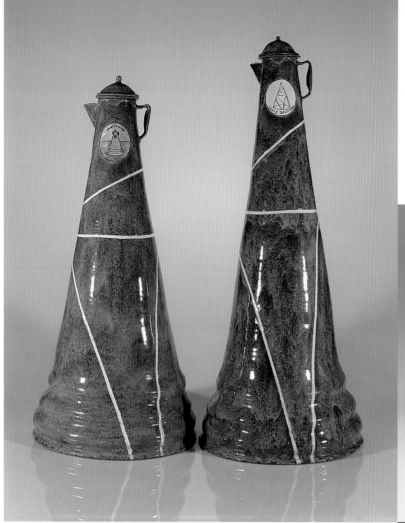

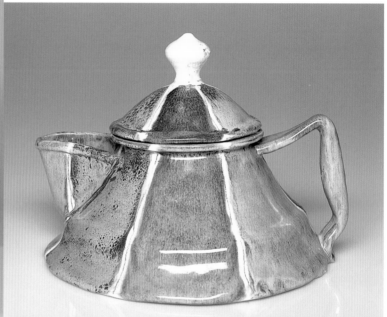

21
*Tall Graniteware Coffeepots
Cut into Conic Sections,*
1972
Wheel-thrown low-fire
clay with glazes
Greatest h. 29 in.
Collection of Nyla
Marnay; collection of
Sis Lawry

Top right:
22
*Graniteware Glaze Test
Coffeepot,* 1971
Wheel-thrown low-fire clay
with glazes
6 × 8 × 7½ in.
Private collection

Right:
23
*Ceramic Coffeepots and Tea
Kettle,* 1971–72
Colored low-fire clay with
clear glazes
Greatest h. 9¼ in.
Private collection

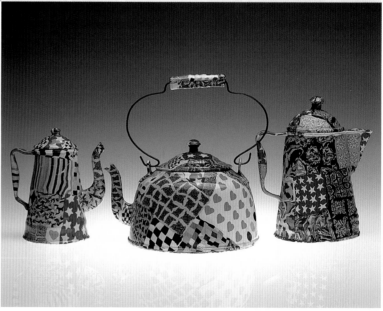

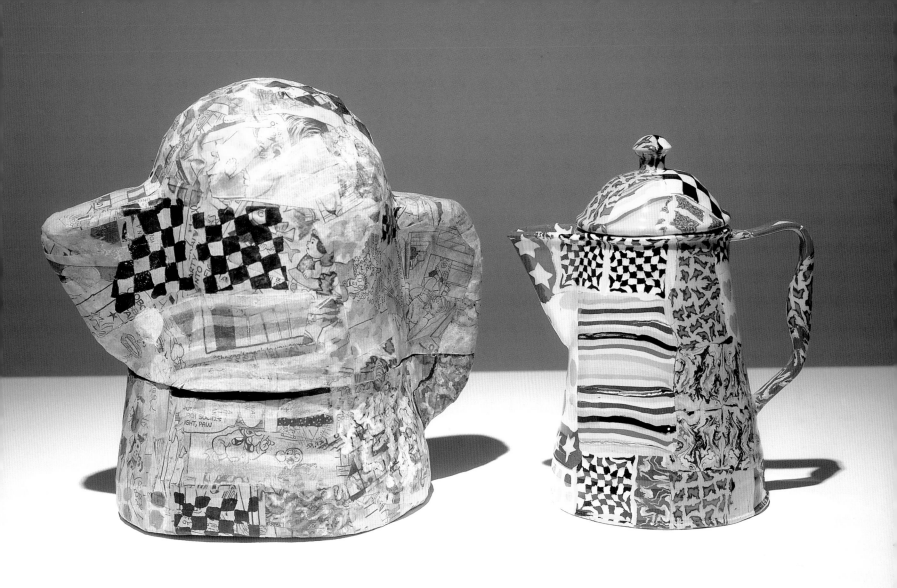

24
Ceramic Coffeepot with Cozy, 1972
Molded colored clay with clear glaze, papier mâché cozy
Cozy by Nora Fanshell and Jan Vail
10 × 9 × 7 in. assembled
Private collection, courtesy Franklin Parrasch Gallery,
New York

"THE SAME WAY YOU CAN MAKE MURRINE IN
GLASS, YOU CAN MAKE THEM IN CLAY, WITH
THE SAME PROBLEMS OF COMPATIBILITY
AND DISTORTION."

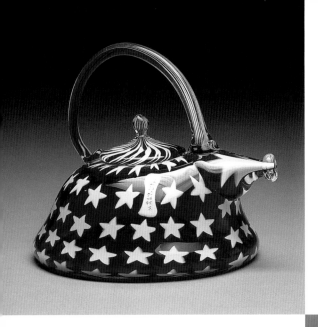

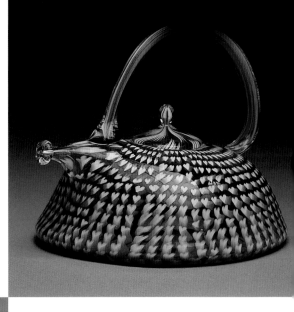

25
Star Pattern Nonfunctional Teapot, 1978
Blown glass, *murrine* technique
Approx. 6 × 5 × 5 in.
Whereabouts unknown

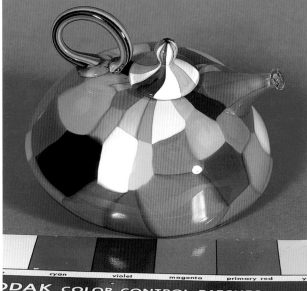

26
Heart Pattern Nonfunctional Teapot, 1978
Blown glass, *murrine* technique
Approx. 6 × 5 × 5 in.
Collection of Brendan Walters

27
*Nonfunctional Checkerboard Pattern Teapot with
Beaded Cozy,* 1973–74
Blown glass, *murrine* technique, beaded leather cozy
Cozy by Jan Vail and Nora Fanshell
3¼ × 6½ × 6½ in.
Corning Museum of Glass, Corning, N.Y.

29
Guinea Hen Feather Pattern Nonfunctional Teapot, 1973
Blown glass, *murrine* technique
4½ × 5 × 5 in.
Private collection

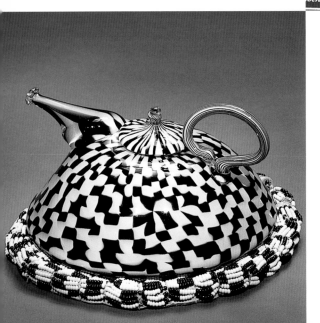

28
Nonfunctional Circus Teapot with Cozy, 1974
Blown glass, *murrine* technique
Cloth cozy (not illustrated) by Nora Fanshell and Jan Vail
4½ × 7 × 7 in. assembled
Collection of Andy and Charles Bronfman

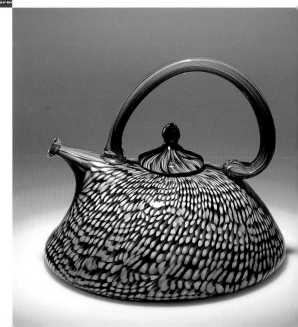

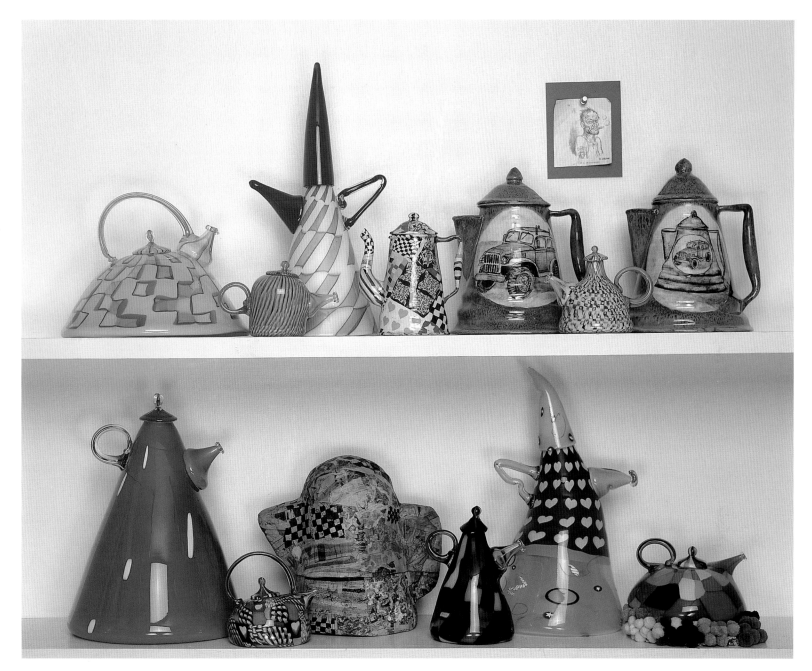

Ceramic and glass teapots from 1970–80 in the artist's studio, 1993.

"I CHOSE TO WORK WITH THE TEAPOT FORM FOR THREE REASONS. FIRST, IT HAD NO GLASS TRADITION. SECOND, IT WAS SO UN-MACHO COMPARED TO THE PREVAILING 'DIP N' DRIP' SCHOOL. LAST, IT HAD SO MANY ELEMENTS (LID, SPOUT, HANDLE, BODY) WITH WHICH TO MESS AROUND."

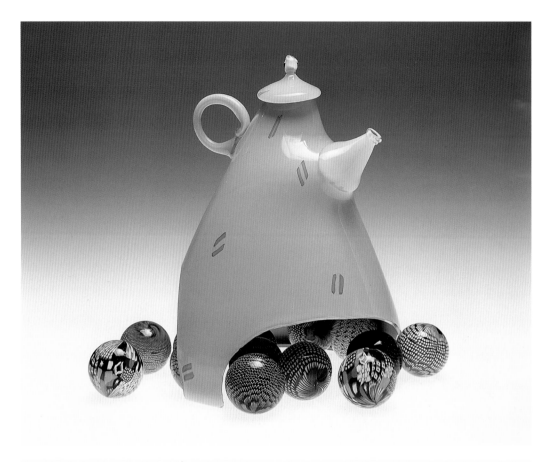

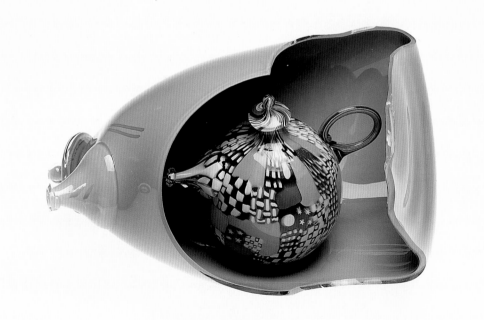

30
Broken Grey #2, 1979
Blown glass, *murrine* technique, marbles
h. 13 in.
Destroyed

31
Broken Grey #1, 1979
Blown glass, *murrine* technique
8 × 14 × 6 in.
Ex-collection Joan and Walter Mondale
Whereabouts unknown

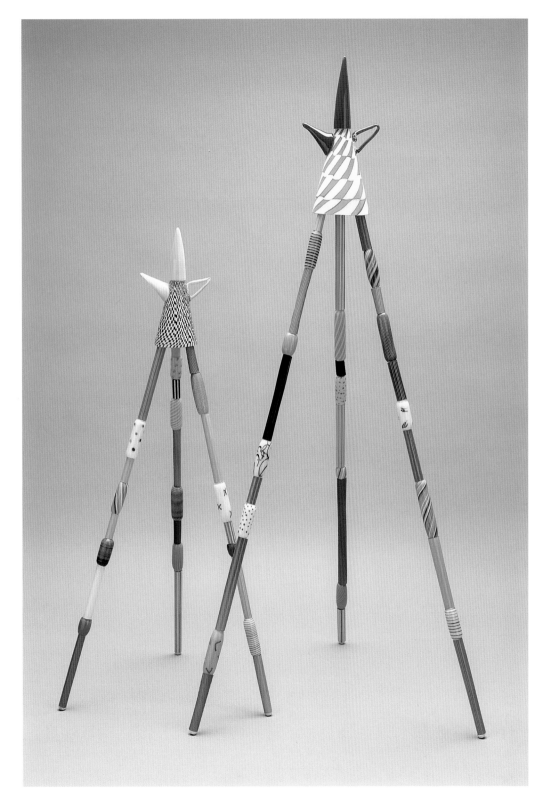

32
Teapot Tripods, 1980–82
Blown glass, various
techniques, aluminum,
cast rubber
Greatest h. 55 in.
Destroyed; collection of
the artist

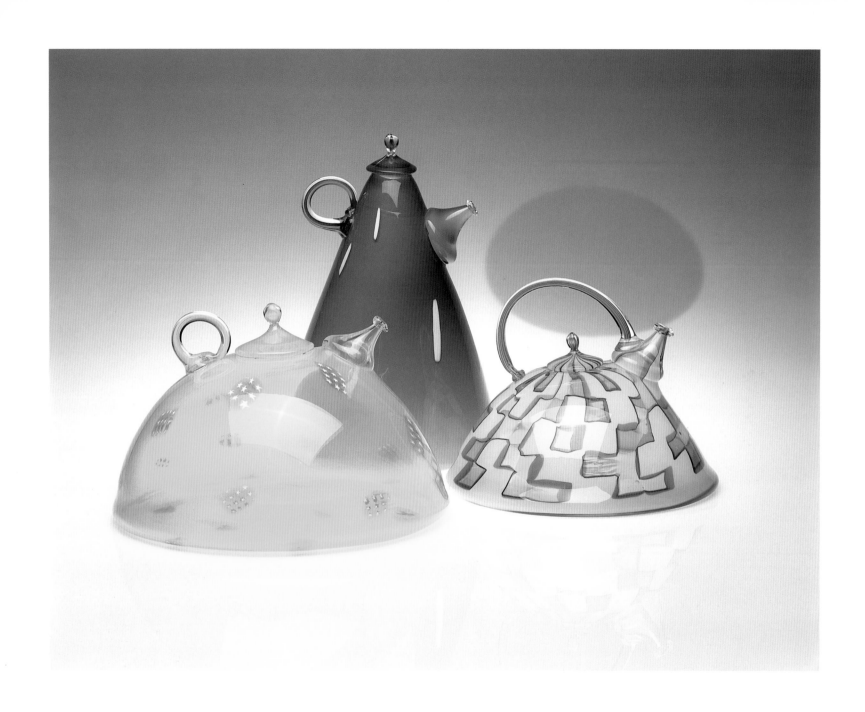

33
Large Teapots, 1980
Blown glass, *murrine* technique
Greatest h. 12 in.
Private collection

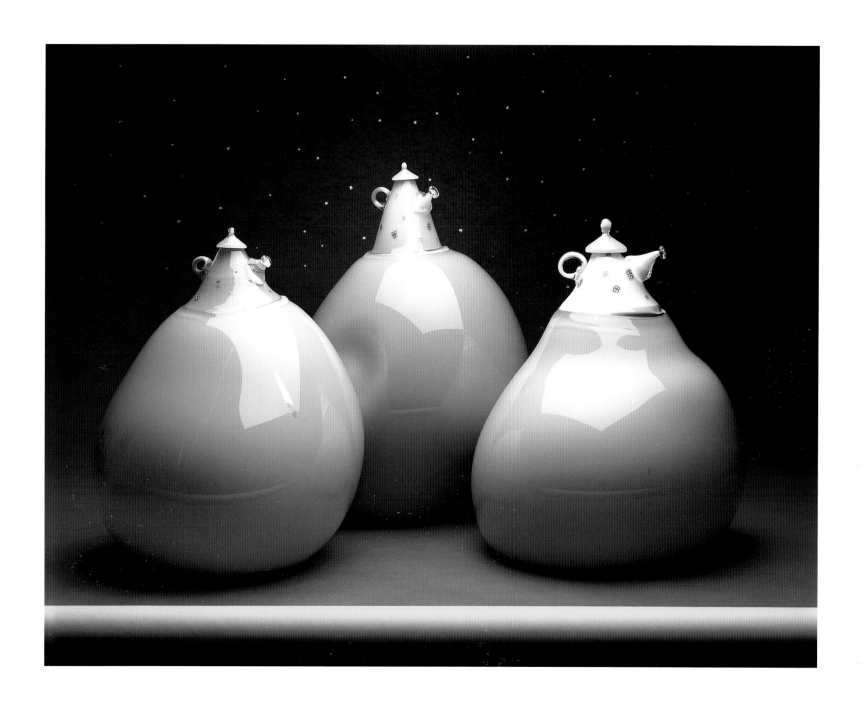

34
Big Greys, 1980
Blown glass
Greatest h. 24 in.
Collection of the artist

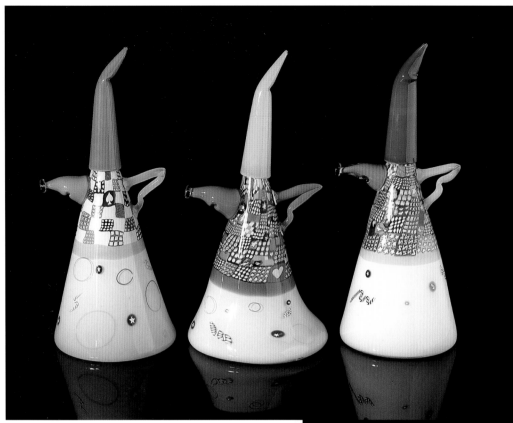

35
Wizard Teapots, 1985–87
Blown glass, *murrine* technique
Greatest h. 19 in.
(l. to r.) Private collection; collection of Stuart Sloan;
collection of Susan and Jeffrey Brotman

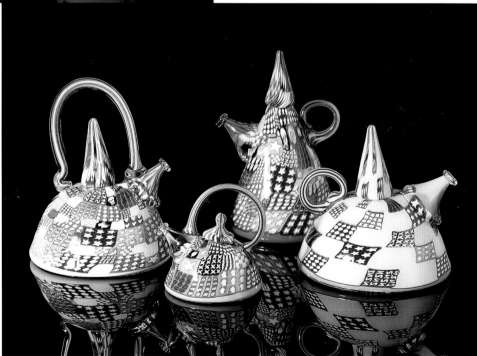

36
Crazy Quilt Teapots, 1985
Blown glass, *murrine* technique
Greatest h. 7 in.
Private collections

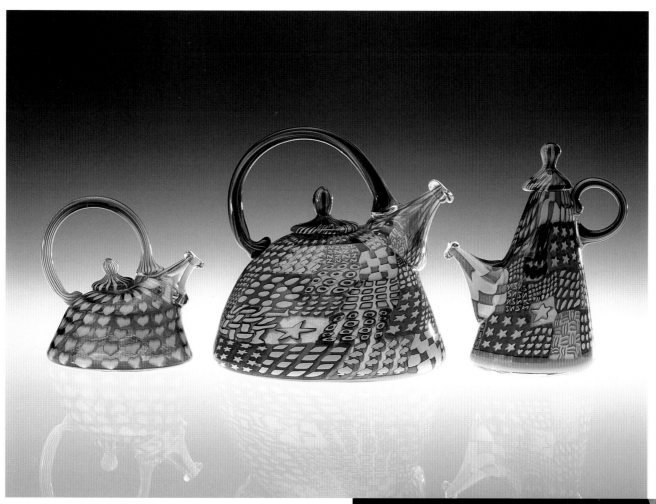

37
*Heart Teapot, Crazy Quilt Teapot, Crazy Quilt
Coffeepot,* 1988–90
Blown glass, *murrine* technique
Greatest h. 6 in.
Collection of Johanna Nitzke Marquis

38
Retrostuff: Stars and Stripes Teapots, 1997
Blown glass, *murrine* technique
Greatest h. 6 in.
Courtesy Elliott Brown Gallery, Seattle

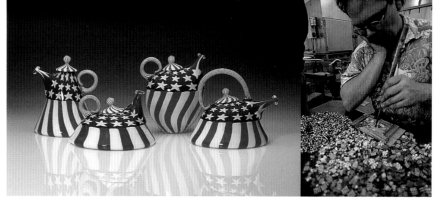

It's not all glamour. Setting
up a *murrine* pattern to
pick up, c. 1984.

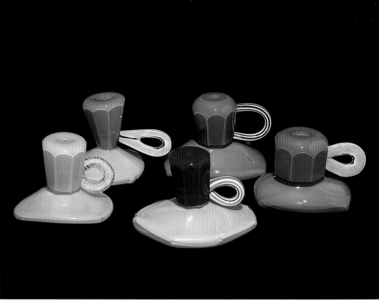

39
Fabricated Cup with Pills,
1977
Blown, faceted, and cold-
fabricated glass with
zanfirico handle and
lampworked pills
4½ × 6 × 4 in.
Collection of Rafaella Del
Bourgo

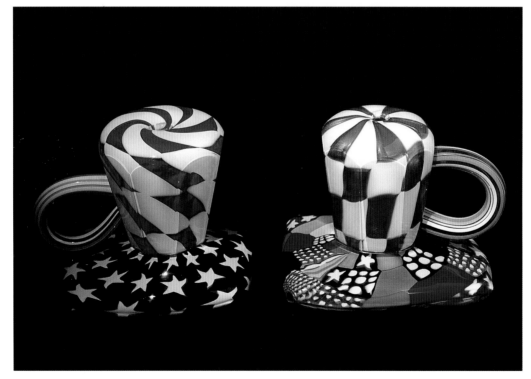

40
Fabricated Cups, from the
Good Taste series, 1978
Blown, faceted, and cold-
fabricated glass with
a canne and *zanfirico*
handles
Greatest h. 5 in.
Public and private
collections

41
Fabricated Cups, from the
Bad Taste series, 1978
Blown and faceted glass
with *murrine* and *a canne*
handles
Greatest h. 5½ in.
Private collections

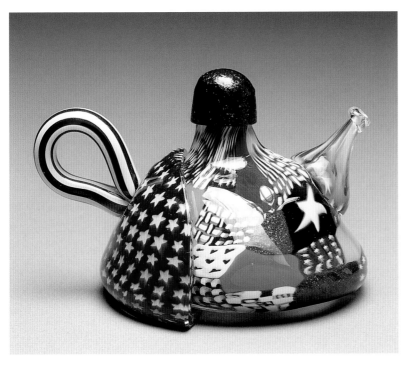

43
Fabricated Teapot (FWS #1), 1979
Blown and cold-fabricated glass
5 × 6 × 4 in.
Los Angeles County Museum of Art

42
Fabricated Teapot (FWS #2), 1979
Blown and cold-fabricated glass
3¾ × 5½ × 4¾ in.
Toledo Museum of Art

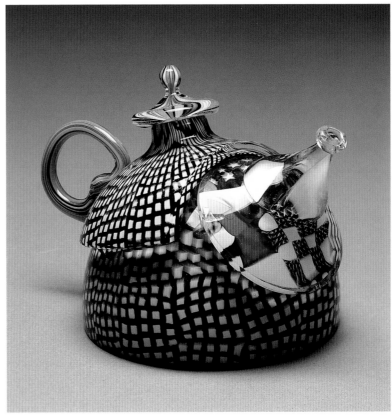

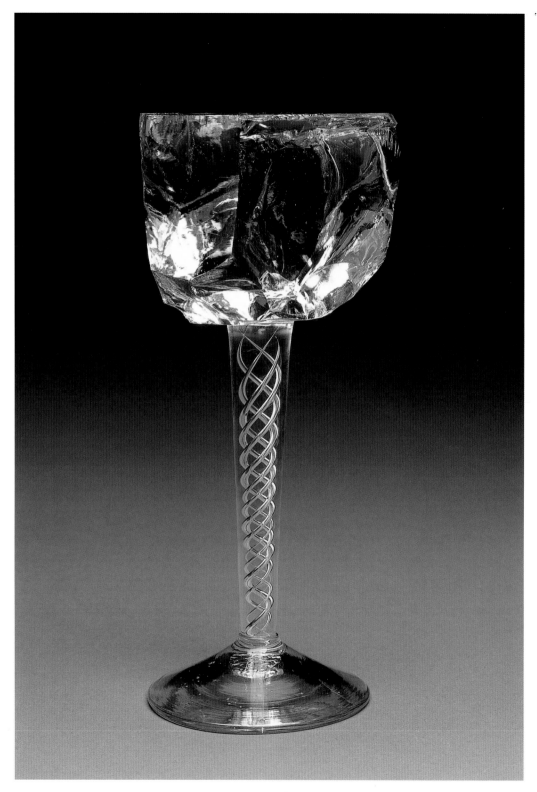

"THERE CAME A POINT WHEN I WASN'T SATISFIED WITH JUST BLOWING GLASS. THE LOGICAL STEP WAS TO ASSEMBLE DIFFERENT ELEMENTS AND 'CHEMICALLY BOND' THEM. IT WAS LIKE HAND BUILDING CLAY AND USING GLUE INSTEAD OF SLIP. FOUND OBJECTS FROM MY COLLECTIONS BEGAN TO APPEAR IN THE WORK."

44
Rock Crystal Airtwist Goblet, 1979
Blown, solid, and cold-fabricated glass
9 × 4 × 3¾ in.
Indiana University Art Museum, Bloomington

46
Teapot Form with Lord's Prayer,
1979
Solid and cold-fabricated
and solid-worked glass,
zanfirico and *murrine*
5 × 5 × 3¼ in.
Destroyed

45
Rock Cup (FWS #3), 1979
Blown, solid, and cold-fabricated glass
4 × 6½ × 3½ in.
Collection of the artist

48
Cup Form with X Handle (FWS #7)
Blown, slumped, faceted, and cold-fabricated
glass with *murrine*
4 × 5¼ × 4 in.
Collection of the artist

47
Potato Cup (FWS #4), 1980
Blown, solid, and cold-fabricated glass with *murrine*
5 × 4½ × 3¾ in.
Collection of Jack Wax

49
Signature Cane Cup (FWS #10), 1979
Blown, slumped, and cold-fabricated
glass with *murrine*
4 × 9¼ × 4½ in.
Collection of Dorothy and George Saxe

50
Potato Landscape Piece, 1979
Blown and cold-fabricated
glass, *filigrana* technique,
murrine, found object
The *murrina* "spout" reads
in cross section, "Chuck
the Duck says life is mostly
hard work."
7 × 4¾ × 4¾ in.
Corning Museum of Glass,
Corning, N.Y.

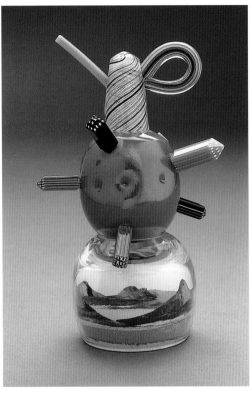

51
Cactus Landscape Goblet,
1981
Blown and cold-fabricated
glass, found objects
10 × 7½ × 4¾ in.
Private collection, courtesy
Elliott Brown Gallery,
Seattle

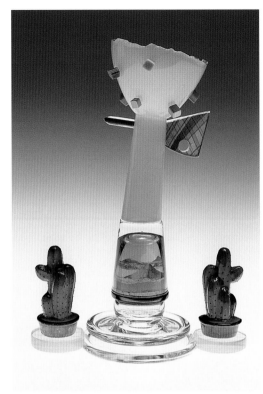

52
Jagged Lip Cup (FWS #42),
1981
Blown and cold-fabricated
glass with *murrine* and
filigrana
7 × 8½ × 4¼ in.
Collection of the artist

53
Gun Cup, First Reincarnation,
1979
Blown, fused, slumped,
engraved, and cold-
fabricated glass, found
object
3¾ × 7 × 5 in.
Whereabouts unknown

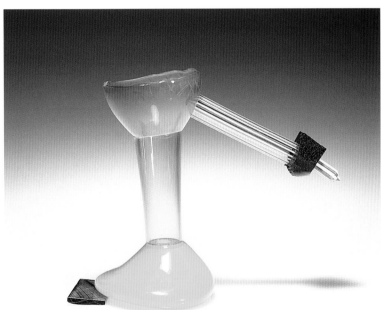

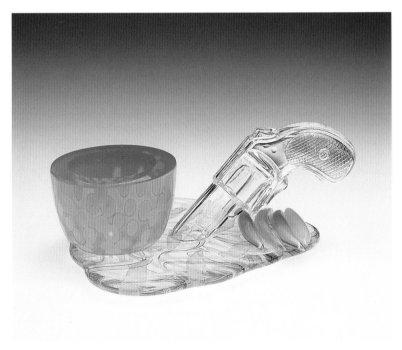

68

「ボタンインコには、いつも何か私の興味をそそるものがあります。私がボタンインコを最初にペットとして飼ったのは1976年、タスマニアに住んでいたときのことです。彼女の名前はドナで、私とラファエラ・デルボーゴと一緒に、バークレーに戻ってきました。彼女は、おびただしい数の冒険を経験し、私の喜びと驚嘆の源でもありました。彼女は最近ニューヨークでその生涯を閉じました。今は、自分のことを犬だと思っているマンディという名のボタンインコを飼っています。彼女もまた、私の喜びと驚嘆の源でもありますが、それに加えてイライラの種でもあります。アートワークですよ、彼女は」。

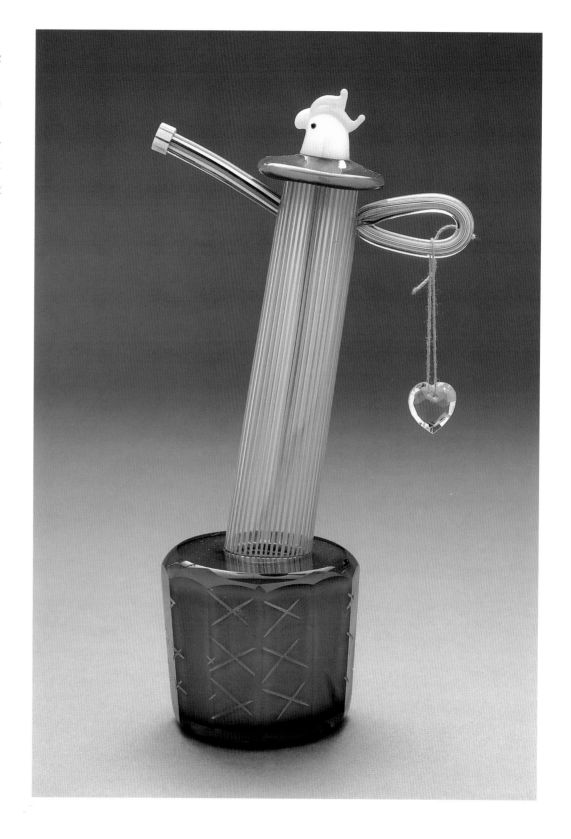

54
ボタンインコのハート付きティーポット
（FWS #22）1979 年
吹き硝子を冷却後、組み立てた硝子細工、
カーネー技巧
鋳造物
24.13 X 11.43 X 7.62 センチメートル
個人蔵

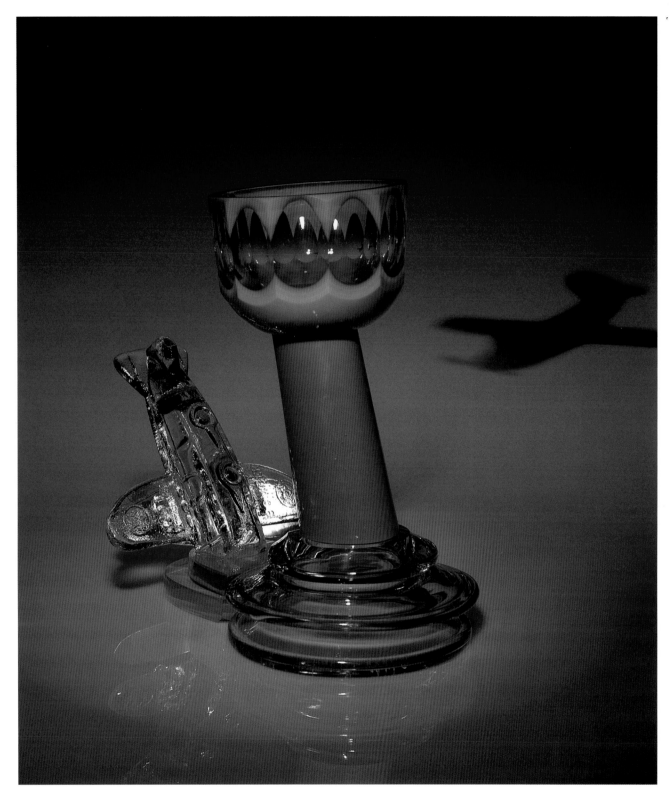

55
*Bohemian Airplane Goblet
(FWS #39)*, 1980
Blown and cold-fabricated
glass, found object
6¾ × 7½ × 4¼ in.
Collection of the artist

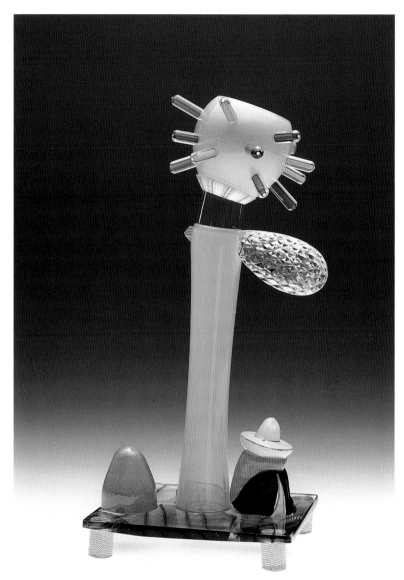

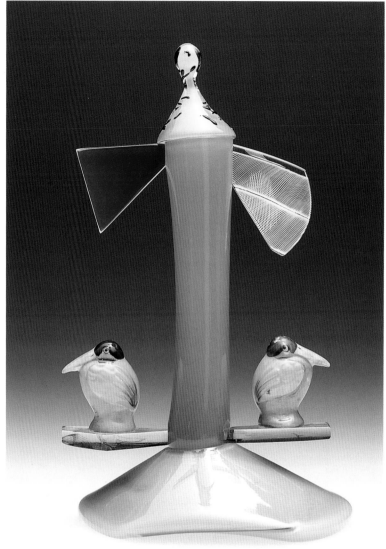

56
Siesta Goblet (FWS #34), 1980
Blown, slumped, fused, and cold-fabricated
glass, found objects
11 × 5¼ × 5 in.
Collection of Charlie and Polly Frizzell

57
Purple Bird Jar (FWS #35), 1980
Blown and cold-fabricated glass,
found objects
10½ × 6¾ × 5¼ in.
Collection of the artist

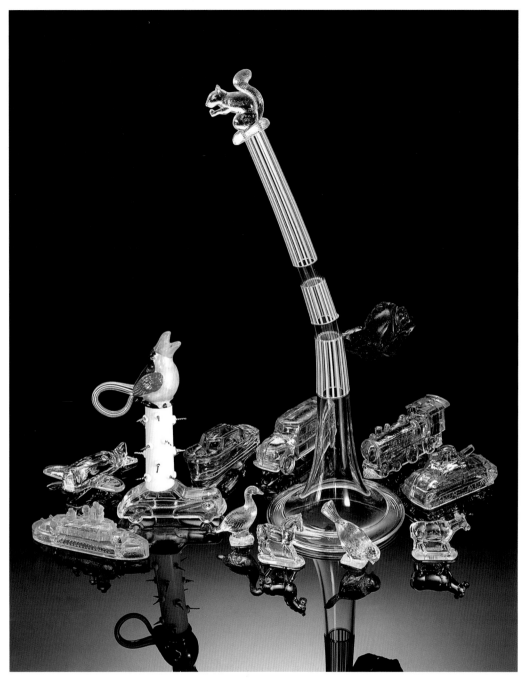

Opposite:
59 (top left)
Venetian Waldglas Fish Goblet (FWS #44), 1980
Blown, fused, and cold-fabricated glass, *murrine*
and *zanfirico* techniques, silicone
9¼ × 8 × 5¼ in.
Collection of Paul and Elmerina Parkman

60 (bottom left)
Saturn Duck Rocket and *Egyptian Sand-core*
Shriner Duck (FWS #57), 1981
Core-formed, blown, and cold-fabricated glass,
found object (left); blown and cold-fabricated glass,
murrine, found object (right)
15½ × 4½ × 4½ in., 12 × 6 × 4½ in.
Collection of the artist; private collection,
courtesy Franklin Parrasch Gallery, New York

61 (right)
Difficult Color Combination Jar, 1981
Blown and cold-fabricated glass, *reticello*
technique, *murrine*
15 × 6½ × 3¾ in.
Photographed with Rempel rubber squeeze toys
Collection of Ben W. Heineman Sr.

58
Car Bird Pitcher and *Squirrel Horn*, 1981
Lampworked, blown, and cold-fabricated glass, found objects (left)
Blown and cold-fabricated glass, *a canne* technique, found objects (right)
8 × 5 × 2¼ in., 18¼ × 8 × 6 in.
Photographed with glass candy containers and figures
Collection of Ben W. Heineman Sr.

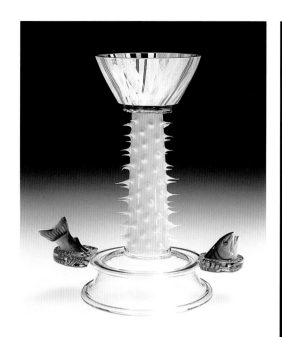

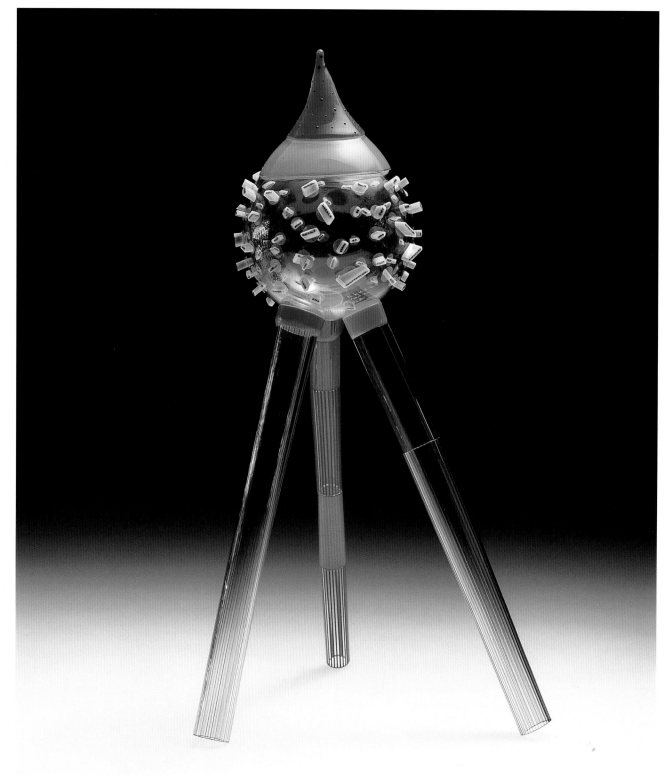

"IN THE MIDDLE OF
THE PROCESS OF
MAKING THE LORD'S
PRAYER MURRINA,
I HAD ALL THE
WORDS. SO I TOOK
THE GROUND AND
POLISHED WORD
MURRINE AND
ATTACHED THEM
TO THE TRIPOD'S
SPHERE. I CHANGED
THE WORD
'HALLOWED' TO
'HAROLD.'"

62
*The Lord's Prayer Tripod:
Harold Be Thy Name*, 1980
Blown and cold-fabricated
glass, *a canne* technique,
murrine
16 × 9 × 9 in.
Private collection

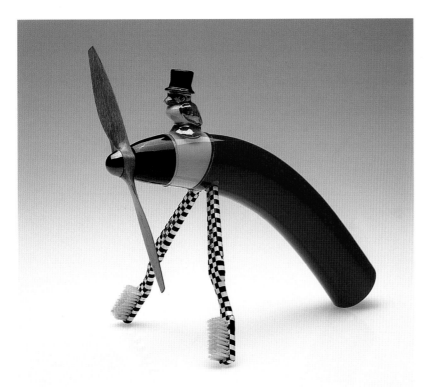

63
Toothbrush Propeller Lustre Bird, 1981
Blown and cold-fabricated glass, found objects
9½ × 10 × 8 in.
Collection of Johanna Nitzke Marquis

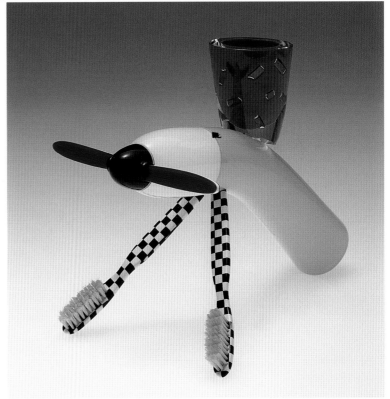

64
Toothbrush Propeller Cup, 1981
Blown and cold-fabricated glass, found objects
7½ × 10 × 5½ in.
Private collection, courtesy Elliott Brown Gallery, Seattle

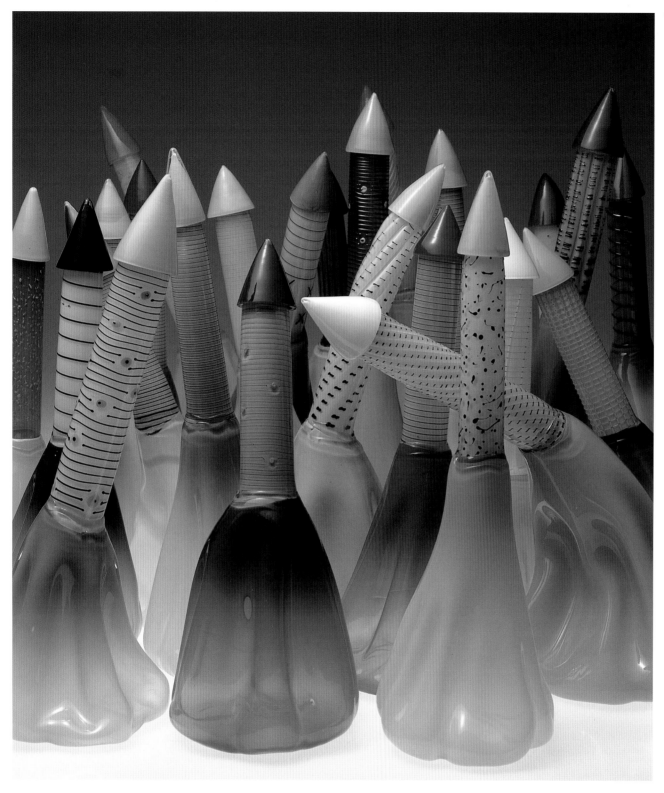

"THE ROCKET JARS WERE DERIVED FROM PICTURES FROM THE U.S. SPACE PROGRAM. WONDERFUL PICTURES OF ROCKETS RISING FROM THE LAUNCHING PLATFORM IN BILLOWS OF EXHAUST. I THOUGHT OF THEM ONLY AS ROCKETS AND CONCERNED MYSELF WITH THE SHAPES, COLORS, AND PATTERNS. WHEN THE CERAMIST NANCY SELVIN SAW THEM, SHE EXCLAIMED HOW PHALLIC THEY WERE. THAT RUINED THEM FOR ME."

65
Rocket Jars, 1981
Blown glass
Greatest h. 30 in.
Public and private
collections

76

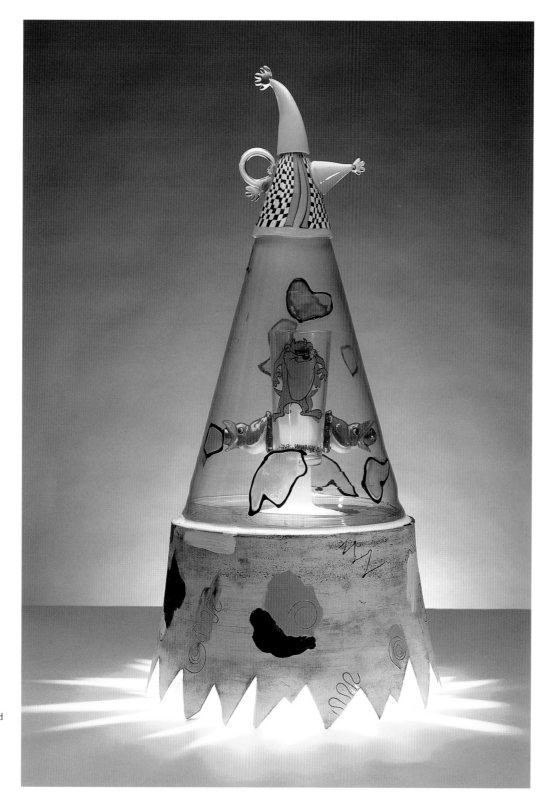

66
Tasmanian Devil Floor Lamp,
1982
Blown and cold-fabricated
glass, *murrine* technique,
ceramic, electric light,
paint, found objects
27 × 13½ × 13½ in.
Collection of the artist

"THE CONCEPT OF THE **BOTTLES AND
PLATES** IS SORT OF COMPLEX. I'D BEEN
TELLING MY GRADUATE STUDENTS AT
UCLA THAT 'JUST BECAUSE YOU ARE
GOOD AT SOMETHING DOESN'T MEAN
IT'S A GOOD IDEA FOR YOU TO MAKE
THAT THING.' I'D ALSO BEEN CONSIDER-
ING RAUSCHENBERG'S ERASING OF A
DE KOONING DRAWING. I LIKED THE
CONCEPT OF 'NEGATION' SO I MADE
THESE COMPLEX PATTERNED BOTTLES
AND PLATES AND 'UNDID' THEM. HARDLY
ANYONE GOT IT."

67
Bottles and Plates, 1983
Bottles: blown glass,
zanfirico technique, acrylic
paint
Plates: wheel-thrown
ceramic with various
glazes, underglazes,
overglazes, and lustres,
acrylic paint
Greatest h. 10½ in.
Collection of the artist

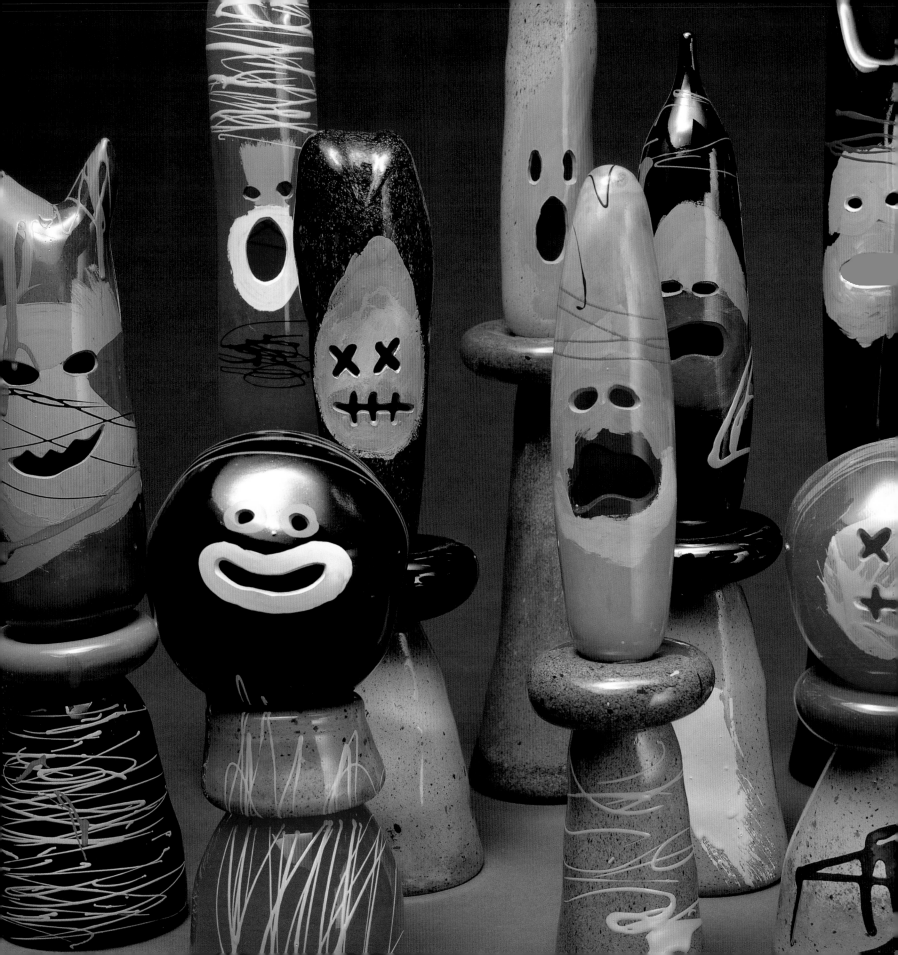

Opposite:
68
Small Heads, 1985
Blown glass, paint
Greatest h. 11 in.
Private collections

"OH MAN, THESE
PIECES ARE HARD
TO EXPLAIN. MY
CAREER WAS GOING
PRETTY WELL; I WAS
BEGINNING TO BE
TAKEN SERIOUSLY.
I THEN SUCCESS-
FULLY TORPEDOED
MY CAREER BY
MAKING THESE
STUPID HEADS.
EXHIBITIONS WERE
CANCELED; THERE
WAS GENERAL
CONCERN. BUT I
THOUGHT IT WAS
GOOD: NO SENSE
IN BEING PIGEON-
HOLED."

69
Orange Smiley Face Neon Head, 1984
Blown glass, neon, transformer, found objects, paint
Approx. 23 × 18 × 16 in.
Collection of Susie Shapiro Magdanz

70 (inset)
Yellow Screamer Neon Head, 1984
Blown glass, neon, transformer, found objects, paint
24 × 14 × 13 in.
Collection of the artist

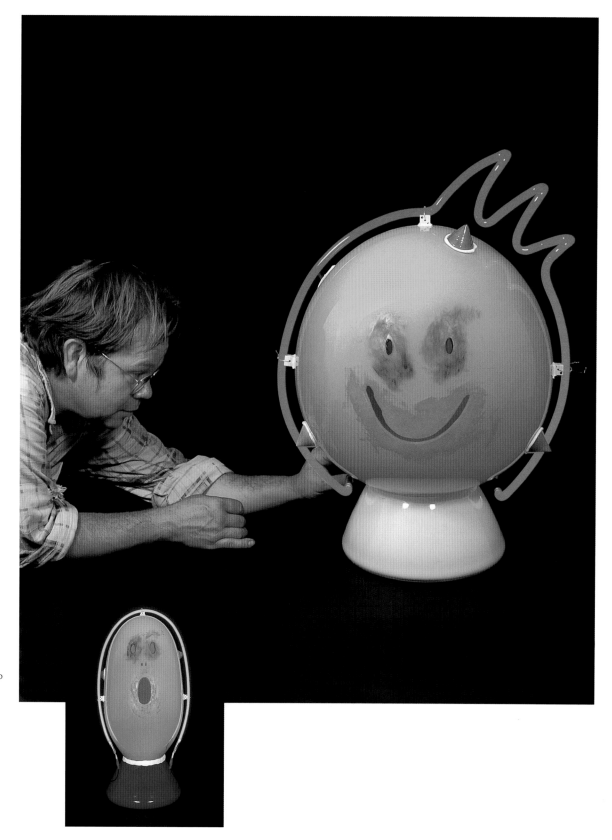

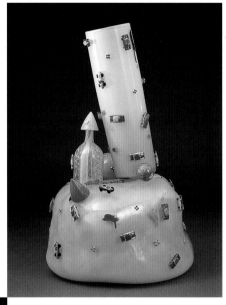

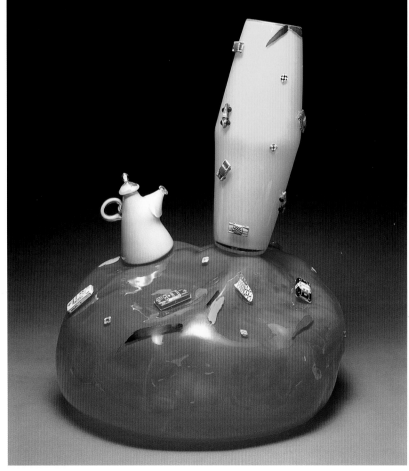

Above:
71
Grey Rock, Sky Blue Vase, Zanfirico Bottle, 1985
Blown glass, *zanfirico* technique, *murrine,* found
objects, paint
24½ × 15 × 15 in.
Private collection

Left:
72
Red Rock, Yellow Vase, Grey Teapot, 1986
Blown glass, *murrine,* found objects, paint
25 × 20 × 20 in.
Collection of Sonja Blomdahl and Dick Weiss

Opposite:
73
Green Rock, White Vase, Red Teapot, 1986
Blown glass, *murrine,* found objects, paint
24 × 21 × 19 in.
Collection of the artist

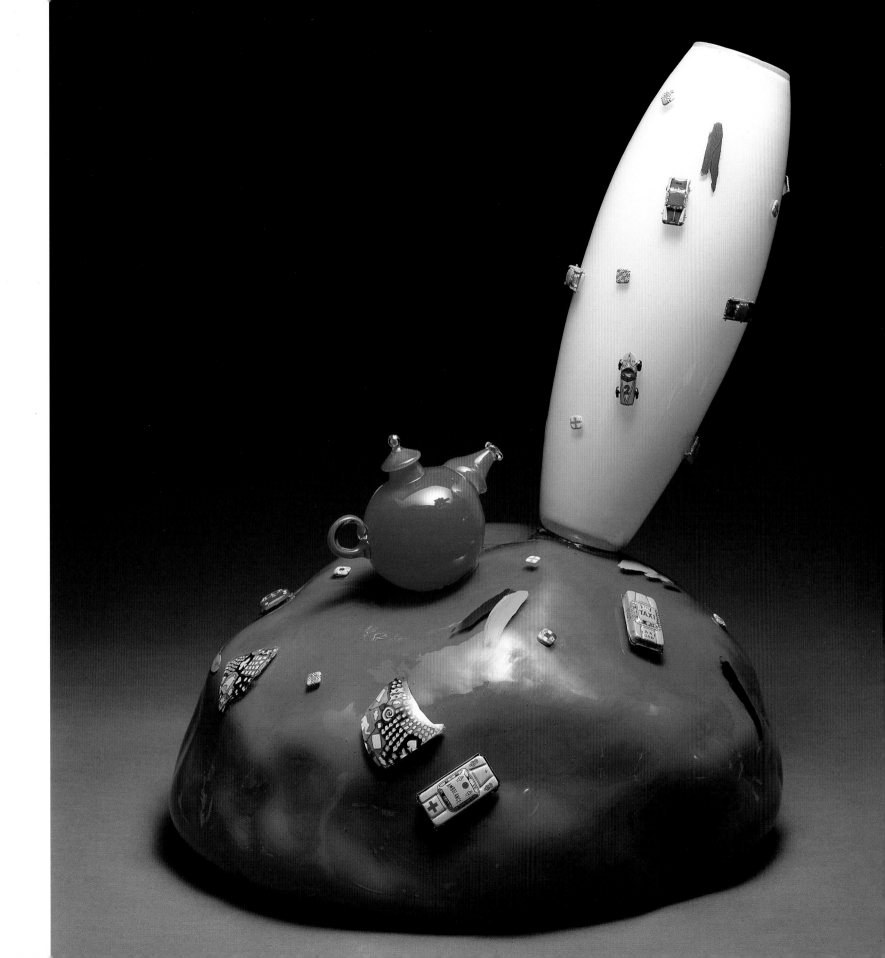

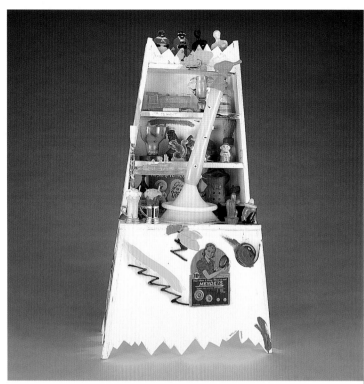

74
Personal Archive Unit: Battleship Bird Horn,
1984
Mixed media
32 × 16 × 8 in.
Collection of Johanna Nitzke Marquis

Opposite:
76
Personal Archive Unit: Bottle with Funnel,
1984
Mixed media
33½ × 20 × 9 in.
Collection of Sonny and Gloria Kamm

75
Personal Archive Unit: Glass Eye
Tripod, 1984
Mixed media
29½ × 20 × 8 in.
Collection of the artist

"I MADE THESE THINGS IN ORDER TO PRESENT MY PIECES IN THE CONTEXT I NORMALLY SAW THEM: ON SHELVES IN MY HOUSE AND STUDIO MIXED UP WITH ALL THE JUNK I COLLECTED. AS OPPOSED TO ON A WHITE PEDESTAL WITH HEROIC LIGHTING IN A MUSEUM OR GALLERY. AT FIRST I WAS INTIMIDATED BY H. C. WESTERMANN'S WORK AND KEN PRICE'S HAPPY'S CURIOS CABINETS, WITH THEIR SUPERB CRAFTSMANSHIP. I THEN FIGURED THAT IF I LIMITED MYSELF TO PLYWOOD, A SKILLSAW, AND A SABER SAW I WOULDN'T ENTER THAT REALM OF PROPER WOODWORKING. INITIALLY, I MADE THESE PIECES JUST FOR MYSELF—NOT TO SELL, BECAUSE I WAS USING A BUNCH OF STUFF THAT WAS PERSONALLY IMPORTANT TO ME. BUT WHEN THE CABINETS WERE DONE IT WAS WEIRD: I WAS NO LONGER PERSONALLY ATTACHED AND LET THEM GO. NOW I WANT THEM ALL BACK."

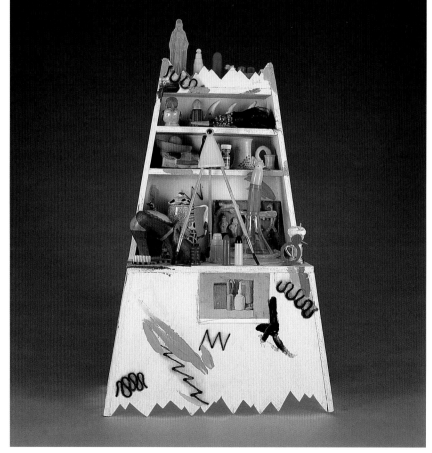

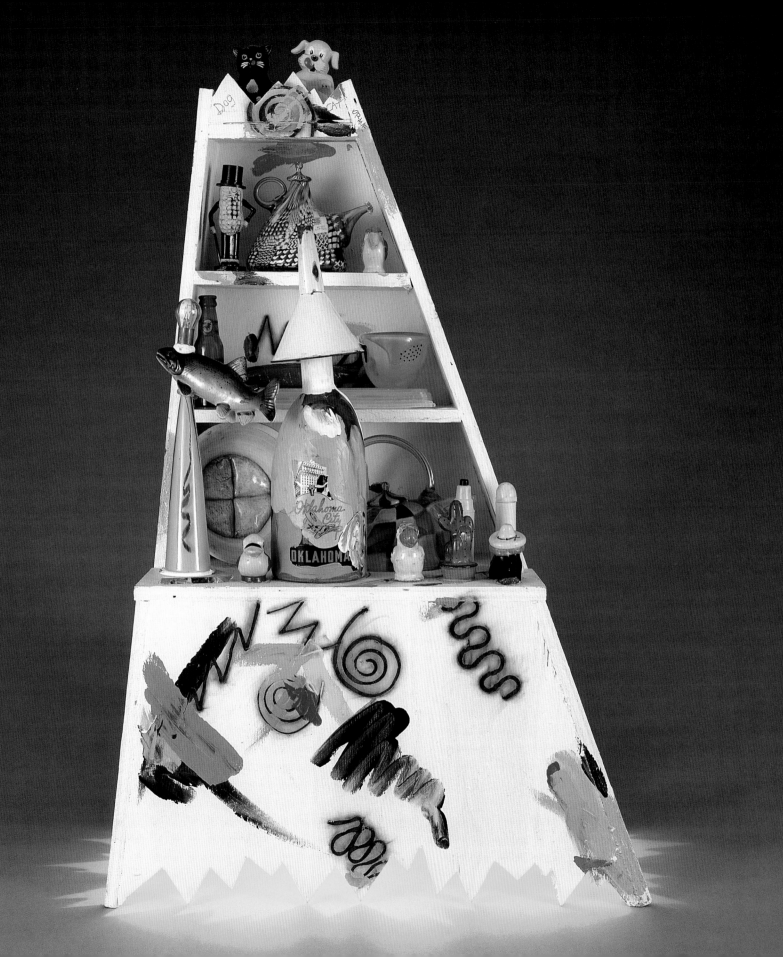

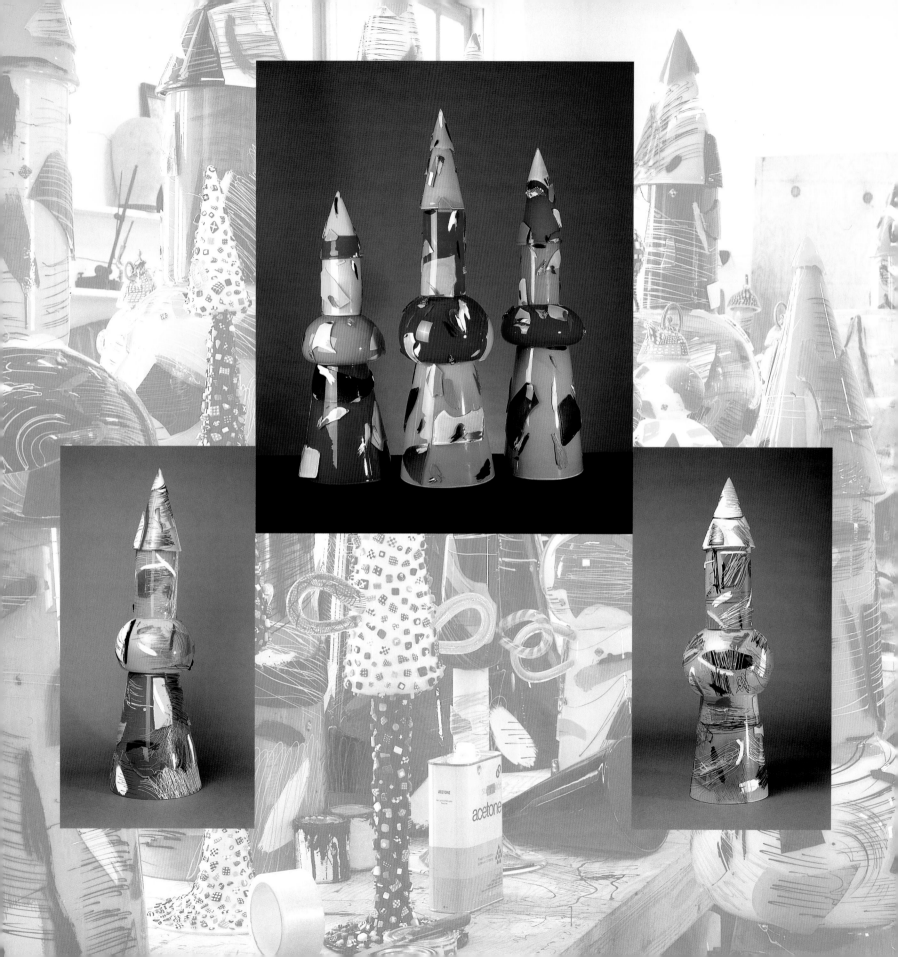

Opposite:
77 (left)
Shard Rocket #6, 1988
Blown glass, paint
49 × 13½ × 13½ in.
Dowse Art Museum,
New Zealand

78 (center)
Shard Rockets, 1985
Blown glass, paint
Greatest h. 55 in.
Private collection

79 (right)
Shard Rocket #8, 1988
Blown glass, paint
46 × 12 × 12 in.
Private collection

80
Shard Pot, 1987
Blown glass, paint
28½ × 16 × 16 in.
Collection of the artist

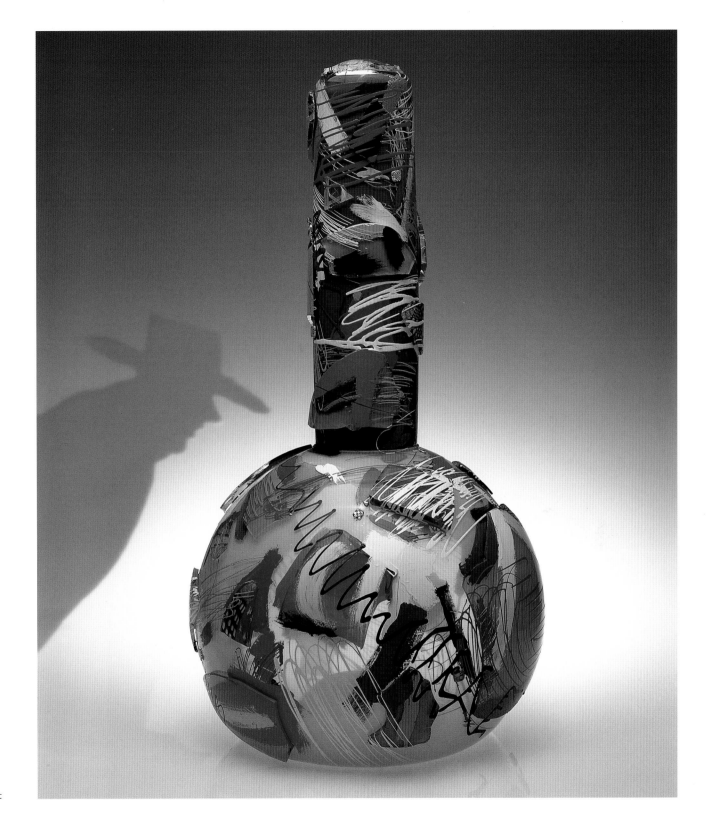

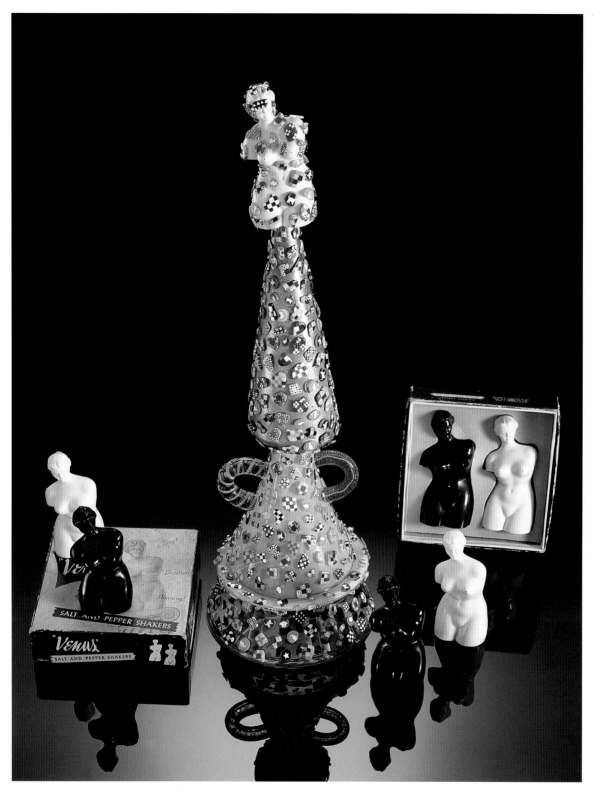

"THE VENUS DE MILO SALT
SHAKERS (GAY! AMUSING!) ARE
FROM THE 1950S. JUST THINK:
SOMEBODY ACTUALLY HAD TO
GET THE PROJECT OKAYED, DO
WORKING DRAWINGS, FIGURE
OUT THE SIZE OF THE HOLES IN
THE NIPPLES, AND FIGURE OUT
DISTRIBUTION, AND SO ON. IT
AMAZES ME."

81
Venus d'Marquis, 1986
Blown glass, *murrine, zanfirico* handles,
found object
17½ × 6 × 6 in.
Collection of Johanna Nitzke Marquis

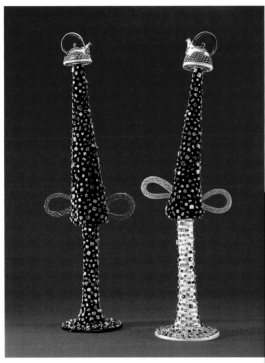

82
D'Marquis Teapot Trophies, 1987–88
Blown glass, *murrine* technique,
zanfirico handles
34½ × 11 × 7¼ in., 34 × 10¼ × 7¾ in.
Collection of Arthur Liu; collection of
Stuart Sloan

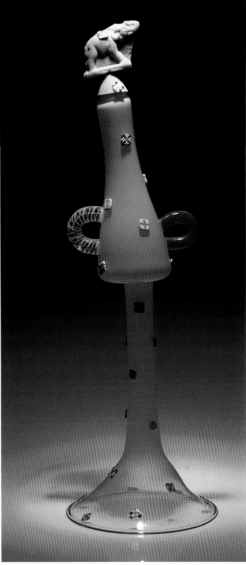

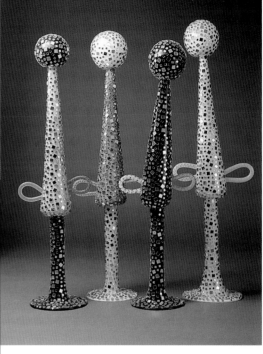

83
Disco Ball Trophies, 1990
Blown glass, *murrine*, *zanfirico* handles,
mirrors
Greatest h. 36 in.
(l. to r.) Collection of Mrs. Eugene Glick;
collection of the artist; collection of the artist;
collection of Francine and Benson Pilloff

"I ALWAYS LOVED THOSE DISCO BALLS—
I MEAN, REALLY, YOU CAN'T BEAT THEM.
THE LITTLE MIRRORS WERE MADE IN
CZECHOSLOVAKIA IN THE 1930S OR
1940S."

84
Elephant Trophy, 1986
Cast and blown glass, *murrine*,
zanfirico handles
19 × 6 × 6 in.
Collection of the artist

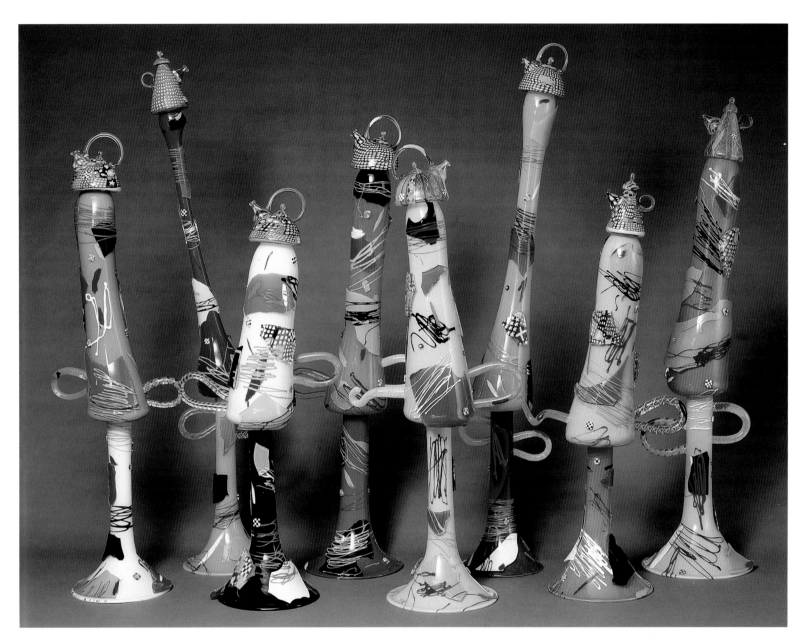

85
Teapot Trophies, 1989–92
Blown glass, *murrine* technique, *zanfirico*
handles, paint
Greatest h. 35 in.
Private collections

86
D'Marquis Bubble Boy, 1990–96
Blown glass, *murrine* technique,
zanfirico handles
29¼ × 13 × 7½ in.
Collection of Andy and
Charles Bronfman

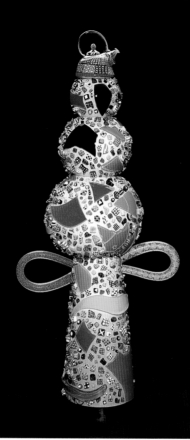

87
Bubble Boy, 1988
Blown glass, *murrine* technique,
a canne handes, paint
27 × 12½ × 7 in.
Collection of Mrs. Eugene Glick

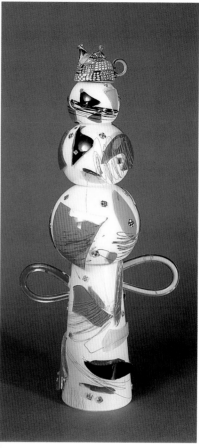

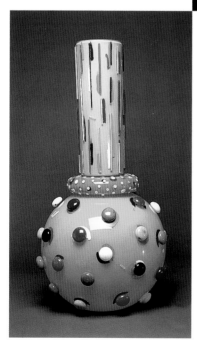

88
Uncle Frank, 1994
Blown and solid-worked glass,
found objects, paint
45½ × 24½ × 24½ in.
Private collection

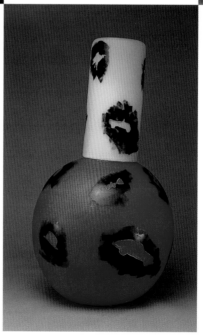

89
Uncle Babe, 1994
Blown glass, paint
42½ × 21½ × 21½ in.
Collection of the artist

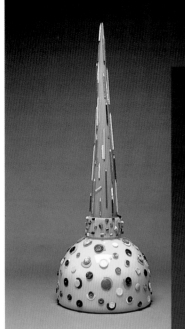

90
Oil Can #2, 1993-94
Blown glass, found objects,
paint
52 × 19 × 19 in.
Courtesy of Elliott Brown Gallery,
Seattle

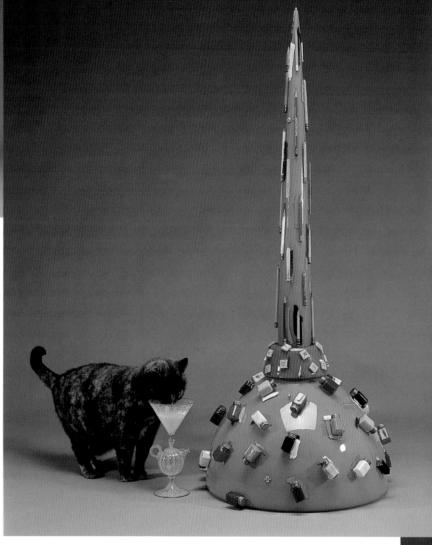

92
Oil Can #8, 1993-94
Blown glass, found objects,
paint
53 × 19 × 19 in.
Collection of the artist

91
Oil Can #1, 1993-94
Blown glass, found objects, paint
51¼ × 21½ × 19 in.
Photographed with Gateaux, the French Kitty
Courtesy Elliott Brown Gallery, Seattle

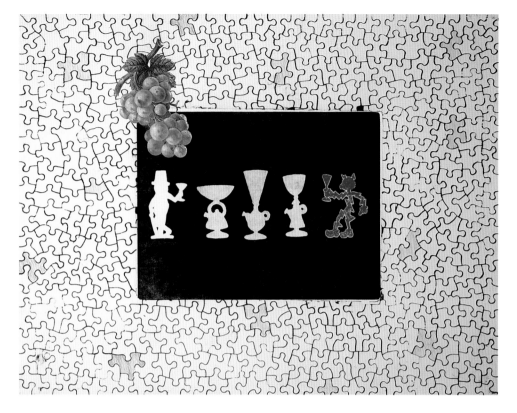

93
Jigsaw Puzzle, Mr. Peanut,
Reddy Kilowatt, 1993
Monotype with Victorian
stencil, colored pencil
22½ × 30 in.
Private collection

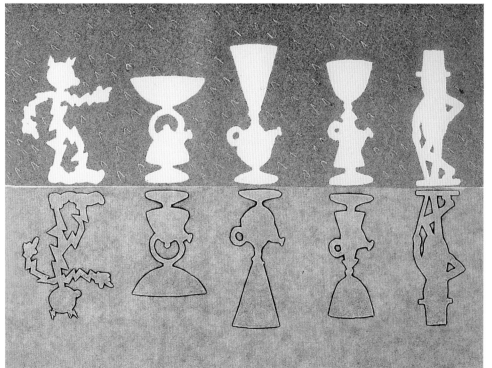

94
Untitled (detail), 1993
Monotype
22½ × 30 in.
Collection of the artist

Following pages:
95
Teapot Goblets, 1989–94
Blown glass, *zanfirico*
technique
Greatest h. 11 in.
Collection of Johanna
Nitzke Marquis

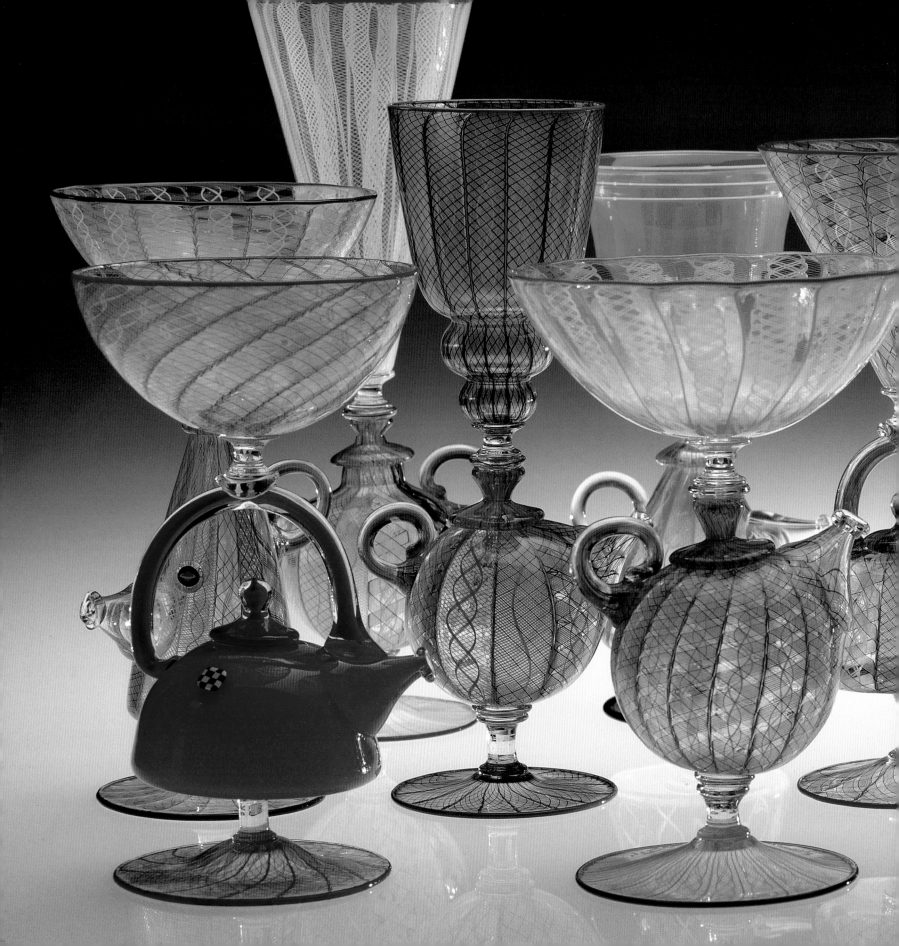

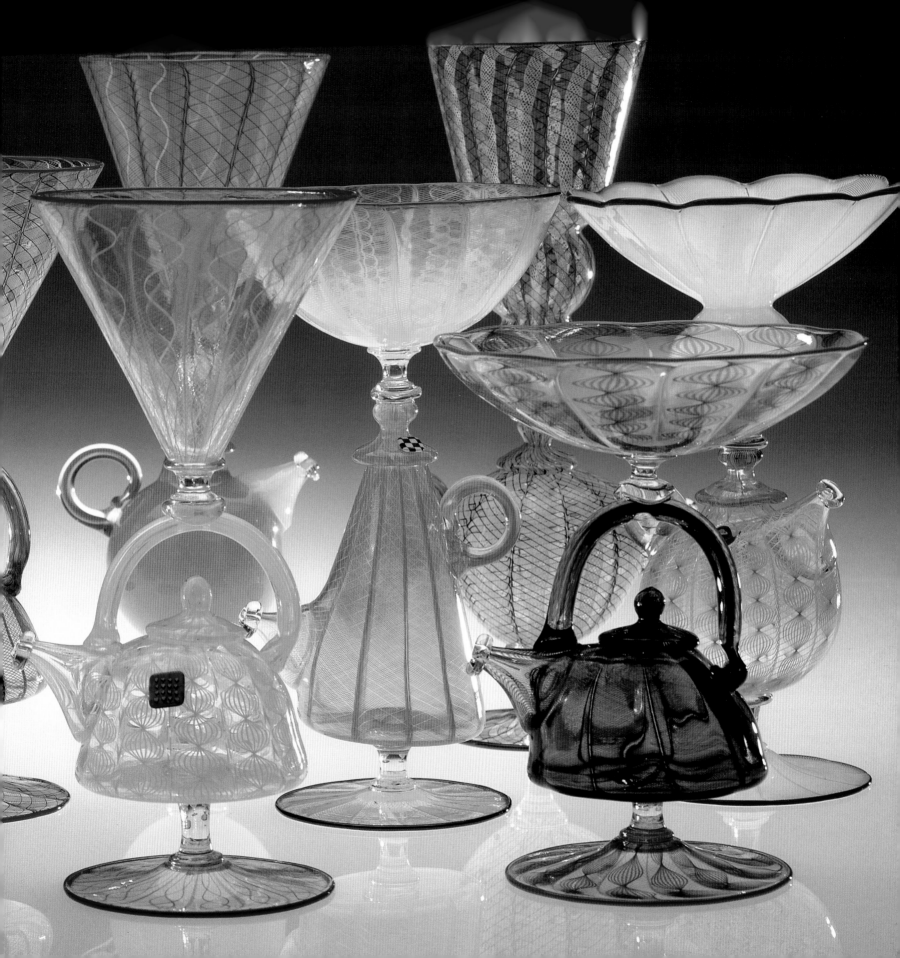

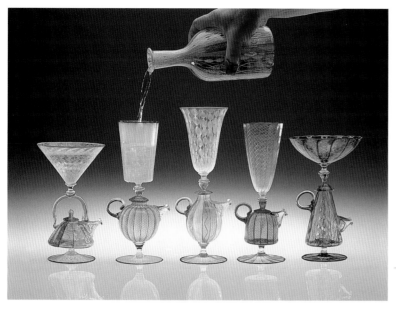

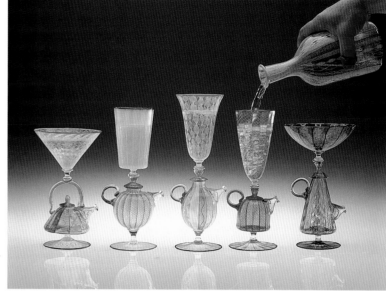

"EVERY ONCE IN AWHILE DANTE MARIONI
COMES UP TO MY PLACE AND WE MAKE
TEAPOT GOBLETS. I'VE PREVIOUSLY MADE
ALL THE **ZANFIRICO CANNE** AND TEAPOTS,
AND DANTE BLOWS THE **BEVANTE** AND **PIEDE**
AND STICKS ALL THE PARTS TOGETHER. WE
DRINK BEER AND EAT PASTA AND TALK
ABOUT THE MARINERS, MURANO, AND
MOTORCYCLES AND SOLVE PROBLEMS OF
THE UNIVERSE."

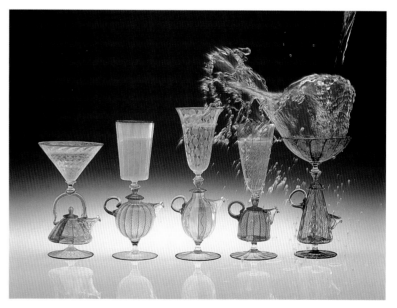

97a–c
Teapot Goblets, 1989–94
Blown glass, *zanfirico* technique
Greatest h. 11 in.
Private collections

Opposite:
96
Working Drawing (detail), 1990
Pencil and watercolor on paper
11 × 14 in.
Private collection

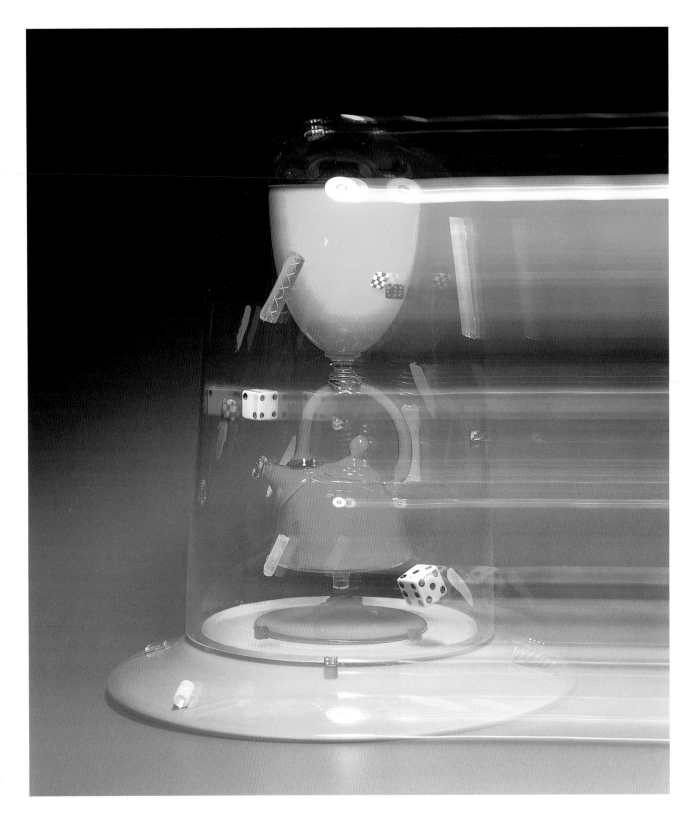

98
Bell Jar #14, 1990
Blown glass, found
objects, paint
11¾ × 10 × 10 in.
Collection of Sonny and
Gloria Kamm

99
Kylikes, 1990
Blown glass, *zanfirico*
technique, *a canne* handles
Greatest h. 8 in.
Private collections

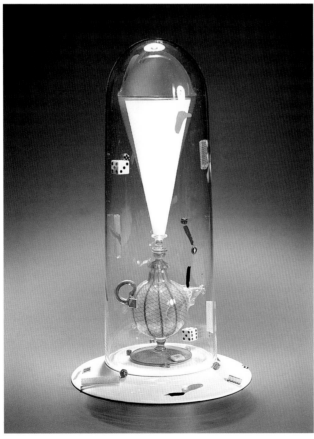

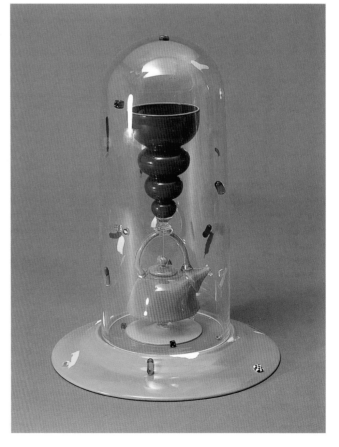

100
Bell Jar #15, 1991
Blown glass, *zanfirico*
technique, found objects,
paint
17 × 9¾ × 9¾ in.
Collection of Johanna
Nitzke Marquis

101
Bell Jar #30, 1991
Blown glass, found
objects, paint
13½ × 9¾ × 9¾ in.
Collection of Denny
Abrams

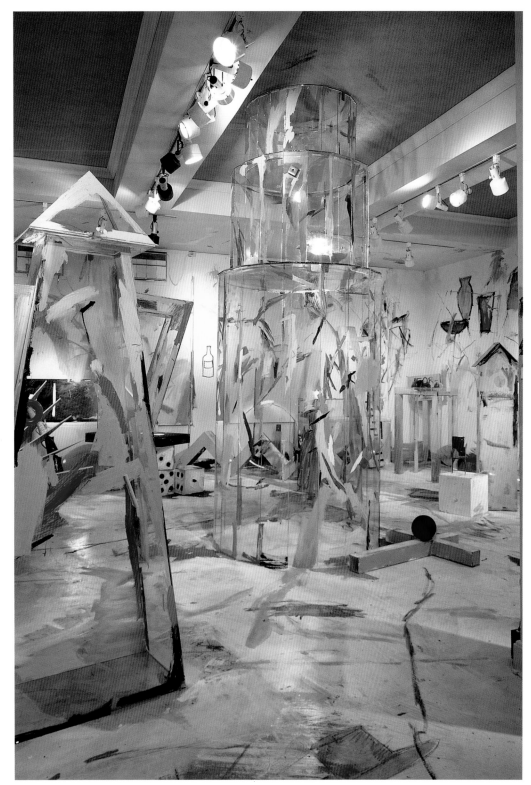

"I STARTED WORKING WITH THERMAN STATOM IN 1981 WHEN WE WERE IN THE FOUR LEADERS IN GLASS SHOW IN LOS ANGELES. FOR THE NEXT SEVEN YEARS WE DID ABOUT A DOZEN MAJOR INSTALLATIONS AROUND THE COUNTRY. WE CALLED IT 'HARD FUN.'"

102
Richard Marquis and Therman Statom
Untitled, 1986
Installation at San Jose Museum of Art
Glass and mixed media

103
Richard Marquis and Therman Statom
Untitled, 1983
Installation at Traver Sutton Gallery, Seattle
Glass and mixed media

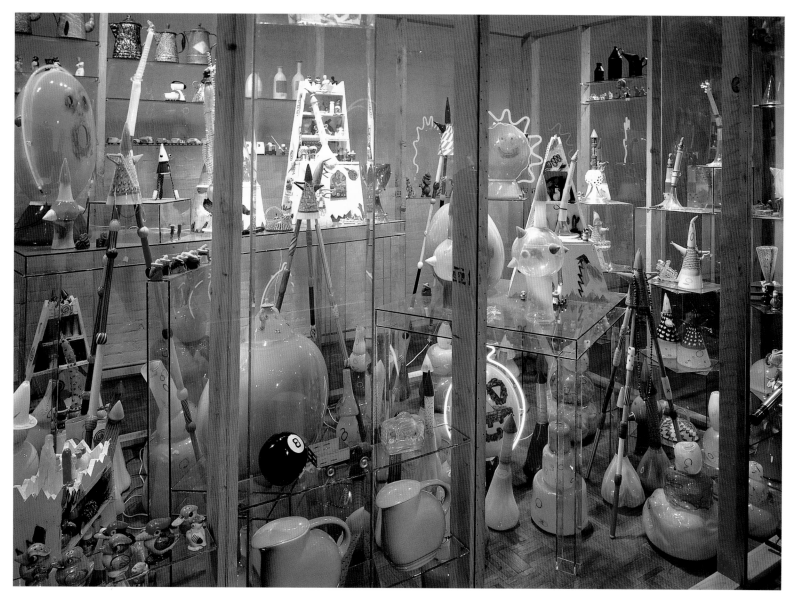

"INVENTORY WAS THE SAME CONCEPT AS
THE PERSONAL ARCHIVE UNITS ON A
LARGER SCALE. A BUNCH OF WORK WITH
A BUNCH OF OTHER STUFF."

104
Inventory, 1985
Installation at Foster/White Gallery, Seattle
Glass and mixed media
8 × 12 × 8 ft.

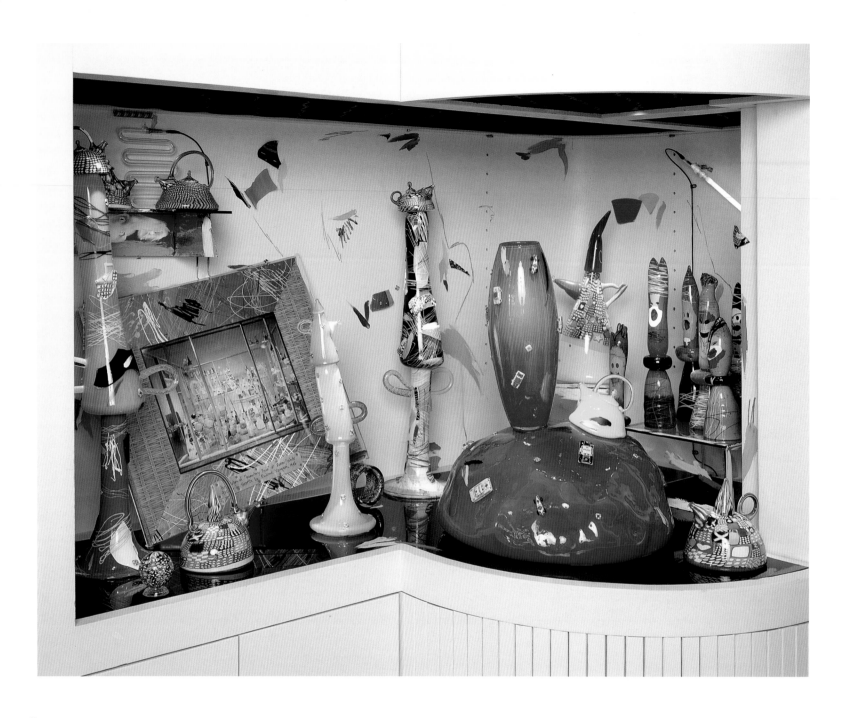

"JERRY AND JUDY ROSE APPROACHED ME AND ASKED ME TO DO
AN INSTALLATION IN THEIR HOME WITH MY WORK, WHICH THEY'D
PREVIOUSLY COLLECTED. THEY HAD LIKED THERMAN'S AND MY
INSTALLATION AT THE SAN JOSE MUSEUM OF ART. OF COURSE
THEY NEEDED MORE STUFF. I LOVED DOING THE PROJECT."

105
The Rose Installation, 1987
Glass and mixed media
Neon by Bill Concannon
36 × 72 × 24 in.
Collection of Judy and Jerry Rose

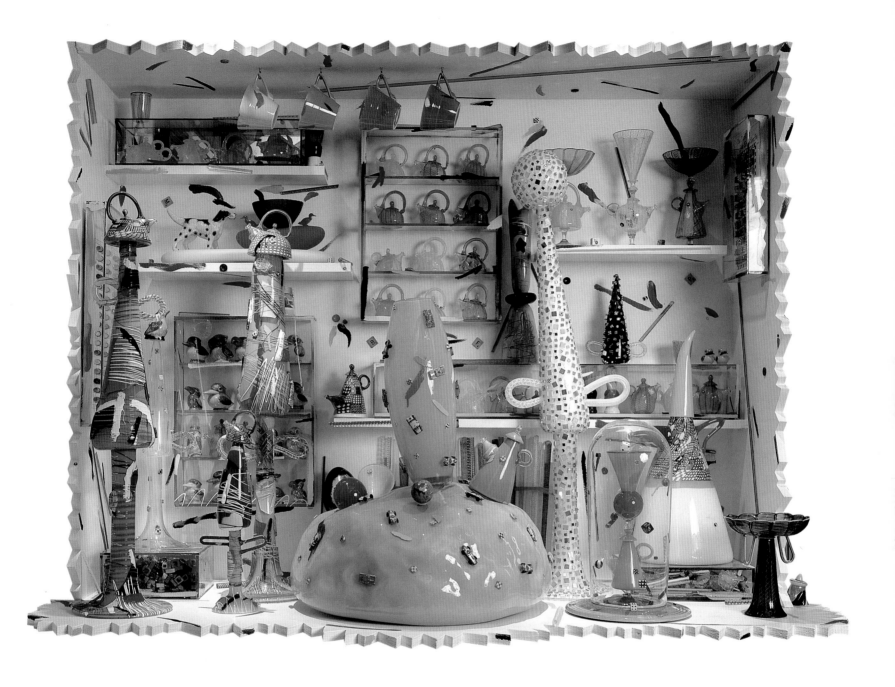

"FRANCINE AND BENSON PILLOFF ASKED ME TO SHOWCASE MY
WORK THAT THEY HAD COLLECTED. FRANCINE TALKED ABOUT
'THE THEATER OF ALL THESE THINGS RELATING TO ONE AN-
OTHER.' THE PIECE DOCUMENTS MOST OF THE SERIES OF WORK
I DID FOR TEN YEARS."

106
*Pilloff Installation: Marquis Decade
Archive Unit (1985–95)*, 1995
Glass and mixed media
44½ × 57½ × 27½ in.
Collection of Francine and Benson Pilloff

"IN THE NINETEENTH CENTURY ARCHAEOLO-
GISTS WERE DIGGING UP DINOSAUR BONES
AND OFTEN PUTTING THEM TOGETHER WRONG,
ENDING UP WITH SOME INTERESTING CRE-
ATIONS. WHEN GEORGE AND DOROTHY SAXE
ASKED ME TO MAKE SOMETHING OUT OF OTHER
ARTISTS' BROKEN PIECES RESULTING FROM
THE 1989 BAY AREA EARTHQUAKE, I AP-
PROACHED THE PROBLEM AS IF I WAS FROM
ANOTHER PLANET AND JUST FOUND ALL THIS
STUFF. A CURIO CABINET FROM MARS."

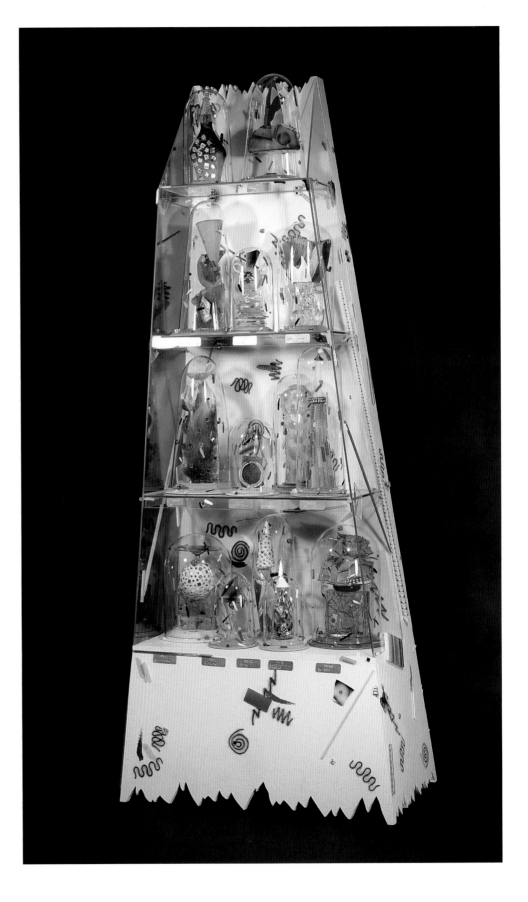

107
Seven Point One, 1991
Painted wood cabinet, 14 blown-glass bell jars,
each containing assembled shards from various glass
artists' pieces destroyed in the October 17, 1989,
San Francisco earthquake
85½ × 34 × 19¾ in.
Collection of Dorothy and George Saxe

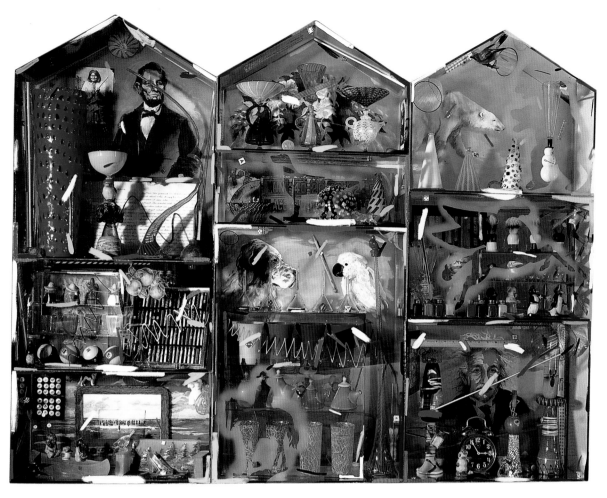

Above:
108
Jangaard Installation, 1996
Glass, mixed media, paint, found objects
Collaboration with Johanna Nitzke Marquis and Rene Marquette
50 × 66 × 7 in.
Collection of Robert and Sharon Jangaard

Left:
109
Time Frame #15, 1989
Blown glass, plate glass, wood, photograph, found objects
18 × 15 × 5 in.
Private collection

Right:
110
Time Frame: Goblets #5, 1989
Blown glass, plate glass, wood, photograph, found objects
19¼ × 22¼ × 5¼ in.
Collection of the artist

111
Zanfirico Sample Box #12 (Smith & Wesson),
1994
Zanfirico rods, plate glass, cord, colored
pencil on mat board, wood, paint
21½ × 11½ × 1¾ in.
Collection of the artist

Opposite:
112
Murrine Sample Box #13 (Chris-Craft),
1995
Murrine, plate glass, colored pencil
on mat board, wood, paint
7¼ × 5 × 1½ in.
Collection of the artist

113
*Murrine Sample Box #5 (The Secret of
Being a Convincing Talker)*, 1994
Murrine, plate glass, colored pencil
on mat board, wood, paint
12½ × 7½ × 1½ in.
Collection of Kate Elliott

114
Murrine Sample Box #4 (Elgin), 1992
Murrine, plate glass, colored pencil
on mat board, wood, paint
12½ × 7½ × 1½ in.
Collection of the artist

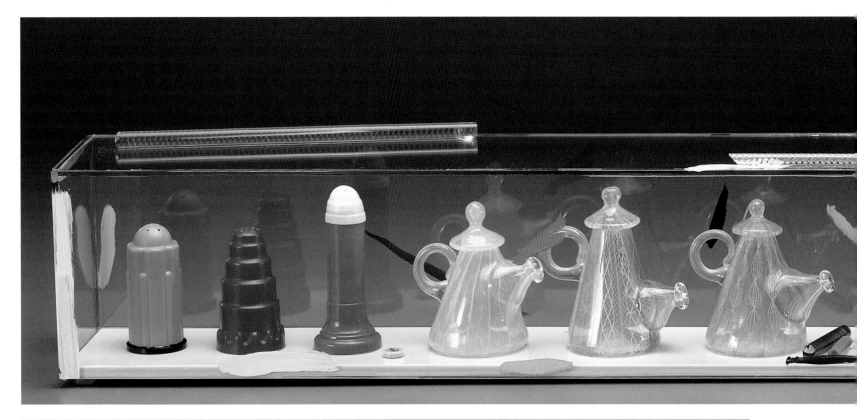

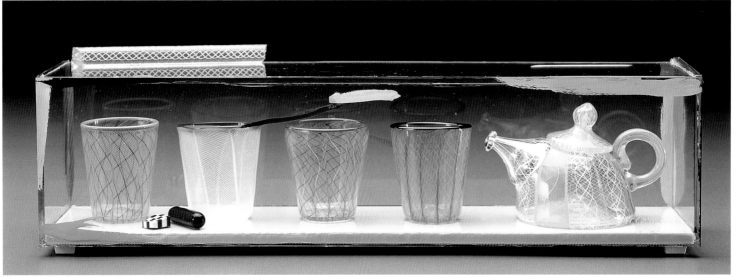

115
Shot Glass Long Box #4, 1993
Blown glass, *zanfirico* technique, *murrine*, sheet glass,
mirror, Vitrolite, found objects, paint
4 × 13¾ × 3¼ in.
Private collection

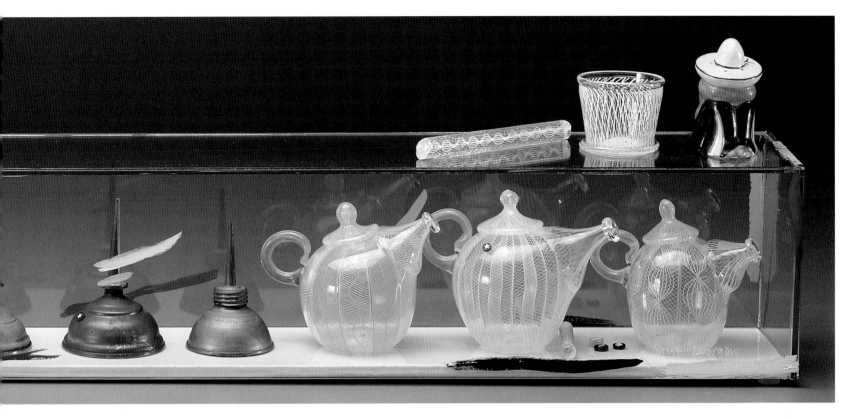

116
Teapot Long Box #11, 1993
Blown glass, *zanfirico* technique,
murrine, sheet glass, mirror, Vitrolite,
found objects, paint
6¼ × 35 × 3½ in.
Collection of the artist

"WITH LITTLE THINGS YOU NEED QUITE A
FEW TO HAVE A COLLECTION. BUT WITH BIG
STUFF, LIKE CARS, BOATS, AND LOCOMO-
TIVES, YOU ONLY NEED THREE TO CALL IT
A COLLECTION. THEREFORE I SEE THREE
OF SOMETHING AS A BASIS FOR STUDY AND
A KIND OF AGGRANDIZEMENT. THE WHOLE
APPEARS TO BE MORE THAN THE SUM OF
ITS PARTS."

117
Object Comparison Box #1-94, 1993–94
Blown glass, *zanfirico* technique, sheet
glass, Vitrolite, found objects, paint
22 × 11¾ × 3½ in.
Collection of the artist

118
Coffeepot Sample Box, 1993–94
Blown glass, *zanfirico* technique, sheet
glass, wood, found objects, paint
19 × 12 × 4 in.
Collection of Kate Elliott

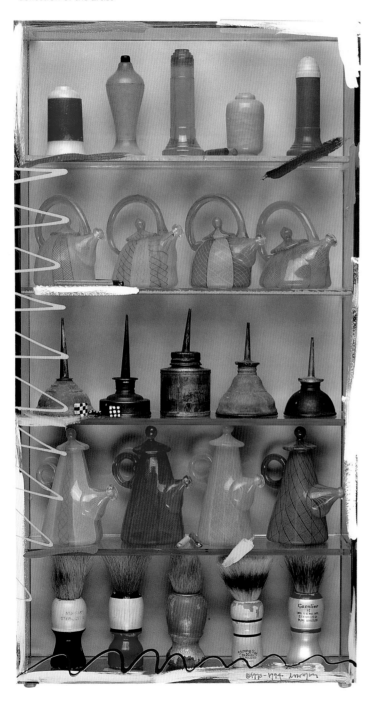

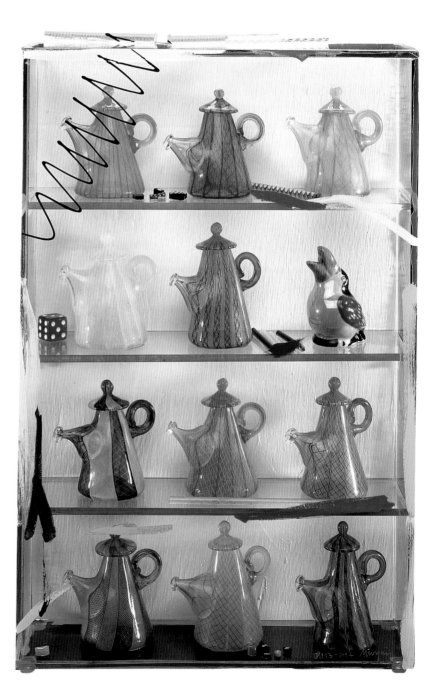

119
Shot Glass Sample Box #1, 1992
Blown glass, *zanfirico* technique, sheet
glass, wood, wire, found objects
14 × 11 × 3 in.
Collection of Johanna Nitzke Marquis

120
Shaving Brush Box, 1993–94
Blown glass, *zanfirico* technique, sheet glass,
Vitrolite, found objects, paint
19¾ × 11¾ × 3½ in.
Collection of the artist

Opposite:

122
Rempel Wall, 1994
Installation at Elliott Brown Gallery, Seattle
Artist's work with Rempel rubber squeeze toys
96 × 48 × 7½ in.

123
Siesta Wall, 1994
Installation at Elliott Brown Gallery, Seattle
Two of artist's glass pieces, *Teapot Long Box #10* (1993)
and *Siesta Goblet (FWS #25)* (1980), wood, found objects,
paint. Paint-by-numbers painting by William Hinck, the
artist's grandfather, 1955
96 × 48 × 7½ in.

121
Shotglass Sample Box #3 (Pettijohn's), 1992, and
Murrine Sample Box #4 (Elgin), 1992
Blown glass, *zanfirico* technique, sheet glass,
wood, wire, found objects
14 × 11 × 3 in.; 12½ × 7½ × 1½ in.
Photographed with old chemistry sets
Private collection; collection of the artist

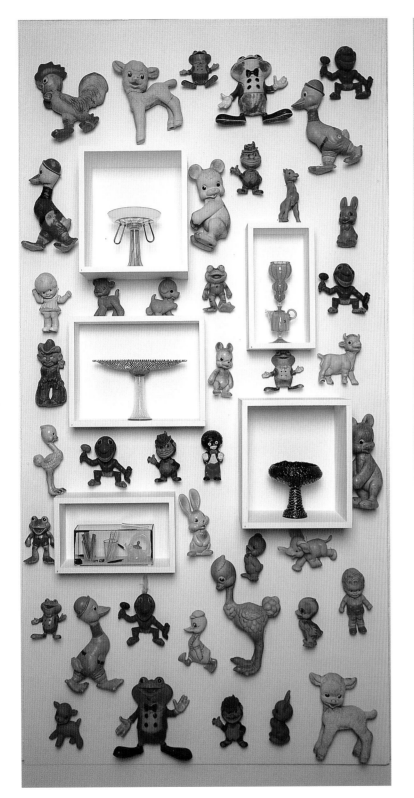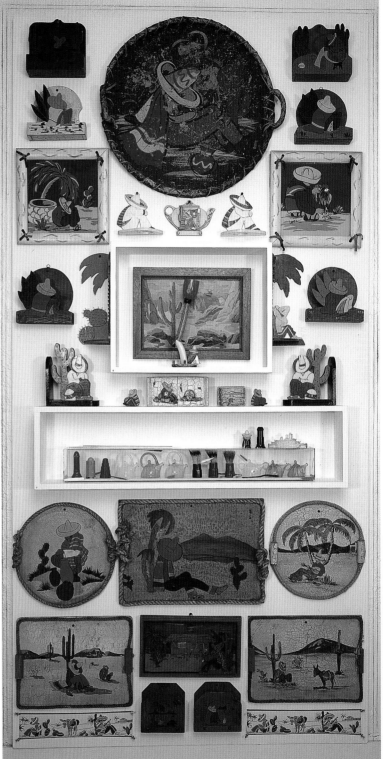

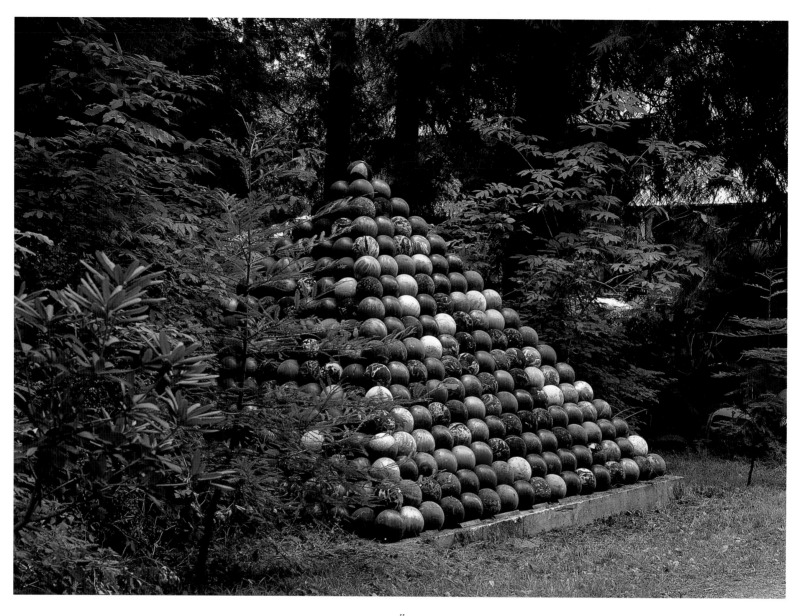

124
Bowling Ball Pyramid, 1984–94
1,805 bowling balls on concrete foundation
94 × 148 × 148 in.
Collection of the artist

"BOWLING BALLS ARE ONE OF THE FEW THINGS THAT ARE VERY EXPENSIVE INITIALLY AND THEN, WITHOUT REALLY CHANGING, BECOME ALMOST VALUELESS. WHEN YOU BUY YOUR FIRST BOWLING BALL YOU ARE PAYING FOR A RITE OF PASSAGE. WHEN YOU GIVE UP BOWLING AND THE BALL FALLS OUT OF YOUR CLOSET ON YOUR FOOT YOU CAN'T JUST THROW IT AWAY—IT ENDS UP SOMEPLACE WHERE I CAN BUY IT FOR A QUARTER."

125
Bundle of Silhouette Murrine,
1983–87
Murrine
Each rod 3 × approx.
¼ in. diam.
Collection of Johanna
Nitzke Marquis

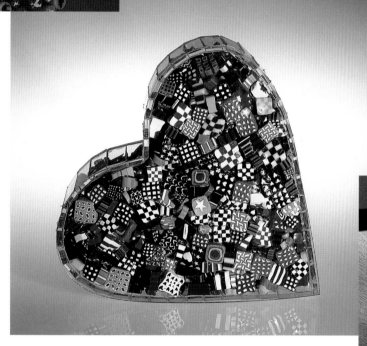

126
Murrine Heart, 1994
Murrine, flat glass
7 × 7 × 2½ in.
Collection of Johanna Nitzke Marquis

127
Valentine Candy Box, 1992–95
Silhouette *murrine,* cardboard box, paper
10 × 9¼ × 1 in.
Collection of Johanna Nitzke Marquis

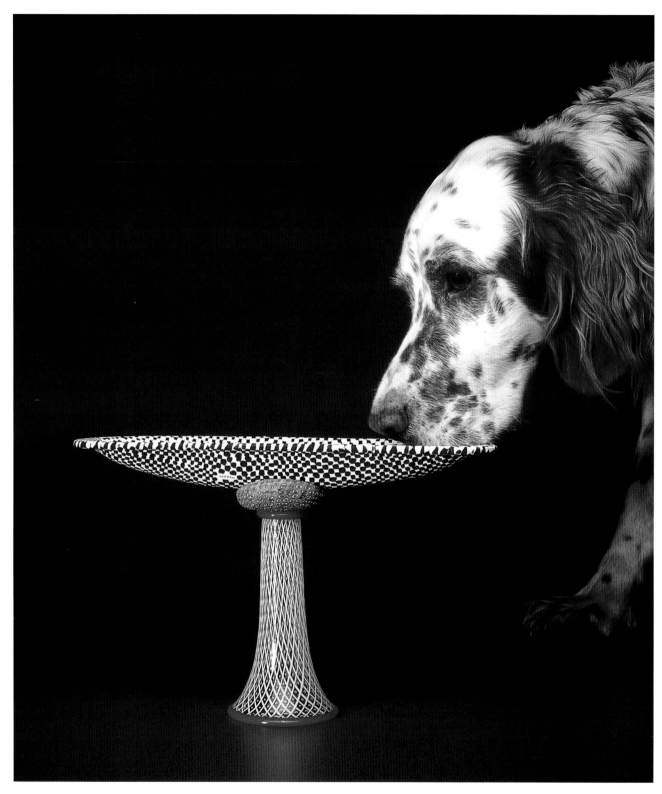

"WHEN I WAS WORK-
ING AT VENINI
FABBRICA, THE
CARLO SCARPA
MURRINE BOWLS
WOULD SOMETIMES
STILL BE MADE. I
LOVED THE END
PRODUCT BUT
WASN'T AT ALL
INTERESTED IN THE
PROCESS. YEARS
LATER WHEN I
STARTED MAKING
THESE PIECES
BASED ON
SCARPA'S DESIGNS,
I REDISCOVERED
THE SAME THING.
THIS IS ABOUT THE
ONLY WORK I MAKE
WHERE I DON'T
ENJOY THE PRO-
CESS, BUT I LIKE
HOW IT LOOKS
WHEN IT'S DONE."

128
Marquiscarpa #30, 1991–94
Fused, slumped, blown,
and wheel-carved glass,
murrine and *reticello*
techniques
8 × 12½ × 2½ in.
Photographed with Pete
Collection of Polly and
Buzz Strasser

Below:
129a–b (top and side views)
Marquiscarpa #7, 1991
Fused, slumped, blown, and wheel-carved glass, *murrine* technique
5 × 9½ × 4½ in.
Collection of Daphne Farago

Right:
130a–b (top and side views)
Marquiscarpa #8, 1991
Fused, slumped, blown, and wheel-carved glass, *murrine* technique
4¼ × 5½ × 5½ in.
Collection of Johanna Nitzke Marquis

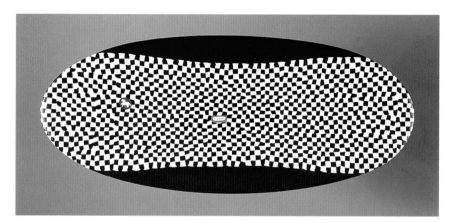

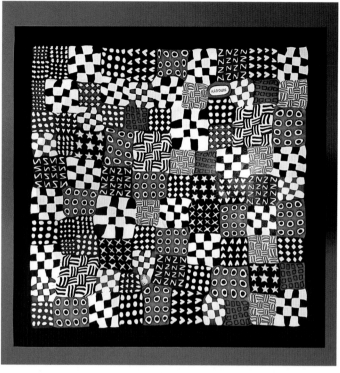

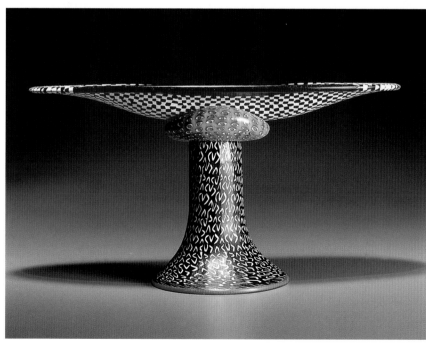

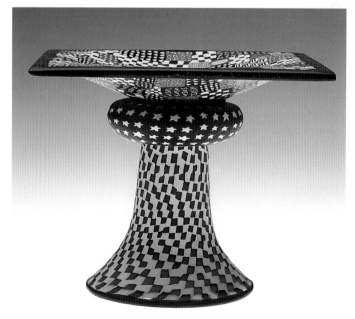

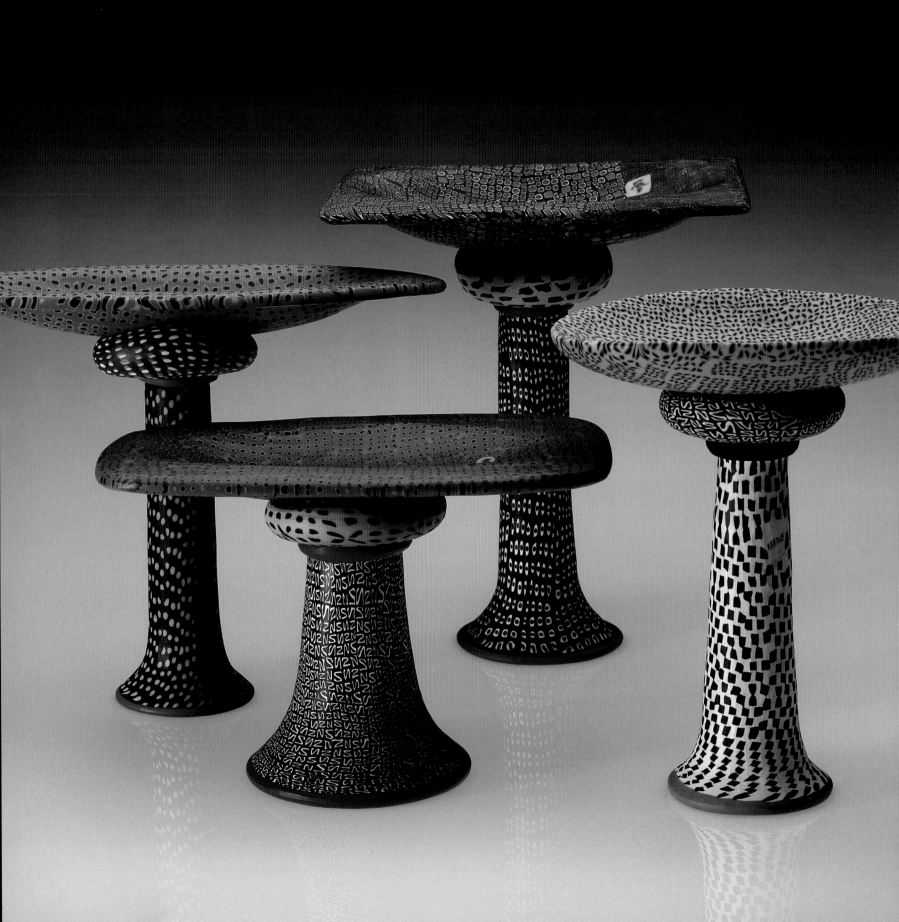

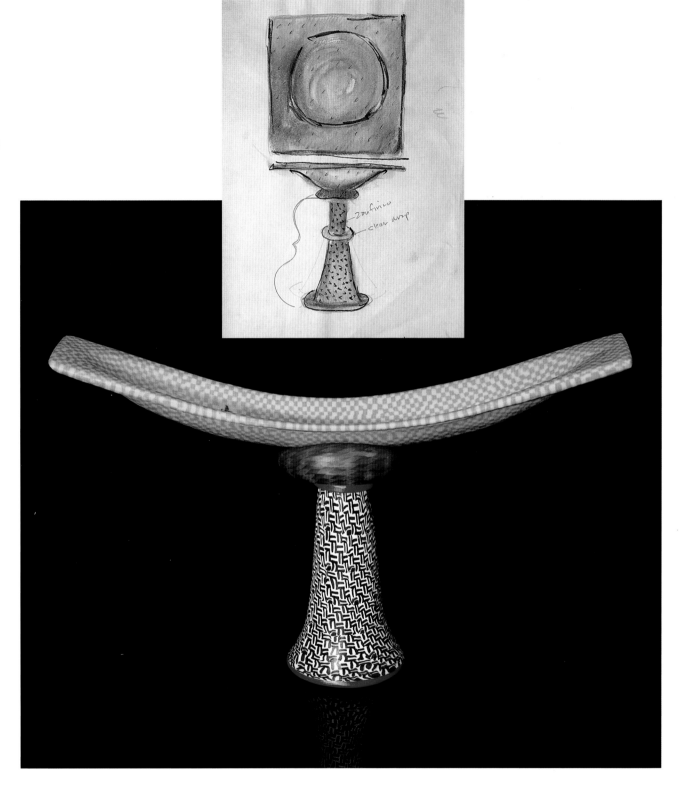

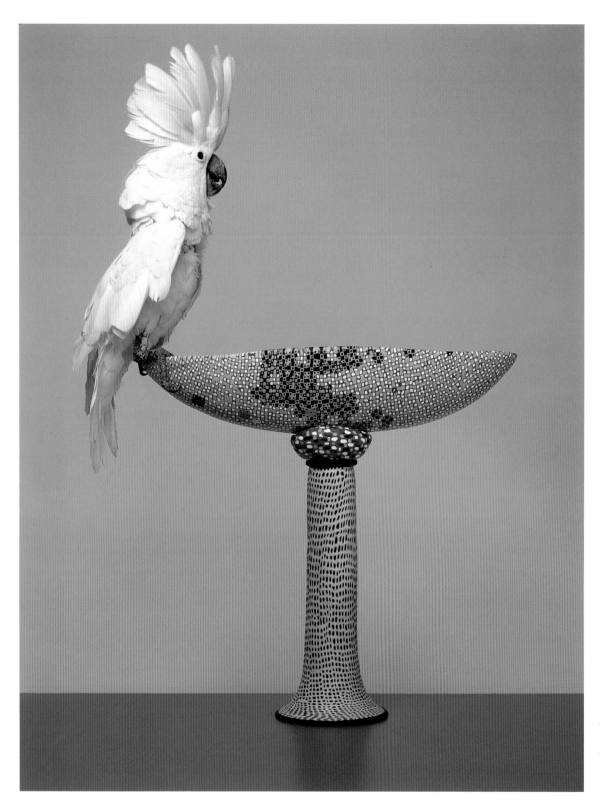

134
Marquiscarpa #95-4, 1995
Fused, slumped, blown, and wheel-carved
glass, *murrine* technique
17¼ × 18½ × 5½ in.
Photographed with Mandy (aka Cupcake)
Courtesy Franklin Parrasch Gallery, New York

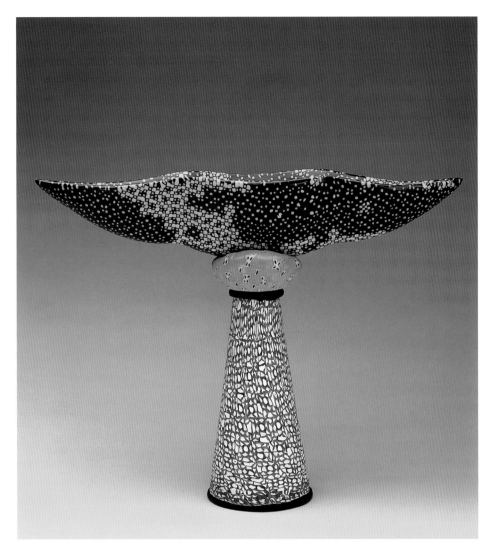

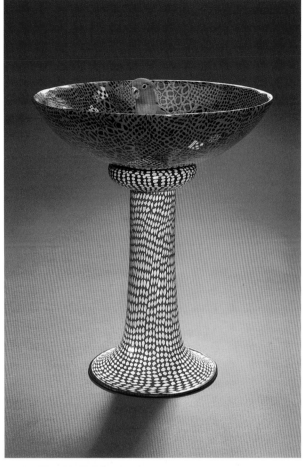

135
Marquiscarpa #95-5, 1995
Fused, slumped, blown, and wheel-carved glass, *murrine* technique
13¾ × 18 × 4¾ in.
Collection of Pam Biallas

136a–b (side and top views)
Marquiscarpa #95-9, 1995
Fused, slumped, blown, and wheel-carved glass, *murrine* technique
14 × 12¼ × 12¼ in.
Photographed with Ollie
Philadelphia Museum of Art

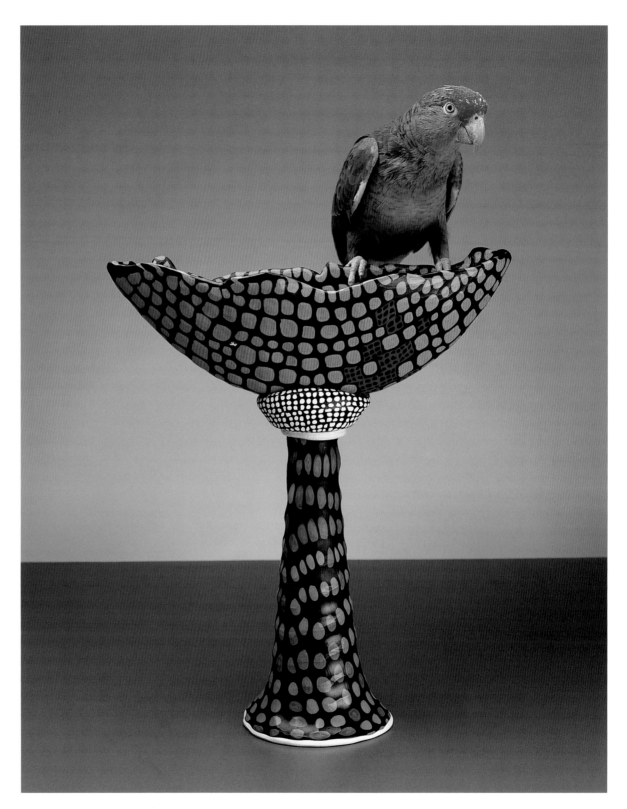

137
Marquiscarpa #95-10, 1995
Fused, slumped, blown, and wheel-
carved glass, *murrine* technique
16 × 13½ × 5¼ in.
Photographed with Red Hot
Courtesy Elliott Brown Gallery, Seattle

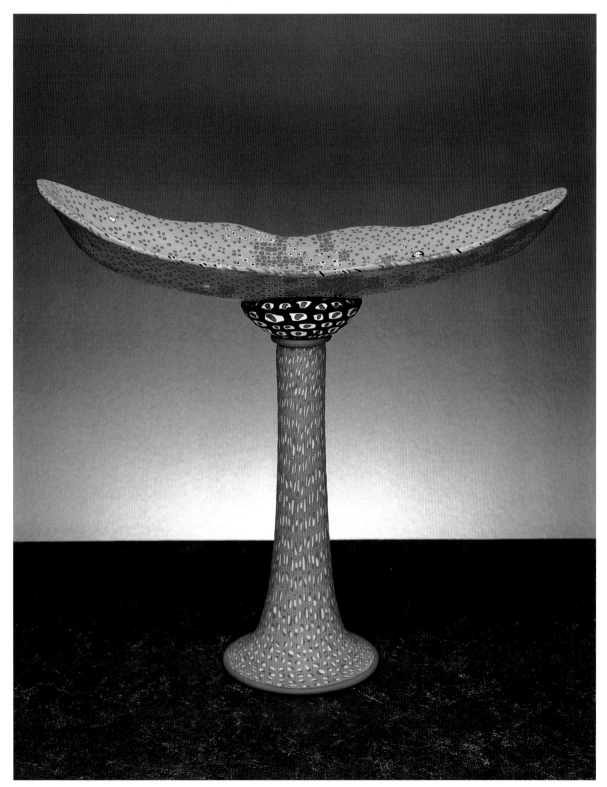

138
Marquiscarpa #95-1, 1995
Fused, slumped, blown, and wheel-
carved glass, *murrine* technique
15 × 16½ × 6¼ in.
Private collection

The making of *Marquiscarpa #94-1*, 1994, which is shown on the opposite page.

Setting up the patterns.

The *murrine* pattern sitting on ceramic paper, ready to be heated.

Heating up the *murrine* with Dimitri Michaelides and Alison Chism.

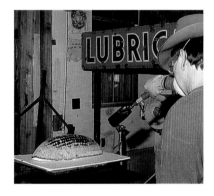

Squeezing and shaping the hot *murrine*.

Flipping the sheet of fused *murrine* over onto the preheated ceramic mold.

The ceramic paper is then removed.

Futzing with the final shape with torches; the shaped glass is then put in the annealing oven.

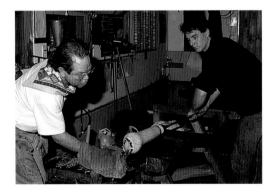

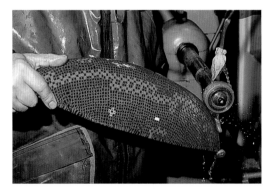

Shaping the *murrine* foot.

Kotoro Hamada backing me up as I flare the *murrine* foot.

Wheel carving the top part.

139
Marquiscarpa #94-1, 1994
Fused, slumped, blown, and
wheel-carved glass, *murrine*
technique
18½ × 19 × 7 in.
Collection of Adele and Leonard
Leight

140
English Setter Installation, 1994
Installation at Elliott Brown Gallery, Seattle
Found paintings, puzzles, magazines, calendars,
postcards, advertising paraphernalia

Seen on shelf:
Pete and Frosty, 1994
Blown glass, found plaster dog
6¾ × 17½ × 6 in.
Private collection

Untitled, 1994
Blown glass, *granulare* technique, *murrine,*
found objects
6½ × 12 × 6¼ in.
Collection of Ben W. Heineman Sr.

Untitled, 1994
Blown glass, *granulare* technique, found objects
5½ × 15 × 16½
Collection of Francine and Benson Pilloff

Lino's Granulare Sake Cup on Pete, 1994
Blown and acid-etched glass, *granulare* technique,
found cast-iron doorstop
10¾ × 15 × 6¼ in.
Collection of the artist

141
Granulare Siesta Bowl, 1994
Blown glass, *granulare*
technique, found objects
4¾ × 15 × 7 in.
Collection of Arthur Liu

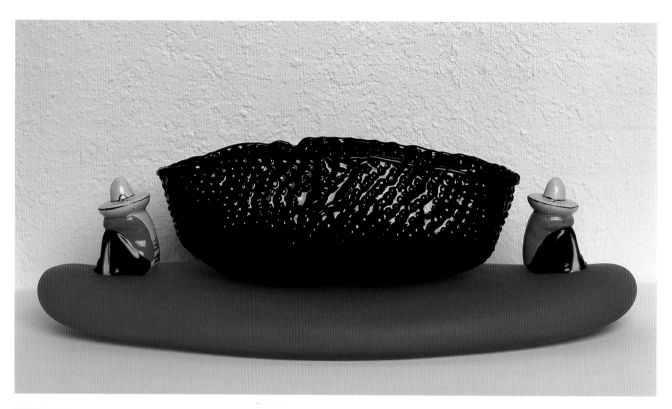

142
*Granulare Bowl with Sleeping
English Setter,* 1994
Cast and blown glass,
granulare technique
4 × 17 × 9½ in.
Collection of Arthur Liu

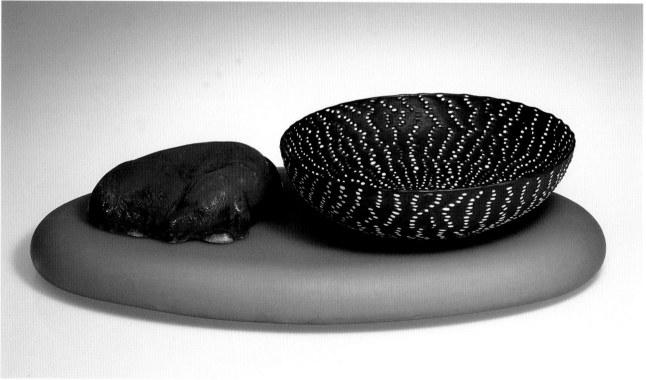

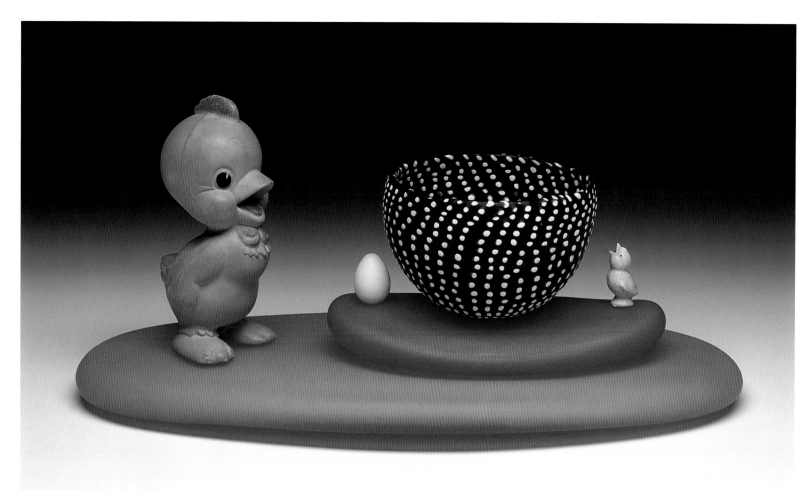

143
Rubber Chick Bowl, 1994
Blown glass, *granulare* technique,
found objects
7 × 16 × 7 in.
Collection of the artist

"THE **GRANULARE** PIECES (SOMETIMES CALLED **PERLETO** IN BOOKS
AND LUMPYWARE BY ME) ARE MADE ONLY FROM **MURRINE** THAT
HAVE A 'HARD' CENTER INSIDE A 'SOFT' FIELD. WHEN THE
MURRINE ARE PICKED UP ON A BLOWPIPE, SHAPED, AND THEN
BLOWN, IT GOES ALL LUMPY. IT'S LIKE TRYING TO BLOW A BUBBLE
WITH CHEWING GUM INSTEAD OF BUBBLE GUM OR RATHER LIKE
CHEWING GUM IMPREGNATED WITH BB'S. IT DOESN'T WANT TO
BE A SMOOTH BUBBLE. IT DOESN'T WANT TO BE ANYTHING."

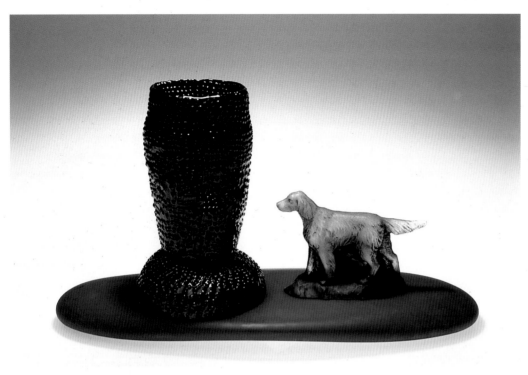

"THERE CAME A TIME WHEN I WAS MAKING
SERIOUS DENTS IN MY ENGLISH SETTER
COLLECTION BY PUTTING THEM IN PIECES.
SO I STARTED CASTING THEM IN GLASS—
MAKING MY OWN 'FOUND OBJECTS.'"

144
Wellwyn Geronimo Boy, 1994
Cast and blown glass,
granulare technique
12 × 21½ × 8¼ in.
Collection of the artist

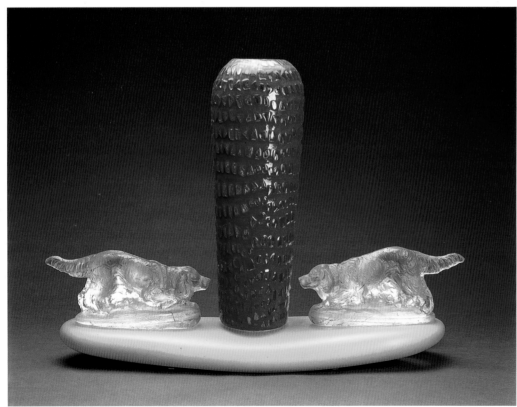

145
Hightone Red Rocket, 1995
Cast and blown glass,
occhi technique
22 × 29 × 8½ in.
Courtesy Elliott Brown
Gallery, Seattle

Opposite:
146
Blue Boy's Mamie, 1995
Cast and blown glass,
occhi technique
21½ × 23 × 13 in.
Metropolitan Museum
of Art, New York

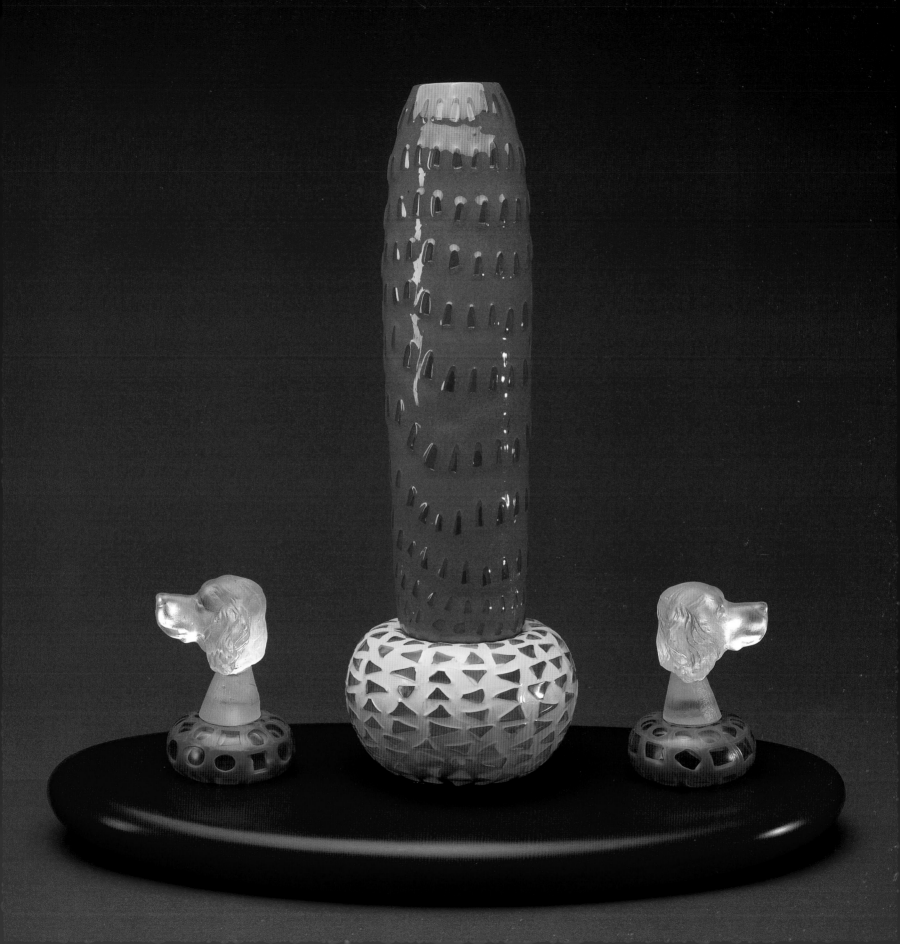

Making a blown mosaic piece at Benjamin Moore's studio, 1995.

Pulling the *murrine* squares with Dante Marioni on the ladder.

Setting up the patterns with Robbie Miller.

Heating up the *murrine* in the glory hole.

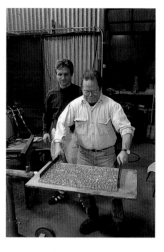

Squeezing the *murrine* together; it's hotter than it looks.

Picking up the fused sheet of *murrine* on the blowpipe.

Futzing around with the *murrine* with Janusz Pozniak and Paul Cunningham.

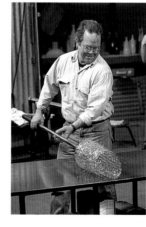

Marvering the *murrine* cylinder into shape.

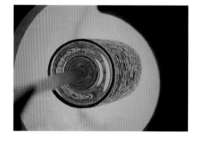

Back into the glory hole—great photography by Russell Johnson.

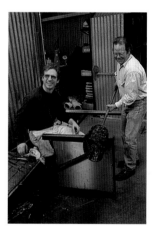

Dante and I respond to an observation by Paul.

Checking out the piece with Dante and Paul while Janusz makes eyes.

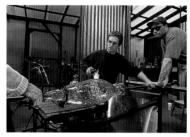

Dante blows out the shape with Paul while Preston Singletary attaches the punty.

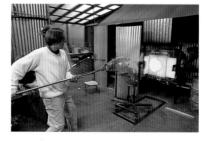

Preston takes the almost completed shape to the glory hole. The finished piece is on page 133.

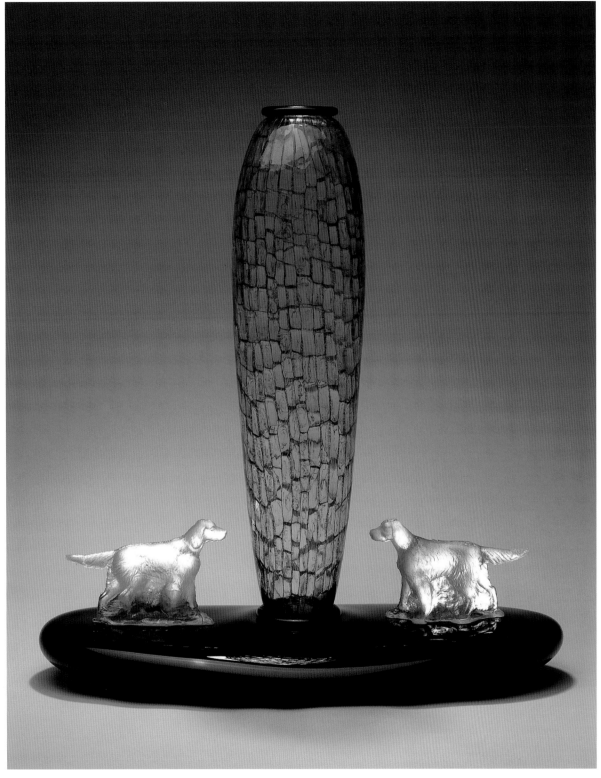

147
Blizzard's Suspense, 1995
Cast and blown glass, mosaic
technique
26½ × 26 × 10 in.
Seattle Art Museum, Northwest
Acquisition Fund, Margaret E. Fuller
Purchase Fund, and partial gift of
Kate Elliott

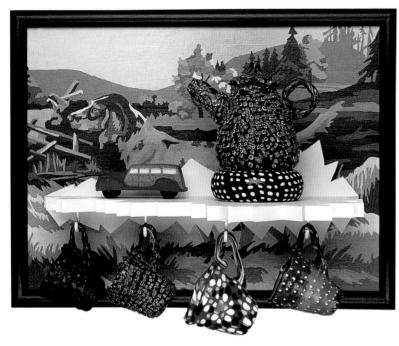

148
Lumpyware Tea Service (Earl Grey), 1995
Blown glass, *granulare* technique, wood,
paint-by-numbers painting, found object
13 × 17 × 9 in.
Collection of Betsy and Andy Rosenfield

149
Neo Murrine Teapots, 1994
Pencil on paper
14 × 11 in.
Private collection

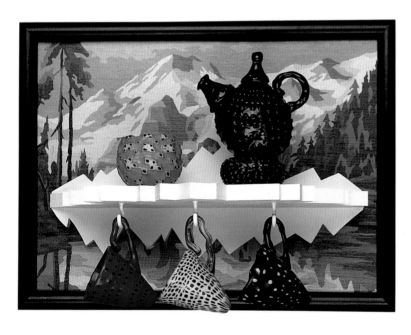

150
Lumpyware Tea Service (Gunpowder), 1995
Blown glass, *granulare* technique, wood,
paint-by-numbers painting
13 × 17 × 9 in.
Collection of Johanna Nitzke Marquis

151
Granulare Pot Form, 1997
Blown glass, *granulare*
technique
15¼ × 10½ × 10½ in.
Courtesy Franklin Parrasch
Gallery, New York

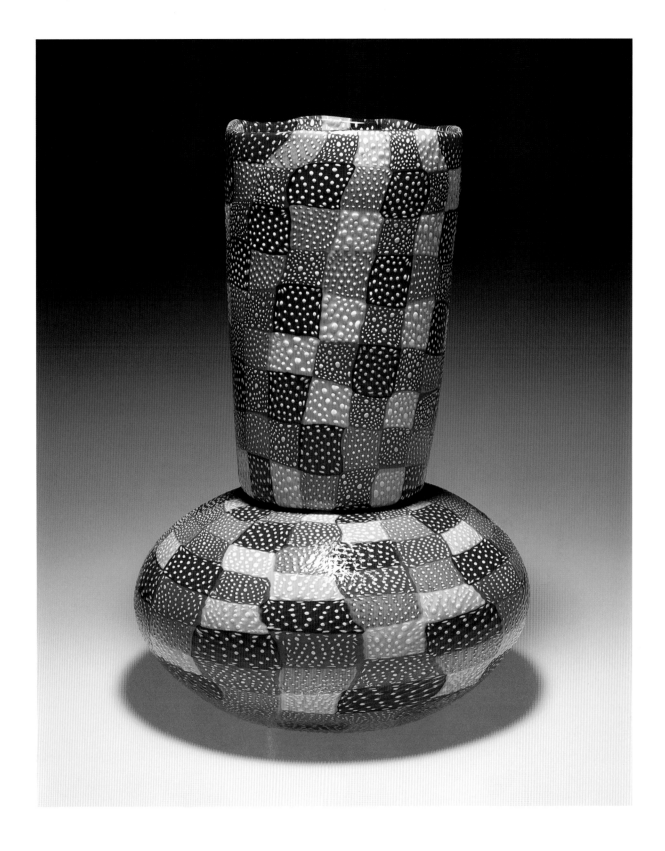

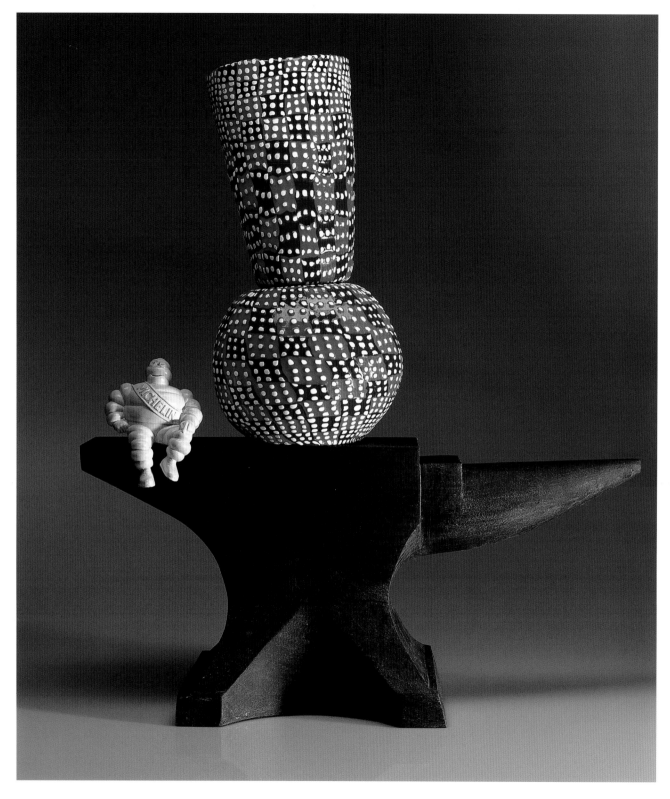

152
Granulare/Anvil (Michelin Man), 1997
Glass, wood, mixed media
21½ × 19 × 6½ in.
Courtesy Elliott Brown
Gallery, Seattle

CHRONOLOGY

BY RICHARD MARQUIS

1945 Born a triple Virgo in Bumblebee, Arizona, the second of four children, to Chuck and Verna Marquis.

1959–63 Attended Upland High School in Southern California.

1962 Old setter "Blackie" dies.

1963 Moves to Berkeley, California, where he is based until 1982. Enters University of California at Berkeley (UCB) to study architecture.

1964 Free Speech Movement.

1965 Sees Ron Nagle's beaded checkerboard moccasins.

1965–69 Studies with Peter Voulkos, Jim Melchert, Ron Nagle, Robert Hudson, Ed Rossbach and Marvin Lipofsky to learn everything about everything.

1966 Sees abstract-expressionist ceramics exhibition at University of California, Irvine, with work by Price, Voulkos, Melchert, Nagle, and Michael Frimkiss. Transfers to decorative arts department (later called the design department), UCB, to concentrate in ceramics and glass.

Included in first *Toledo Glass National*.

1967–69 Has numerous confrontations with the Oakland Draft Board.

1967 The Summer of Love. Drives across the country with Lipofsky to be his teaching assistant at Haystack School of Crafts.

Sees *Funk* show curated by Peter Selz at University Art Museum, Berkeley.

Eisner Prize for Design and President's Undergraduate Fellowship from UCB enables building of own glassblowing studio.

Sees *American Sculpture of the Sixties* at the Los Angeles County Museum of Art which includes works by Ken Price and H. C. Westermann.

1968 People's Park confrontation in Berkeley. General craziness.

Sees *H. C. Westermann* at the Los Angeles County Museum of Art.

Included in exhibition *The American Craftsmen's Invitational Exhibition* at the Henry Art Gallery, University of Washington, Seattle. Also included were Robert Arneson, Ron Nagle, Wendell Castle, Arlene Fisch, Paolo Soleri, Ken Cory, Nick Labino, and Bob Stockside.

1969 Awarded Fulbright-Hayes Fellowship to Italy; lives in Venice and works at Venini Fabbrica in Murano.

Visits the late Giorgio Morandi's studio outside Bologna, Italy.

Included in *Young Americans* at the American Craft Museum, New York.

Included in *Objects USA*, an exhibition organized by Paul Smith and Lee Nordness for Johnson Wax Foundation.

1970 Teaches glass and ceramics at the University of Washington in Seattle for a year.

English setter, Nigel, whelped.

1971 Has solo show at Manolides Gallery in Seattle.

Visits glassblowing camp in Stanwood, Washington, later named Pilchuck. Determines that it'll never work.

1972 Produces *Lord's Prayer Murrina* at Chico State University as part of UCB master's thesis.

Actually tries wearing "Earth Shoes."

1973 Teaches at Haystack School of Crafts, where he develops *murrine* teapots.

Travels in Europe and Far East.

Returns to Murano, Italy, on first of many visits over the next twenty-four years.

1974 Receives first of four National Endowment for the Arts (NEA) Fellowships.

Conducts series of workshops in Australia with grant from the Australian Crafts Council.

1975 Blows glass in Berkeley and Benicia with Australian Nick Mount.

Brother Bill dies.

1976 Builds glass shop in Hobart as artist-in-residence at the Tasmanian School of Art.

Has solo traveling exhibition in Australia entitled *Technique Is Not So Cheap*.

1977 Establishes Marquis Deluxe Studios in Berkeley with Jack Wax and Jody Fine.

Begins "The Big Commute"—six years of teaching glass at University of California, Los Angeles, while operating the studio in Berkeley.

Mistakes are made.

1978 Sees Ken Price's *Happy's Curios* show at the Los Angeles County Art Museum. Is blown away.

Second NEA grant enables Marquis to develop the *Fabricated Weird* series.

1979 Included in *New Glass: A Worldwide Survey* at the Corning Museum of Glass, Corning, N.Y.

"Marquis Deluxe Studios" pupates into "Marlux" which then metamorphoses into "HOTMIRE" (an acronym for Hippies Out To Make It Rich Experiment). Whole operation ceases in 1980 or 1981.

1980 Travels and works in New Zealand on Senior Fulbright Fellowship.

1981 Collaborates with Therman Statom on large-scale installations. They work together over the next seven years.

1983 Quits teaching at UCLA, pulls up stakes in Berkeley, and buys property on an island in Puget Sound. Starts Noble Effort Design with Ro Purser and produces some of the strangest production glass ever made.

1984–86 The Lost Years. Works on *Neon Heads*, *Personal Archive Units*, *Big Rocks*, and starts endless project of building a 1934 Ford Street Rod.

1985 Takes "Frizzell's Friendly Photo Correspondence Course" and sets up photography studio.

1986 *Shard Rockets* included in *Poetry of the Physical* at the American Craft Museum, New York.

Famous Dog Nigel goes to Happy Bird Hunting Grounds.

1987 Begins exhibiting at Betsy Rosenfield Gallery, Chicago, and Kurland/Summers Gallery, Los Angeles.

Marries Johanna Nitzke.

Dissolves partnership in Noble Effort and begins to concentrate on his own work.

Father dies.

English setter Pete whelped.

1988 Returns to New Zealand on second Senior Fulbright Fellowship to produce exhibition at Dowse Art Museum.

Begins working with Dante Marioni on *Teapot Goblets*. Their working relationship continues to the present, including teaching workshops worldwide.

1990 While in New Zealand, discusses making pieces based on work Carlo Scarpa did at Venini. Lino Tagliapietra suggests the name "Marquiscarpa" for these works.

1991 Exhibition at Kurland/Summers Gallery in Los Angeles dedicated to Carlo Scarpa and Ludovico Diaz de Santillana.

1992 Mother dies.

Travels in Ireland and Alaska. Begins research on *granulare, occhi,* and blown mosaic techniques.

1993 Frank Zappa dies.

1994 Vincent Black Shadow arrives on doorstep courtesy of Bob Naess.

Begins exhibiting at Elliott Brown Gallery, Seattle.

1995 Elected to the College of Fellows of the American Crafts Council, New York.

Included in *Holding the Past: Historicism in Recent Northwest Glass Sculpture* at the Seattle Art Museum, curated by Patterson Sims and Vicki Halper.

Exhibits large "Marquiscarpa" pieces at Franklin Parrasch Gallery, New York.

In the fall, turns fifty years old and decides to take a year off from making objects. Year turns into eighteen months.

1996 Works on old cars, old boats, and new kitchen.

1997 Works on monograph and his retrospective at Seattle Art Museum.

Begins collaboration with Bullseye Glass in Portland.

Begins exhibiting at Galleria d'Arte Vetri, Bergamo, Italy.

EXHIBITION HISTORY

EDUCATION

1972 M.A., University of California, Berkeley

1969 B.A., University of California, Berkeley

SELECTED HONORS AND AWARDS

1995 Elected to the College of Fellows of the American Crafts Council, New York

1974, '78, '81, '90 National Endowment for the Arts Fellowship

1982, '88 Fulbright-Hayes Grant (Senior), New Zealand

1979, '80, '81, '82 Research Grant, University of California, Los Angeles

1974, '75, '76 Australian Crafts Council Grant

1969 Fulbright-Hayes Fellowship, Venice, Italy (Venini Fabbrica)

1968 President's Undergraduate Fellowship, University of California, Berkeley

1967 Eisner Prize for Design, University of California, Berkeley

SELECTED SOLO EXHIBITIONS

1997–98 Elliott Brown Gallery, Seattle

1995 *Suffering from Versatility*, Elliott Brown Gallery, Seattle

Franklin Parrasch Gallery, New York

1994 *Recent Works in Context*, Elliott Brown Gallery, Seattle

1993 Gallery Nakama, Tokyo

1991 Betsy Rosenfield Gallery, Chicago

Kurland/Summers Gallery, Los Angeles

1990 Sandra Ainsley Art Forms, Toronto

Kurland/Summers Gallery, Los Angeles

Betsy Rosenfield Gallery, Chicago

1989 Louise Allrich Gallery, San Francisco

1988 Auckland Art Museum, New Zealand

Dowse Art Museum, Wellington, New Zealand

1987 Betsy Rosenfield Gallery, Chicago

Kurland/Summers Gallery, Los Angeles

1986 Foster/White Gallery, Seattle

B. Z. Wagman Gallery, St. Louis

1985 Snyderman Gallery, Philadelphia

1984 San Francisco State University Art Gallery

Traver/Sutton Gallery, Seattle

1983 Warner Gallery, Los Angeles

1981 Auckland Art Museum, New Zealand

1980 Branch Gallery, Washington, D.C.

Heller Gallery, New York

1978 Gallery Marronnier, Kyoto, Japan

Habatat Gallery, Detroit

Peabody College Art Gallery, Nashville

1976 Macquarie Gallery, Sidney, Australia

Queen Victoria Museum, Launceton, Tasmania

Tasmanian Art Museum, Hobart, Tasmania

1974 Realities Gallery, Melbourne, Australia

1971 Manolides Gallery, Seattle

1969 Palomar College, San Marcos, Calif.

SELECTED GROUP EXHIBITIONS

1997 *Trashformations: Recycled Materials in American Art and Design*, Whatcom Museum of History and Art, Bellingham, Wash. (traveled)

¡Calido! Contemporary Warm Glass, Tucson Museum of Art, Ariz. (traveled)

1996 *Twenty-Five at Twenty-Five*, Society of Contemporary Crafts, Pittsburgh, Pa.

Murrine Storia, Elliott Brown Gallery, Seattle

1995 *Holding the Past: Historicism in Recent Northwest Glass Sculpture*, Seattle Art Museum

Light Interpretations: A Hanukkah Menorah Invitational, Jewish Museum of San Francisco

Designs in Miniature: The Story of Mosaic Glass, Corning Museum of Glass, Corning, N.Y.

Breaking Tradition: The Fine Art of Glass, Wignall Museum/Gallery, Chaffey College, Rancho Cucamonga, Calif.

1994 *World Glass Now '94*, Hokkaido Museum of Modern Art, Sapporo, Japan

1993 *Glass '93 in Japan*, Odakyu Museum, Tokyo

1993–95 *Contemporary Crafts and the Saxe Collection*, Toledo Museum of Art (traveled)

1992–96 *Clearly Art: Pilchuck's Glass Legacy*, Whatcom Museum of History and Art, Bellingham, Wash. (traveled)

1992–94 *Glass: From Ancient Craft to Contemporary Art*, Morris Museum, Morristown, N.J. (traveled)

1992 *The International Exhibition of Glass Kanazawa '92*, Kanazawa, Japan

1991–92 *World Glass Now '91*, Hokkaido Museum of Modern Art, Sapporo, Japan (traveled)

1991 *National Objects Invitational*, Arkansas Arts Center, Little Rock

Beauty of Contemporary Glass Art, Studio S, Tokyo

1990	*The International Exhibition of Glass Kanazawa '90,* Kanazawa, Japan
1989–93	*Craft Today USA,* American Craft Museum, New York (traveled)
1989	*Expressions en Verre II,* Musée des Arts Decoratifs, Lausanne, Switzerland
	The Venetians: Modern Glass 1919–1990, Muriel Karasik Gallery, New York
1988	*The International Exhibition of Glass Craft '88,* Kanazawa, Japan
1986–88	*Poetry of the Physical,* American Craft Museum, New York (traveled)
1986	*Contemporary American and European Glass from the Saxe Collection,* Oakland Museum, Calif. (traveled)
	Architecture of the Vessel, Bevier Gallery of Art, Rochester Institute of Technology, Rochester, N.Y.
1985–86	*Transparent Motives: Glass on a Large Scale,* Contemporary Arts Center, Cincinnati, Ohio (traveled)
1985	*World Glass Now '85,* Hokkaido Museum of Modern Art, Sapporo, Japan
1984	*Contemporary Glass: A Decade Apart,* Boise Gallery of Art, Idaho
1982	*World Glass Now '82,* Hokkaido Museum of Modern Art, Sapporo, Japan
	Art and/or Craft: USA and Japan, Kanazawa, Japan
	International Directions in Glass Art, Art Gallery of Western Australia, Perth
1981	*Americans in Glass,* Leigh Yawkey Woodson Art Museum, Wausau, Wis.
	Works in Glass, 1981, Fox Fine Arts Center, El Paso, Tex.
	Made in LA—Contemporary Crafts '81, Craft and Folk Art Museum of Los Angeles
	Contemporary Glass: Australia, Canada, USA, and Japan, National Museum of Modern Art, Kyoto, Japan
	New American Glass: Focus West Virginia, Huntington Galleries, Huntington, W.Va.
	Emergence: Art in Glass, 1981, Bowling Green State University, Ohio
	Glass: Artist and Influence, Jesse Besser Museum, Alpena, Mich.
1980	*New American Glass: Focus West Virginia,* Huntington Galleries, Huntington, W.Va.
	Robert L. Pfannebecker Collection: A Selection of Contemporary American Crafts, Moore College of Art, Philadelphia
	Contemporary Glass, Indiana University Art Museum, Bloomington
1979	*New Glass: A Worldwide Survey,* Corning Museum of Glass, Corning, N.Y.
1978	*Glass America, 1978,* Lever House, New York
	Americans in Glass, Leigh Yawkey Woodson Art Museum, Wausau, Wis.
1976	*American Crafts '76,* Museum of Contemporary Art, Chicago
1975	*International Studio Glass,* Illums Bollighus, Copenhagen
1972–74	*American Glass Now,* Toledo Museum of Art (traveled)
1971	*First National Invitational Hand-Blown Glass Exhibition,* Tacoma Art Museum, Wash.
1970	*Toledo Glass National III,* Toledo Museum of Art
1969–70	*Objects USA,* Johnson Wax Foundation, Racine, Wis. (traveled)
1969	*Young Americans,* American Craft Museum, New York
1968	*California Design Ten,* Pasadena Art Museum, Calif.
	The American Craftsmen's Invitational Exhibition, Henry Art Gallery, University of Washington, Seattle
	Toledo Glass National II, Toledo Museum of Art
1967	*First Survey of Contemporary American Crafts,* University Art Museum, Austin, Tex.
1966	*Toledo Glass National,* Toledo Museum of Art

SELECTED PUBLIC COLLECTIONS

American Craft Museum, New York

American Glass Museum, Millville, N.J.

Australian Council for the Arts, Sydney

Australian National Gallery, Canberra

Carnegie Museum of Art, Pittsburgh

City Art Gallery, Wagga Wagga, Australia

Corning Museum of Glass, Corning, N.Y.

Craft and Folk Art Museum, Los Angeles

Dowse Art Museum, Wellington, New Zealand

Finnish National Glass Museum, Riihimaki, Finland

Indianapolis Museum of Art, Ind.

Indiana University Art Museum, Bloomington

J. B. Speed Art Museum, Louisville, Ky.

Johnson Wax Collection, Racine, Wis.

Kunstmuseum im Ehrenhof, Dussledorf, Germany

Lannan Foundation Museum, Palm Beach, Fla.

Los Angeles County Museum of Art

Metropolitan Museum of Art, New York

Musée des Arts Decoratifs, Lausanne, Switzerland

Museum fur Kunsthandwerk, Frankfurt, Germany

Museum of Art, Auckland, New Zealand

Museum of Art, Rhode Island School of Design, Providence

National Art Museum, Auckland, New Zealand

National Gallery of Victoria, Melbourne, Australia

National Glasmuseum, Leerdam, Holland

National Museum of American Art, Renwick Gallery, Smithsonian Institution, Washington, D.C.

New Glass Museum, Tsukuba, Japan

New Orleans Museum of Art

Philadelphia Museum of Art

Powerhouse Museum, Sydney, Australia

Prescott Collection of Pilchuck Glass at U.S. Bank Center, Seattle

Queen Victoria Museum and Art Gallery, Launceton, Australia

Royal Ontario Museum, Toronto

Sea of Japan Collection, Tokyo

Seattle Art Museum

Seattle First National Bank, Seattle

Seattle Sheraton Hotel and Towers, Seattle

Swedish Hospital and Medical Center, Seattle

Tasmanian Art Museum, Hobart, Tasmania

Toledo Museum of Art

Wustum Museum of Fine Arts, Racine, Wis.

SELECTED BIBLIOGRAPHY

CATALOGUES AND BOOKS

American Craft Museum. *Craft Today USA*. New York, 1989, p. 32.

——. *Vessels: From Use to Symbol*. New York, 1990, p. 2.

Arkansas Arts Center. *National Objects Invitational*. Little Rock, Ark., 1991, pp. 38–39.

Art Gallery of Western Australia. *International Directions in Glass Art*. Perth, Australia, 1982, pp. 62, 96.

Bellevue Art Museum. *Pilchuck School: The Great Northwest Glass Experiment*. Bellevue, Wash., 1988, p. 13.

Bettagno, Alessandro, et al. *Gli artisti di Venini: Per una storia del vetro d'arte Veneziano*. Milan: Electa, 1996, pp. 34–45.

Bevier Gallery of Art, Rochester Institute of Technology. *Architecture of the Vessel*. Rochester, N.Y., 1986, p. 17.

Boise Gallery of Art. *Contemporary Glass: A Decade Apart*. Boise, Idaho, 1984, pp. 22–23.

Bowling Green State University. *Emergence: Art in Glass, 1981*. Bowling Green, Ohio, 1981, p. 26.

Burpee Art Museum/Rockford Art Association. *Art in Other Media*. Rockford, Ill., 1971, p. 31

Centro de Arte Vitro. *Cristalomancia: Contemporary Art in Glass*. Monterey, Mexico, 1992, pp. 110–11.

Chambers, Karen. *Transparent Motives: Glass on a Large Scale*. Cincinnati, Ohio: Contemporary Arts Center, 1986, pp. 24–25.

City of Kanazawa. *Art and/or Craft: USA and Japan*. Kanazawa, Japan, 1982, p. 99.

——. *The International Exhibition of Glass Craft '88*. Kanazawa, Japan, 1988, p. 125.

——. *The International Exhibition of Glass Kanazawa '90*. Kanazawa, Japan, 1990, p. 164.

——. *The International Exhibition of Glass Kanazawa '92*. Kanazawa, Japan, 1992, p. 142.

Corning Museum of Glass. *New Glass: A Worldwide Survey*. Corning, N.Y., 1979, p. 147.

——. *New Glass Review 2*. Corning, N.Y., 1981, p. 7.

——. *New Glass Review 3*. Corning, N.Y., 1982, p. 11.

——. *New Glass Review 16*. Corning, N.Y., 1995.

——. *New Glass Review 17*. Corning, N.Y., 1996.

Cousins, Mark. *Twentieth-Century Glass*. Secaucus, N.J.: Chartwell Books, 1989, p. 123.

Craft and Folk Art Museum. *Four Leaders in Glass*. Los Angeles, 1980, pp. 3–4.

Crocker Art Gallery. *Pacific Dimensions Exhibition*. Sacramento, Calif., 1969, p. 1.

Dolez, Albane. *Glass Animals: 3,500 Years of Artistry and Design*. New York: Harry N. Abrams, 1988, pp. 200, 205.

Frantz, Susanne K. *Contemporary Glass: A World Survey from the Corning Museum of Glass*. New York: Harry N. Abrams, 1989, pp. 69, 110–11.

Hall, Julie. *Tradition and Change: The New American Craftsman*. New York: E. P. Dutton, 1977, p. 124.

Hampson, Ferdinand. *Glass: State of the Art 1984*. Huntington Woods, Mich.: Elliot Johnston Publishers, 1984, pp. 108–9.

Harrington, LaMar. *Ceramics in the Pacific Northwest: A History*. Seattle: Henry Art Gallery and University of Washington Press, 1979, p. 111.

Heineman, Ben. *Contemporary Glass: A Private Collection*. Chicago: Falcon II Press, 1988, p. 61.

Henry Art Gallery. *The American Craftsmen's Invitational Exhibition*. Seattle, 1968, p. 30.

Herman, Lloyd E. *Clearly Art: Pilchuck's Glass Legacy*. Bellingham, Wash.: Whatcom Museum of History and Art, 1992, pp. 20, 26, 39, 49.

Hokkaido Museum of Modern Art. *World Glass Now '82*. Sapporo, Japan, 1982, pp. 174–75, 250.

——. *World Glass Now '85*. Sapporo, Japan, 1985, p. 191.

——. *World Glass Now '91*. Sapporo, Japan, 1991, pp. 42, 86–87, 223.

——. *World Glass Now '94*. Sapporo, Japan, 1994, pp. 73, 171.

Huntington Galleries. *New American Glass: Focus West Virginia*. Huntington, W.Va., 1980, p. 52.

——. *New American Glass: Focus West Virginia*. Huntington, W.Va., 1981, pp. 8–9.

Indiana University Art Museum. *Contemporary Glass*. Bloomington, Ind., 1980, pp. 46–47.

Ioannou, Noris. *Australian Studio Glass: The Movement, Its Makers and Their Art*. Roseville East, New South Wales: Craftsman House and Australian Council for the Arts, 1995, pp. 21, 30, 33, 117, 121, 122, 124, 125.

Jesse Besser Museum. *Glass: Artist and Influence*. Alpena, Mich., 1981, pp. 14–15.

Klein, Dan. *Glass: A Contemporary Art*. New York: Rizzoli, 1989, pp. 34–35, 200.

Lappin, Kathryn A., ed. *The Fine Art Index*. Chicago: International Art Reference, 1992, p. 348.

Layton, Peter. *Glass Art*. London: A. & C. Black; Seattle: University of Washington Press, 1996, pp. 24, 32, 62, 64, 68.

Leigh Yawkey Woodson Art Museum. *Americans in Glass*. Wausau, Wis., 1978, p. 41.

——. *Americans in Glass*. Wausau, Wis., 1981, p. 51.

Lowe Art Museum. *International Glass Sculpture*. Coral Gables, Fla.: University of Miami, 1973, pp. 19, 36.

Moore College of Art. *Robert L. Pfannebecker Collection: A Selection of Contemporary American Crafts*. Philadelphia, 1980, p. 16.

Morris Museum. *Glass: From Ancient Craft to Contemporary Art*. Morristown, N.J., 1992, p. 53.

Muriel Karasik Gallery. *The Venetians: Modern Glass 1919–1990*. New York, 1989, pp. 56–57.

Musée des Arts Decoratifs. *Expressions en Verre II*. Lausanne, Switzerland, 1989, p. 34.

Museum of Contemporary Art. *American Crafts '76*. Chicago, 1976, p. 28.

National Museum of Modern Art. *Contemporary Glass: Australia, Canada, USA, and Japan*. Kyoto, Japan, 1981, pp. 69–71.

——. *Contemporary Studio Glass: An International Collection*. Kyoto, Japan, 1981, pp. 96–98

Nordness, Lee. *Objects USA*. New York: Viking Press, 1970, p. 162.

Oakland Museum. *Contemporary American and European Glass from the Saxe Collection*. Oakland, Calif., 1986, p. 31.

Odakyu Museum. *Glass '93 in Japan*. Tokyo, 1993, p. 5.

Pasadena Art Museum. *California Design Ten*. Pasadena, Calif., 1968, p. 62.

Schofield, Maria. *Decorative Art and Modern Interiors 1974–75*. New York: Viking Press, 1974, p. 125.

Studio S. *Beauty of Contemporary Glass Art*. Tokyo, 1991, p. 24.

Tacoma Art Museum. *First National Invitational Hand-Blown Glass Exhibition*. Tacoma, Wash., 1971, p. 7.

Tankosha Publishing. *Glass in the Modern World*. Kyoto, Japan, 1981, pp. 227–28.

Toledo Museum of Art. *Toledo Glass National*. Toledo, Ohio, 1966, p. 5.

——. *Toledo Glass National II*. Toledo, Ohio, 1968, p. 16.

——. *Toledo Glass National III*. Toledo, Ohio, 1970, pp. 17–18.

——. *American Glass Now*. Toledo, Ohio, 1972, pp. 40–41.

——. *Contemporary Crafts and the Saxe Collection*. Toledo, Ohio, 1993, pp. 60–61.

Tsuneo, Yoshimizu. *Survey of Glass in the World*. Vol. 6. Tokyo: Kyuryudo Art Publishing, 1992, p. 22.

Tuscon Museum of Art. *¡Calido! Contemporary Warm Glass*. Tucson, Ariz., 1997, ill. p. 63.

Usui, Shiro. *Glass in the Modern World*. Kyoto, Japan: Tankasha Publishing Co., 1981, pp. 93–96.

World Crafts Council. *In Praise of Hands: Contemporary Crafts of the World*. Greenwich, Conn.: New York Graphic Society, 1974, p. 185.

SELECTED ARTICLES AND REVIEWS

Anderson, Nola. "Pranks and Prunts." *Craft Arts*, no. 17 (1989), pp. 50–54.

Ehrmann, Siegfried. "The Magic of the Teapot." *Kunst + Handwerk* (March/April 1984), p. 83.

Glowen, Ron. "Through the Looking Glass: Richard Marquis at Elliott Brown Gallery." *Artweek* (April 21, 1994), p. 15.

——. "Glass Funk: Richard Marquis." *American Craft*, vol. 42, no. 6 (December 1982/January 1983), pp. 34–37.

Hannum, Jill. "Marbles." *Glass*, vol. 6, no. 1 (January 1978), pp. 20–25.

Hollister, Paul. "The Pull of Venice/Die Magische Anziehung Venedigs." *Neues Glas*, no. 1 (1990), pp. 4–9.

Lynes, Russell. "The Sophisticated Crafts." *Architectural Digest* (June 1981), pp. 34, 38, 42, 44.

Marquis, Richard. "Murrine and Cane and Their Use in Blown Glass." Master's thesis, University of California, Berkeley, 1972.

——. "Murrini [sic]/Canne." *Glass Art* (January/February 1973), pp. 39–44.

——. "Richard Marquis—Editorial." *Glass Art Society Journal 1981* (1981), pp. 55–56.

——. "Decoration and Expression (Richard Marquis)." *Glass Art Society Journal 1985–86* (1986), pp. 64–65.

Matano, Koji. "Production/Artist/Artwork: Richard Marquis." *Glasswork*, no. 2 (July 1989), pp. 20–25.

Miller, Bonnie J. "The Irreverent Mr. Marquis." *Neues Glas*, no. 2 (April–June 1988), pp. 78–84.

Milne, Victoria. "In Context: Richard Marquis." *Glass*, no. 56 (Summer 1994), pp. 46–49.

Porges, Maria. "Richard Marquis: Material Culture." *American Craft* (December 1995/January 1996), pp. 36–40.

Reed, Rochelle. "Glassware." *New West*, vol. 4, no. 6 (1979), p. 23.

Simmons, Robert Hilton. "Objects USA—The Johnson Collection of Contemporary Crafts." *Craft Horizons* (November/December 1969), pp. 25–52.

Weiss, Dick. "Glass Painters in the Northwest." *Glasswork*, no. 8 (February 1991), pp. 28–41.

Woods, Jane. "Summervail Symposium: Glass Consciousness 1982." *American Art Glass Quarterly* (Winter 1983), pp. 50–61.

Edited by Suzanne Kotz with assistance by Pamela Zytnicki
Principal photography by Richard Marquis
Designed by Ed Marquand with assistance by Melanie Milkie
and Angela Skeldon
Typeset in ITC Legacy Sans and Legacy Serif, and Agfa Type
Sackers Gothic
Produced by Marquand Books, Inc., Seattle
Printed by C & C Offset Printing Co., Ltd., Hong Kong